Influences in Victorian Art and Architecture

Edited by Sarah Macready and F. H. Thompson

SOCIETAS LONDINI REI ANTIQVARIÆ STVDIOSA
Ian: Aᵒ MDCCXVIII

Occasional Paper (New Series) VII

THE SOCIETY OF ANTIQUARIES
OF LONDON

Burlington House, Piccadilly, London W1V 0HS
1985

Distributed by Thames and Hudson Ltd

PRINTED IN GREAT BRITAIN BY
ADLARD & SON LTD, DORKING, SURREY

Contents

Editorial Note

The papers which make up this volume were delivered at a seminar entitled 'Sources of Inspiration for Victorian Art and Architecture' on 25th November 1983. It was the sixth in the series of research seminars held by the Society of Antiquaries, and was organized jointly with the Victorian Society. On this occasion it was necessary largely to limit the discussion to architecture, sculpture and painting, but a further seminar, devoted to the decorative arts, is to be held on 22nd November 1985, and it is hoped that those papers will also be published, in a complementary volume. We are most grateful to Dr Patrick Nuttgens for presiding and for contributing an introduction to the collected papers, and to all who took part.

June 1985

S.M.
F.H.T.

THE VICTORIAN SOCIETY

The Victorian Society was founded in 1958 with the aim of preserving the best of Victorian and Edwardian architecture, and of studying the art and history of the period. From its foundation the Society has cooperated with official bodies in securing the listing of important buildings of the nineteenth and early twentieth centuries.It also advises on conservation areas, and initiates campaigns to save major buildings.

The Society's headquarters are in London, and it now has regional groups in twelve areas: Avon, Birmingham, East Anglia, Hampshire, Hull, Leicester, Liverpool, Manchester, East Midlands, South Wales, South Yorkshire and West Yorkshire.

The Victorian Society
1 Priory Gardens
Bedford Park
London W4 1TT

ALAN CRAWFORD
Chairman

Illustrations

Introduction

Patrick Nuttgens, *Chairman*

The seminar which produced the papers that form this volume was a crowded and never less than stimulating day. The subject was huge, the conspectus wide, the material apparently endless in variety and scope. In that, the seminar reflected the richly disparate society that was celebrated in this collaborative study of the sources of inspiration for Victorian art and architecture.

The period is a rich one because it was one of fantastic industry and social change. In that change no phenomenon was more strident in its implications or its effect upon daily life than the unprecedented growth of the great cities in which the art and architecture took shape. It was the age of steam and gas, of railways and trams; and its scale was different from anything known or recorded before.

What seems to me clear (and was borne out by the seminar) was that the Victorians were not looking for sameness or uniformity. They reacted in their literature as much as in their visual arts against what they saw as the dullness of the Georgian town, with its repetitive houses and streets. They wanted not uniformity but more variety, more diversity. They therefore searched in the past for inspiration for a future which would have not one face but many.

The varied papers in the seminar therefore rightly emphasized, even in their presentation, the conflicts inherent in a rapidly developing society. No paper attempted to analyse or present the total situation, and perhaps that is impossible. For the contrasts and conflicts took place on many different levels. While polite and wealthy society, for example, was becoming more stratified and exclusive, information and skills were being deliberately brought to the labouring or working classes by the Mechanics Institutes, those relatively unsung pioneer establishments of education which were launched in all the great cities from the 1820s. The arts and the architecture reflect the need to be comprehensible to all, while satisfying the taste of the cultivated. In such an environment diversity was of the very essence.

So the Victorian period is one of arrogance and apparent confidence that I suspect covered a profound insecurity, enlivened by the constant search for certainty in a given field. And the aesthetic as well as the social problems relate to that—how, for example, to combine originality and authority and display one

without destroying the other. It is a conflict that becomes more clearly defined as the century progresses; the major paper by R. W. Lightbown on 'The Inspiration of Christian Art' which started the seminar is very different in style from the paper which finished it, Alan Crawford's essay on 'Sources of Inspiration in the Arts and Crafts Movement'.

The papers tell that story with their own verve, originality and, ultimately, authority.

The Inspiration of Christian Art

R. W. Lightbown, F.S.A.

There appeared in a *Punch* of the early 1960s a cartoon of two dear middle-aged ladies in an Italian gallery. One is saying to the other, 'Just as you want to leave, there's always another Fra Angelico'. The days when this state of mind was general are gone or, if not gone, going, and the purpose of this paper is to trace its first origins in the doctrines of Christian Art, which were to have so profound an influence on Victorian attitudes to the art of the past and on the models that were held up in the Victorian age to artists, architects and the cultivated public for admiration and imitation. The subject is a large one, and I shall restrict myself here to those figures and those books and writings that had most to do with its dissemination in England. I shall concentrate on the 1830s, 1840s and 1850s, saying rather less about Ruskin and his followers than some perhaps might hope, and not more about the Gothic Revival or Tractarianism than is necessary to link them with my theme, which is the origins and spread of that consistent theory of art and art history which was known in its own day as Christian Art. Again for reasons of space, I shall lay greater stress on books and journals than on the works of painters such as the Nazarener, if only because this first school of Christian art is already covered in English.

Gothic architecture, as is well known, enjoyed an antiquarian revival in the eighteenth century. From a letter of Sir Edward Turner to the antiquary and amateur architect Sanderson Miller (1717–80) of Rodway, in Worcestershire, we see that in the 1750s, when used for religious buildings, it was considered to be a High Church style, marking Toryism in the builder.[1] This was in keeping with the Caroline tradition of the High Church party, which had long used the style to emphasize the continuity of the Anglican church with the medieval and early church in England. In addition, the High Church was by no means averse to painted windows and to altarpieces, provided the subjects they represented were scriptural, like the Last Supper, or symbolical, like the Holy Name. But when these were introduced into London churches, as in the case of the early sixteenth-century window of the *Crucifixion* installed in 1758 as the East Window in St Margaret's, Westminster, there were

furious attacks on them as revivals of the idolatry of Rome.[2] The influence of a High Church squire and parson might secure tolerance for them in the country, but even in the 1770s, when the revival of English painting during a period of exceptional cultivation had secured a new respect for art, Bishop Thomas Newton was unable to set on foot his scheme for decorating the walls of St Paul's with religious scenes because of the hostility of general public opinion, still sternly Protestant in its objection to Popish decorations in churches.

Nevertheless, religious painting made some progress in pious England. George III had Benjamin West decorate his chapel at Windsor with paintings illustrating the Progress of Revealed Religion. And a surprising number of country churches, especially in Devonshire, were adorned with altarpieces by well-known painters from the 1780s to the 1820s. The publisher and print-seller Thomas Macklin commissioned in the 1780s pictures 'illustrative' of the Bible for his Poets' Gallery, while West and Haydon later executed ambitious religious pictures which were exhibited in London and the provinces. The case was different with religious sculpture: with one or two exceptions during the Laudian decade of the 1630s, hostility to 'graven images' in churches as idolatrous prevailed unbroken in England from Elizabethan times until the Tractarian movement.

The models of these religious paintings were the heroic canvases of the Italian and French and Flemish Baroque, works by the Caracci, by Rubens, by Poussin, by Le Sueur. One of the purposes of this paper is to trace the evolution by which this classical style came to be regarded as profoundly irreligious. That it came to be so regarded is an irony of history, for in part it had come into being in response to the prompting of the reforming clergy who sought to put into execution the decrees of the Council of Trent. Thus Cardinal Federigo Borromeo's little treatise of 1625 on Christian art is firm in its insistence that the over-muscular bodies, complex poses and vacant faces of Mannerism did not constitute a valid style for Christian art.[3] It must be emphasized that in England, France, Italy, Spain, even Germany itself, throughout the first half of the nineteenth century respect for the High Baroque masters was still general. The advocates of Christian Art were a minority, fighting a battle against a powerful critical orthodoxy that saw in the great masters of the sixteenth and seventeenth centuries, in classical sculpture and in classical architecture, the culminating expressions of art. What we shall consider is the change by which doctrines essentially non-aesthetic helped to undermine this deeply rooted critical orthodoxy, substituting religious sincerity in the artist and mystical idealism in his works as the canons by which religious art ought to be judged.

The movement that sought to reject the art of the seventeenth and eighteenth centuries in favour of medieval and early Renaissance art began in Germany. Interest in Italian primitives and in Italian Gothic and early Renaissance sculpture had already revived in Italy itself during the eighteenth century, among certain foreign artists and antiquaries resident there as well as among the Italians themselves, and also among English collectors and connoisseurs, notably William Lock of Norbury and Lord Bristol.[4] But it was an interest in earlier pictures and sculptures as illustrating the stages by which the fine arts had risen and progressed from their thirteenth-century barbarism to the perfection of the High Renaissance. It was thus essentially historical and antiquarian in its bias and, though it increased respect among the learned and among connoisseurs for the achievements of medieval and early Renaissance artists, it did not lead to a complete revaluation of their styles. This crucial evolution was

not the consequence of an evolution of critical opinion proceeding from a closer study of earlier works of art, or of any caprice of taste; it was wrought by a change of sentiment.

The cult of sentiment in the eighteenth century cracked many rigid aesthetic moulds in literature and the arts, and it is not surprising that it eventually led to a revolution in attitudes to medieval and early Renaissance art. Its essential innovation was not so much in the stress it laid on the portrayal of emotion, as in its equation of art with the power to stimulate the better feelings of our nature. The cult of sentiment and sensibility was the cult of emotional idealism. After an early period of essentially secular and social expression, it became linked with that slowly mounting religious revival of the later eighteenth century which was accelerated by the French Revolution into a religious reaction. It first crystallized into a new aesthetic doctrine in sentimental and pious Germany, and found a voice in the *Herzensergiessungen eines kunstliebenden Klosterbrüders* ('Outpourings from the heart of an art-loving monk'), of Wilhelm Heinrich Wackenröder, published anonymously in Berlin in 1797. This little book, edited by Wackenröder's friend Tieck, who later republished it with additions of his own as *Phantasien über Kunst*, was enthusiastically welcomed by German artists in Rome and elsewhere.[5] A vindication of the role of religious sentiment in art, it proposed that artists should seek their ideal in the Middle Ages, when there was no division between art and life, and the artist could figure his love of God in his works, and so fashion them that he expressed in his art the revelations of the divine. Thus artists like Dürer had sought to learn simplicity and spontaneity from the untutored, the better to communicate to them their feelings and their lessons. These doctrines were eagerly embraced by two of the most influential German critics of the early nineteenth century, the Schlegel brothers. The great apostle of Christian Art, Alexis-François Rio, was later to describe Friedrich von Schlegel in 1836 as 'the man who in modern times has felt Christian art most keenly'. Schlegel himself declares in his preface to his *Briefe auf einer Reise durch die Niederlande, Rheingegenden, die Schweiz, und einen Theil von Frankreich* (1806), describing the pictures and architecture he saw on a visit to Paris, the Netherlands and Germany in 1802–4, that only in 1798, 'after I had learned to understand and appreciate the Romantic poetry of the Middle Ages and the deep spiritual love-sense with which it is imbued', had he also become alive 'to new and peculiar beauties in the paintings of the great masters'.[6] This was in the Dresden Gallery, where on a first visit in 1789 he had had eyes only for the antique sculpture and for paintings in the classical taste. In this movement to emphasize the simple and spiritual inspiration of true Christian art, attention soon fell on an early artist who came to be seen as best typifying and justifying the doctrine that personal piety and holiness are essential to the painter of religious pictures, Fra Angelico. In 1817 August Wilhelm von Schlegel published in Paris fifteen line engravings of Angelico's *Coronation of the Virgin* in the Louvre, with a laudatory introduction and a dedication to the King of Prussia.[7]

The writings of Wackenröder and Tieck on art were never translated into English and those of Friedrich von Schlegal only in 1849,[8] when the doctrines of Christian Art were already well known in England from other publications. More important in the 1820s and 1830s for the general European diffusion of those doctrines were two followers of Wackenröder, Tieck, and Schlegel: Sulpice Boisserée (1789–1854) and his brother Melchior (1786–1851).[9] After their return to their native Cologne in April 1804 from a sojourn in Paris, the Boisserée brothers dedicated their fortunes to

forming a collection of Northern primitives, which was the first of its kind and which accompanied them on their migration to Heidelberg in 1810 and later to Stuttgart in 1819. Besides the paintings by early German masters, classed as the 'Byzantine School of the Lower Rhine', there were paintings by the great Flemish masters of the fifteenth century, others by Flemish masters of the sixteenth century, and a group of paintings by Dürer and his contemporaries. And here we must remember that the division between the Gothic Middle Ages and the early Renaissance was not for these early enthusiasts the severance it has become for us. Everything that preceded the classic schools of the High Renaissance and Baroque was grouped together, a concept of period to which we shall return later. The acquisition of the Boisserée collection in 1827 by King Ludwig of Bavaria brought it to Munich, a Catholic city whose scholars and philosophers played, as we shall see, a fundamental role in the formulation of the doctrines of Christian Art. Sulpice Boisserée's other enterprises of significance were the part he played in the restoration of Cologne Cathedral and his great book on its history and architecture. One of Boisserée's most powerful motives in his resuscitation and glorification of the Northern past was the nationalism so characteristic of the German Enlightenment, and even more of German Romanticism. Nationalism made him claim a German origin for Northern painting and, still more sensationally, for Gothic art, even so late as 1837. The origins, dates and nomenclature of English Gothic styles had been matters of bitter controversy among late eighteenth-century and Regency antiquaries and architects, and the whole question was taken up by one of the acutest of them, Benjamin Whewell, Master of Trinity. Whewell made a special tour to the Rhineland in 1829 to see what light German Gothic could cast on the vexed question of origins in particular, subsequently publishing his observations as *Architectural Notes on German Churches* (1835).

In England the great apologist of Gothic architecture as the only style for Christian art was Augustus Welby Northmore Pugin (1812–52). Pugin's first real polemic in favour of this doctrine was his famous *Contrasts; or, a Parallel between the Noble Edifices of the Fourteenth and Fifteenth Centuries, and similar Buildings of the Present Day; Shewing the Present Decay of Taste*, which he published in 1836. In this short book he enunciates one of the cardinal doctrines of Christian Art, that beautiful religious buildings and works of art can only be made by artists who labour in a religious spirit. 'Who can regard', he exclaims, 'those stupendous Ecclesiastical Edifices of the Middle Ages' without feeling how well 'the fabric bespeaks its destined purpose':

> the eye is carried up and lost in the height of the vaulting and the intricacy of the ailes: the rich and varied hues of the stained windows, the modulated light, the gleam of the tapers, the richness of the altars, the venerable images of the departed just,—all alike conspire to fill the mind with veneration for the place and to make it feel the sublimity of Christian worship ... Such effects as these can only be produced on the mind by buildings, the composition of which has emanated from men who were thoroughly imbued with devotion for, and faith in, the religion for whose worship they were erected. Their whole energies were directed towards attaining excellence; they were actuated by far nobler motives than the hopes of pecuniary reward, or even the applause and admiration of mankind. They felt they were engaged in the most glorious occupation that can fall to the lot of man, that of raising a temple to the worship of the true and living God. It was this feeling that

operated alike on the master mind that planned the edifice, and on the patient sculptor whose chisel wrought each varied and beautiful detail. It was this feeling that induced the ancient masons, in spite of labour, dangers and difficulties, to persevere till they had raised their gigantic spires into the very region of the clouds. It was this feeling that induced the ecclesiastics of old to devote their revenues to this pious purpose, and to labour with their own hands in the accomplishment of the work; and it is a feeling that may be traced throughout the whole of the numerous edifices of the middle ages, and which, amidst the great variety of genius which their varied styles display, still bespeak the unity of purpose which influenced their builders and artists. They borrowed their ideas from no heathen rites, nor sought for decorations from the idolatrous emblems of a strange people. The foundation and progress of the Christian faith, and the sacraments and ceremonies of the church, formed an ample and noble field for the exercise of their talents; and it is an incontrovertible fact, that every class of artists who flourished during those glorious periods selected their subjects from this inexhaustible source, and devoted their greatest efforts towards the embellishment of ecclesiastical edifices.[10]

Melancholy the contrast with modern times! 'Yes; the erection of churches, like all that was produced by zeal or art in ancient days, has dwindled down into a mere trade. No longer is the sanctity of the undertaking considered, or is the noblest composition of the architect, or the most curious skill of the artificer, to be employed in its erection; but the minimum it can be done for is calculated from allowing a trifling sum to the room occupied for each sitting; and the outline of the building, and each window, moulding, and ornament, must be made to correspond with this miserable pittance'.[11] These words of Pugin express at a remarkably early date some of the other essential dogmas of Christian Art: that the Gothic architecture and sculpture of the Middle Ages alone express the spirit of Christianity fitly, that they do so because the architects and artists who wrought them worked in a spirit of true piety and devotion, that the religious spirit of the Middle Ages was so pervasive that even ecclesiastics and laymen laboured with their own hands to raise these stupendous edifices.

Did the ideas originate in Pugin's own enthusiastic brain? He had become a convert to Catholicism in 1833, and ardent Catholicism, as we shall see, was the inspiration that originally kindled fervour for Christian Art in at least two other highly influential disseminators of its dogmas, Montalembert and Rio. At this date, however, they had published none of the writings which proclaimed their doctrines of Christian Art, and it is possible that one of the sources of Pugin's inspiration was that key work in the French Romantic revival of enthusiasm for the religious art of the Middle Ages, Victor Hugo's *Notre-Dame de Paris*, published in 1831. For Hugo, the architectural styles and forms of an age were symbols of that age's deepest thoughts and persuasions. He believed that in architecture each successive generation until the invention of printing in the fifteenth century had written its own book in stone. Gothic architecture was the book of the people, of liberty, of man, an expression in its multiplicity of forms, in its wealth of capricious and irreverent ornament, of the liberty, originality, and fantasy of the artist, as opposed to the hierarchical, the sacerdotal rigidity of the Romanesque. In this quintessentially Romantic spirit he exalted Notre-Dame as a colossal achievement of corporate endeavour by artist and workman, condemning the academic architecture of the late sixteenth, seventeenth

and eighteenth centuries as impoverished in spirit and in form. Although he had no sympathy with the religious inspiration of Gothic architecture, Hugo's celebration of its symbolic power as an expression of its age inspired many of his contemporaries to make deeper investigations into its nature and meaning.[12]

To revert now to Montalembert and to Rio, whose careers were closely intertwined throughout their lives. Both had close English connections. Montalembert, the son of Eliza Forbes by a French *émigré*, was born in London in 1810, and lived here as a child under the care of his grandfather James, the author of *Oriental Memoirs*, while Rio, as we shall see, married an English wife. It will be best to begin with Rio, whose book *De la poésie chrétienne, dans son principe, dans sa matière et dans ses formes*, first partially published in 1836, crystallized the ideas of Christian Art concerning painting in a book whose eloquence and persuasiveness gave them European diffusion for the first time, especially in England. Rio and Montalembert were aided in their propaganda by the fact that they wrote in French, in the 1830s still the only language universally familiar to the cultivated classes of Europe, far more so than German, in spite of the great and rapid increase in popularity and prestige of the language of Goethe, Schiller and Kant.

Who was Rio? This is a question we must answer, for his background and early life explain in large part his career as a propagandist in favour of Christian Art. Alexis-François Rio (1797–1874) was born at Port-Louis, not far from Vannes. He was a Breton, then, and in addition came of a deeply pious and royalist peasant family in a region which was one of the most Catholic and royalist of a Catholic and royalist province. Brittany contributed to the Catholic Revival in France not only Chateaubriand, whose *Génie du christianisme* of 1802 was its first manifesto, but also one of its most prominent leaders in the 1830s, the Abbé Félicité de Lammenais, with whom Rio was for a time to be closely associated through his friend Montalembert. Rio's widowed mother sent him to Vannes for his education in the hope that he would become a priest; partly, too, because she wanted him to escape the Napoleonic conscription. Rio, though he felt no vocation for the priesthood, was profoundly influenced by his clerical instructors, not least by the Abbé le Priol, who first introduced him to the contemporary German philosophy that was to have so deep an influence on his life and thought.[13]

In 1815, while still a schoolboy, he fought in the Royalist uprising against the restoration of Napoleon during the Hundred Days known as the Petite Chouannerie, and he never betrayed the fiercely legitimist and Catholic loyalties for which he had taken up arms. His conduct earned him the Légion d'Honneur from Louis XVIII and a commendation from the Comte d'Artois, later Charles X. After decisively rejecting the priesthood, he left Vannes in 1819 for Paris, like so many ambitious youths of early nineteenth-century France fired by hopes of a successful career under royal patronage as a reward for his services. At first he had to be content with posts in provincial *lycées*. His career seemed to be made when, during the second month of 1828, he was taken up by his fellow Breton Auguste Pierre Marie Ferron, Comte de la Ferronnays (1777–1842), who served under Charles X as foreign minister from 1827 to 1829, and then as French ambassador to Rome. La Ferronnays had originally chosen Rio to carry out propaganda for French policy in the foreign press, but he became attached to him personally, and when he was appointed ambassador to Rome invited Rio to accompany him, apparently in the capacity of tutor to his daughters, to whom Rio had been giving private lessons in the history of Italian art. Meanwhile Rio

had received from Montalembert his second introduction to German philosopphy, and in particular to Schelling, Baader and Zimmer, the new Romantic Catholic philosophers of Munich. Montalembert had encountered their works during his sojourn in Sweden in 1828 and, on his return to Paris in the autumn of 1828, fired Rio with his enthusiasm for the new school, so much so that the pair of them studied his extracts from Schelling and Zimmer together.

Already by about 1824 Rio had become preoccupied with his favourite subject, 'the patent and hidden causes of the progress and decadence of the fine arts', with a particular interest in the phenomena of decadence. It is typical of the persistent classicism of the 1820s that he first expressed these interests in an *Essai sur l'histoire de l'esprit humain dans l'antiquité* (1828). He was now to expand his ideas on art by direct contact with the acknowledged master-works of the past. For the cultivated public in general, German, French, English, Classical or Romantic, Italy was still the home of the fine arts, which everyone who aspired to a knowledge of their history and of their finest achievements felt obliged to visit. At first Rio's impressions were confused: he could find no systematic guide through the labyrinth of Italian painting. Cultivated French travellers still took as a guide the *Voyage d'Italie* of the painter Cochin, first published in 1758, and a monument of an intolerantly classic taste in painting, with its unvarying prejudice in favour of the Caracci and the Bolognese. Rio comments on the backwardness of taste French travellers displayed in Italy, a backwardness shared even by Chateaubriand, whom he encountered in Rome. Although Chateaubriand 'had almost caught sight of the true requirements of a Christian aesthetic, he did not understand that the German painters then working in Rome almost under his eyes were accomplishing instinctively a work analogous with his',[14] and reserved all his sensibility for the Caracci and for Michelangelo's *Last Judgement*.

Rio also laments that all spontaneity of impression before works of art was hindered in the French by strong conventional notions, such as their traditional reverence for Poussin and Le Sueur. He himself was liberated by his Catholicism, which drew him to visit the many miraculous Madonnas of Rome and also the Catacombs, then neglected and often inaccessible. The Catacombs aroused his deep devotion, as indeed early Christian art had aroused the devotion of Cardinal Federico Borromeo two centuries before.'This was as it were the first ray of light which came to brighten vaguely and through much darkness, my aesthetic horizon and made me glimpse the possibility of constructing the history of Christian art on a plan which would make its progress depend on the intensity of its inspiration far more than on the perfection of its technique'.[15] During this first Italian journey Rio fell in love with Venice, but he felt the need for philosophical support and guidance in seeking to define his understanding of the beautiful. At Montalembert's suggestion, in the spring of 1830 he went to Munich, then the scene of a historicist revival under King Ludwig, with much enthusiastic imitation of Italian medieval and early Renaissance monuments. More important for Rio, its university was a centre of German Catholic philosophy of the Romantic Revival. Here he won the friendship of Friedrich Wilhelm von Schelling, the most powerful philosophical influence in his life, of Franz von Baader, of Görres and of Johannes von Döllinger, the Catholic historian and theologian, then the youngest professor in Munich and much under the influence of Lammenais. It was Döllinger who introduced him to Dante, an author still little appreciated in France, and who put into his hands the first two volumes of the *Italienische Forschungen* of Karl Friedrich von Rumohr (1827–31).

Rumohr was a wealthy Holsteiner who had been converted to Catholicism in 1805 before Raphael's Sistine Madonna in Dresden, becoming a fervent devotee of Christian art thenceforward.[16] His book was the most important single historical source for Rio's study of the history of Italian art. Its first two volumes contain an essay on aesthetics, followed by a history of Italian art, of 'modern' as opposed to 'antique' art, that is, art from early Christian times until the end of the fifteenth century. The last volume, published in 1831, was devoted to Raphael and to an essay on the origins of the styles of medieval architecture. Rumohr's great innovation was in historical method. Instead of relying solely on published histories and antiquarian essays, though he made full use of these, he searched out original documents in Italian archives, principally in Florence and Siena, greatly enriching the traditional history of early Italian art by his discoveries, and making possible a fuller understanding of its historical context. It was after reading Rumohr's book that Rio saw the possibility of developing a new classification of the history of the fine arts, just as Linnaeus had done for botany. French literature on the fine arts had left his imagination cold: 'what was my surprise when I found, couched in forms of greater or lesser attractiveness, a specialist literature whose aim was to place within the comprehension of every class of reader the deductions or applications of the new science which under the name of aesthetics or the science of beauty had become both in the schools and in books an obligatory adjunct of all philosophical systems and instruction'.[17]

His political career was suddenly ruined later that same year by the fall of his patron after the Revolution of July. But the Orleanist government, thanks to the intervention of Guizot, whose reputation as a historian had been made as a medievalist, continued to pay him a salary as a sort of pension and invited him to devote himself to 'some extensive literary work'. Rio therefore returned to Italy in July 1831, determined to study and classify works of art directly, resisting the influence of conventional critical opinions. At Venice, where he began his researches, he found himself unable to respond to Titian, Veronese, Tintoretto or Bassano, the usual admirations of the visitor. Instead he discovered in himself a deep sympathy with the Bellinis and their contemporaries, and with the neglected Lorenzo Lotto. He studied their pictures, in association with contemporary Venetian chronicles and the traditional legends of Venetian saints, and as a result of this self-immersal in the Venetian past came to see in the old Republic not the Machiavellian monster of conventional history, but a deeply patriotic and religious society. 'By a natural consequence, the devotional image that was contemporary with or the promoter of some great act of national faith had greater intrinsic value in my eyes than the masterpiece most greatly admired for its technical perfection'.[18]

From Venice he went to Padua, largely to see Giotto's frescoes in the Arena, and then on to Ferrara, where he made his first discovery of Francesco Francia. In Bologna he scandalized everyone by rejecting the Caracci in favour of earlier Bolognese painting; in Florence he immersed himself in the art of the fourteenth and fifteenth centuries, taking Rumohr's book as his guide. After three months in Florence, he moved in December to Rome, where he joined his friends Lammenais and Montalembert in a common household. The two were on their famous and fateful mission to secure approval from Pope Gregory XVI for their journal *L'Avenir*, and for its religious, political and social programme.

In Rome he saw the paintings of the Nazarener, to which he was introduced by Baron von Bunsen, Prussian minister to the Pope and one of the great figures of

nineteenth-century cultivated international society. He also met the future Cardinal Wiseman and struck up a close friendship with Monckton Milnes, later to be Lord Houghton, then a young and wealthy poet. This was Rio's first introduction to English society. Madame von Bunsen, born Frances Waddington of Llanover, in Monmouthshire, was Welsh, and his Breton blood made Rio feel a special bond with her. He also made friends with a great Anglo-Indian family, the Malcolms,[19] and at the end of his stay in Rome, he journeyed back with them through Umbria, visiting Assisi, where he admired the frescoes, and Perugia, where the paintings of Perugino threw him into ecstasies. The party then went on through Lombardy to Milan; here the paintings of Leonardo and Luini inflamed Rio with a similar enthusiasm. From Florence he went on to Munich with Montalembert and Lammenais. In Munich Lammenais, though not interested in art, was, as a social reformer, temporarily influenced by the atmosphere into forming a scheme for founding a colony of young Breton artists, who were to model themselves on the Nazarener masters, Overbeck, Cornelius and Veit.

All this happened in 1832. In late 1832–3 Rio visited England and Wales, and at Llanarth, near Abergavenny, met his future wife, Apollonia Jones, a member of one of the few old Catholic families of Wales. He then returned to Munich, drawn by the fascination of Schelling. What attracted him most in Schelling's philosophy was the theory of transcendental idealism in art, of which Schelling was the great apostle, and the idea that art itself is truth revealed through the unconscious medium of the artist, and is superior to science because it represents the infinite in the finite. There is no need to stress the significance for a dedicated believer in Christian art of this philosophical vindication, so characteristic of Romanticism, of the value of religious inspiration in art. Rio recognized that Schelling lacked direct visual experience of the arts and had never made the comparisons, so necessary to a historian of art, of the various schools of painting. He therefore made it his task to apply Schelling's philosophy to the observations and documents he had collected in Italy in 1832–3. During this third sojourn in Munich of 1833, he also came more profoundly under the influence of the mystical Catholic thinkers, Franz Xavier von Baader (1765–1841) and Johan Joseph von Görres (1776–1848), both of whom encouraged his belief in the essentially religious inspiration of art, which in its highest form might be direct mystical inspiration from God. In the end, however, Rio came to prefer Schelling and his doctrine of aesthetic intuition. He himself dated his final conversion to the 'aesthetic religion', of which Munich was the sanctuary, to this third visit.

Rio married Apollonia Jones late in 1833, and she at once constituted herself the faithful helpmate of his researches. They went to Italy for their honeymoon so that Rio could make a deeper study of the Florentine and Umbrian schools. He then came back to Paris by way of Munich in order to write a book on Christian art, all his circle, especially Montalembert, encouraging him with flattering predictions that it would change the aesthetic ideals of France. He finished it in 1835, and then left for Wales, since he and his wife had just had a baby daughter. The book came out in the summer of 1836, and at first fell absolutely flat. For its initial failure, Rio himself must be held partly responsible; its title *De la poésie chrétienne* did nothing to advertise its contents, and it appeared as a fragmentary second part subtitled *Forme de l'art*. Nevertheless, as we shall see, within a year it was making its way, partly through the energetic propaganda of Montalembert, partly on its own merits.

Indeed, *De la poésie chrétienne* is a remarkable book, still worth reading as the

eloquent expression of a doctrine and as a book that broke old moulds of aesthetic judgement. It is not a treatise on art theory, however, but a history of medieval Italian art, written from a novel perspective. To understand its full impact, we must remember that according to the conventional historiography of Italian art, painting and sculpture revived in the thirteenth century from rude beginnings in the Byzantine-Greek style and progressed through the still imperfect art of the trecento and quattrocento until they culminated in the three great geniuses of High Renaissance art, Leonardo, Raphael and Michelangelo. This was the paradigm of their development presented by Vasari, and it was still substantially the picture presented in the *Storia pittorica della Italia dal risorgimento delle belle arti*, the great history of Italian painting published by the Abbate Luigi Lanzi in 1789. Lanzi's book, which appeared, revised and improved, in many Italian editions, was translated into French, German and English and was plagiarized by Stendhal in his *Histoire de la peinture italienne* (1817). It still remained in Rio's day the standard history of Italian painting.

A very different image of the development of Italian art opens on us as we read the pages of Rio's book. In its very first pages we encounter the criterion of judgement he will apply with such rigour. No longer must we allow our eyes to dwell solely on the surface of a painting, we must look beyond, into its inner sentiment.

> When one reflects that it is here, in works so crude, that the peoples of modern times deposited the strongest and purest emotions of their hearts, as well as the freshest creations of their imaginations, when one thinks that it was their hope and their intention that these monuments which we disdain should be immortal and bear witness for ever to their enthusiasm and their faith, then one becomes less difficult over the various kinds of merit whose union constitutes what we conventionally call a masterpiece, and one begins finally to neglect the surface of things a little in order to penetrate more deeply into their nature.[20]

We must notice here that Rio sharply separates technical accomplishment from sincerity of sentiment. This separation is crucial to his doctrine. Works of art are no longer assessed by their comparative perfection of form, of colour, of drawing, but by their genuineness of religious feeling. Throughout his book Rio stresses continually that perfection of form in the simulation of nature is not enough to make a true work of art: this is achieved when faith is the guide of the artist's brush.

There can be no doubt that this new perspective remedied a grave historical and aesthetic injustice. It restored dignity and grandeur of achievement to the Italian primitives, and rescued them from the patronizing attitude of earlier critics and antiquaries, who were apt to praise them, like promising schoolboys, for progress made and improvements shown. But there was a defect to Rio's partisanship, as there is to all partisanship. For him it did not suffice that an artist was sincerely religious, he had to be a Catholic as well, one might even say an Ultramontanist, were this not anachronistic. Accordingly he treats the art of schismatic Byzantium with indignant scorn, reproaching it with hideousness, stiffness, rigidity, with creating vulgar types and elongated, fleshless figures. Unlike his contemporary, Didron, the great antiquary and iconographer, he had no perception of Byzantine religious sentiment and no conception of the influence of Byzantine art on early medieval art; indeed, he expressly denies any such influence. One consequence of this sectarian bias in Rio was to perpetuate incomprehension of Byzantine painting, at any rate in England, until the 1930s.

Using religious sentiment as the true touchstone of art, Rio was able to constitute a new history of its development. He claimed, wrongly as we know, that the age of Charlemagne saw the decomposition of the old pagan language of forms, a decomposition necessary because antique art had to be totally lost sight of by Christian artists in order for them to attain to the conceptions, equally original and sublime, that distinguish the artists of the Middle Ages. These were revolutionary words after four centuries of imitation of the antique, culminating in the movement we know as Neo-Classicism. Under Charlemagne, so he claims, introducing the theory of racial temperament so dear to Romantic nationalism, the Germanic element leads to a renewal, a re-birth of art. But now art is Germano-Christian, not Romano-Christian. For Romano-Christian art falls into ever greater decadence and expires in the thirteenth century. Its mission had been to transmit the early inspirations of Christianity to this vigorous new school: once this task was accomplished, it had no further life to communicate. Rio now traces the history of painting from Carolingian and early medieval manuscript illuminations—one of the positive achievements of the German Romantics and of the theorists of Christian Art was their emphatic recognition of the beauty and interest of medieval book-illumination, previously an antiquaries' preserve.

In Italy this decadence of the Romano-Christian school was ended by the rise of the school of Siena. The late eighteenth-century Sienese antiquary Guglielmo della Valle had overturned traditional notions of the origins of Italian painting by claiming that the Sienese had preceded the Florentines. The cornerstone of his argument was the date, then read as 1221, on the celebrated *Madonna of San Domenico* of Guido da Siena. Rumohr, too, had lavishly praised the Sienese school, and the city itself now rose like an enchanted Gothic paradise before the marvelling eyes of Rio, Montalembert and the enthusiasts for Christian and medieval art who followed in their footsteps. The vogue for Sienese art which they began and which lasted for more than a century (indeed, has only expired in the last fifteen years) was entirely the work of the doctrinaires of Christian Art— another case of an aesthetic injustice repaired for reasons essentially non-aesthetic. The other largely forgotten city rediscovered by the advocates of Christian Art was Pisa, and here, though they admired the cathedral and the leaning Tower, their great enthusiasm was for the Campo Santo, whose frescoes were for them 'a museum of Christian painting', housed in a cemetery of moving patriotic memories and Romantic melancholy. Readers of *Praeterita* will recall how Ruskin's visit to the Campo Santo was a culminating experience of his second Italian journey.

Unlike Rumohr, Rio did not hold that Giotto had given a profane direction to art. With some insight he saw him instead as part of a great movement which emancipated architecture from the Romanesque and the Romance tongues from Latin during these same years. Besides his positive merits, Giotto had for Rio the negative merit of destroying 'certain types which in many respects were superior to his own, but which were incompatible with the great destinies that awaited modern Christian art'.[21] Rio now introduces a new formulation of his cardinal doctrine: the artist must be moved by an inner sympathy with his subject; hence Giotto, who painted so successfully at Assisi, was especially moved by Franciscanism. The revival of the cult of St Francis, so characteristic of the nineteenth century, was shortly to find an enthusiastic exponent in Frédéric Ozanam (1813–53), another member of the circle of Rio and Montalembert, and it was to touch Ruskin in his late association with Francesca Alexander. For

Rio, the life of St Francis lends itself especially to the special aim of painting, which is 'the poetical expression of the profound affections of the soul'.[22] If we recall for a moment the importance attributed in the classical Baroque theory of art to the dramatic representations of the affections, we see that Rio has moved to a Romantic conception of art as the figuration of an inner, personal drama.

There can be no doubt that the fourteenth century, and particularly its latter end, was for Rio the golden age of Italian art. This was because its artists were so uniformly devout: their *ateliers*, he tells us, were, 'so to speak', transformed into oratories. He initiates that cult of Orcagna, 'the Michael-Angelo of his century',[23] which was to last for the rest of the century, but not for longer—there is no modern monograph on the artist. The dramatic motifs and increased human detail introduced into painting by Giotto led, he believes, to a more intimate alliance between art and nature, modifying the idealism and abstraction of early medieval art. But fourteenth-century artists still had the power of assimilating naturalism into the religious subjects which their piety inspired them to paint. Rio in fact does not wholly confuse truth of religious sentiment with greatness in art: the true artist is one who can assimilate the imitation of nature, even the imitation of the pagan antique, into works of religious beauty. This conception of assimilation, or shall we call it due subordination of naturalistic and antique elements of beauty to the devotional mission of art, is fundamental to his aesthetic doctrine. Not that he was unaware of the technical progress made by painting as a representational art in the fourteenth and fifteenth centuries, but his thought, as we have seen, was profoundly influenced by German transcendental idealism, and for him the mere representation of nature could never be the sole end of painting. He, like the theorists of the classical Baroque, saw dry representational skill as prosaic, but the poetry that he sought in painting was not the imitation of the passions so dear to the Baroque, but the Christian poetry of feeling of the sincerely pious soul. It was in fact a Romantic poetry of personal sentiment, not a Baroque poetry of portraiture of man's affections.

During its second period, the fifteenth century, Christian art lost its unity. The rise of the Medici brought luxury, and with luxury increasing patronage of secular paintings for private houses: the new classical education eventually was to blunt sensibility to religious subjects. Painting is no longer exclusively devotional, but influenced by classical pedantry, by frivolity and by patrician vanity. Here we have a strong expression of a myth that continues to influence the study of medieval art: because religious works survive out of all proportion to secular works, it is still all too easily assumed that the role of secular art in the Middle Ages was insignificant. Rio goes on to claim that the fifteenth century's vain patrician custom of introducing actual portraits of contemporaries mingled with holy personages into religious paintings encouraged 'a real element of decadence, that of naturalism, whose disastrous progress, continued at the expense of the poetical element, will become only too plain'.[24] And plain it becomes, as he surveys the great names of the Florentine quattrocento. If Ghiberti can be praised for his purity and elegance of form and Donatello and Brunelleschi for their power of assimilating the purity and elegance of classical art without sacrificing the independence and originality of their genius, Masaccio introduces a dangerous tendency to limit idealism in art in favour of naturalism, while Filippo Lippi's immoral life implies a vulgarity of soul which is reflected in the vulgar naturalism of his art. Here, again, we see the simplistic moral judgements that allow Rio to equate a bad life with bad art, a critical sentence he

pronounces with equal vigour against Andrea del Castagno. The only artist in the representational school he wholeheartedly admired in the 1830s was Domenico Ghirlandaio, who for him rises above naturalism to attain to Christian art.

For Rio, then, art divides itself in fifteenth-century Florence into two schools. Some artists still continued to receive their inspiration from above, while others fell into the snares of naturalism. The imitation of nature became avowedly the supreme aim of art. This might be considered a progress 'if this idolatry of nature had not been pushed to the extent of substituting the prosaic portraits of living personages for the traditional types of Christ, the Virgin, and the Saints.'[25] Ideal subjects, such as the *Coronation of the Virgin*, were abandoned because they did not allow of enough naturalistic detail, and history-painting became the favourite genre of the century. The religious paintings of this school, with their emphasis on accessories and details, do not satisfy a Christian soul, and this decay and decadence will soon be accentuated by pagan influence. Not that Rio is against the antique as such: all depends on the artist's power of subordinating both it and nature to the Christian ideal.

These pernicious tendencies were combated by the mystical school, which for Rio appeared as a reaction against naturalism. Florence was too worldly for the mystical painters, who are found in the monasteries and little hill-towns of Tuscany. He traces the origins of the school, quite unhistorically, to the conservatism of Siena, where the trecento style continued to flourish long after it had disappeared from Florence. The art of its first great representative, Fra Angelico, for him is inspired by miniature-painting, which, as an art of the cloister, maintained its original purity of Christian inspiration, and kept itself free from the corruptions of naturalism and paganism. Simultaneously it disengaged itself from the decadent models of Byzantine art, and so developed a character that was at once progressive and virginal. Rio makes his criteria of response to the art of Fra Angelico and the other Renaissance painters he calls mystical vibrantly clear:

> At this point the competence of those who are vulgarly called connoisseurs is arrested . . . Mysticism in painting is what ecstasy is in psychology . . . It is no longer sufficient to determine the origin and follow the development of certain traditions which impress on the works of the same school a character that is almost always easily recognized. One must also associate oneself, by a strong and deep sympathy, with certain religious thoughts which have preoccupied more particularly such and such an artist in his studio, or such and such a monk in his cell, and combine the effects of that preoccupation with the corresponding dispositions of their fellow-citizens.[26]

By this phrase he means that those artists who have best understood how to produce devotional images which appeal sincerely to popular piety are those who deserve to stand highest in the hierarchy of art.

He insists, it is true, that we ought not to sacrifice all other aspects of the history of the arts in making our judgements. Yet 'even if it has sometimes or even often happened that the combination of form with the idea has not taken place in conformity with the laws of geometry, of optics and of good taste, the incomplete work that results from this transgression does not on this account lose all its right to our attention, and we are not the less obliged to search under this repellent bark for the treasures of Christian poetry that it covers'.[27] Thus Angelico did not have a perfect command of drawing, or of the art of giving his figures relief, or of truthfulness of

detail; his compositions do not show so skilful a distribution of light and shade as those of Masaccio; the heads and busts of his figures are better drawn than their lower limbs. However, these defects were not caused by his lack of technical skill, but by his indifference to all that did not contribute to his transcendental aim.

> The heart's compunction, its surges of uplift towards God, the rapture of ecstasy, the foretaste of heavenly beatitude, such was the order of profound and exalted emotions, which no artist can render without having previously experienced them, that formed as it were the mysterious cycle which the genius of Fra Angelico delighted to travel, and which he began again with the same love as soon as he had finished it. In this genre he seems to have exhausted all possible combinations and every shade of meaning, at least so far as relates to quality and quantity of expression, and if one examines a little more closely certain paintings in which a wearisome monotony appears to prevail, one will discover in them a prodigious variety embracing all the degrees of poetry that the human countenance can express.[28]

Naturally, Rio has only praise for Angelico's pupil Benozzo Gozzoli, above all for his frescoes in the Campo Santo at Pisa, which for him combine the naïveté and grandeur of the fourteenth century with the technical advances of the fifteenth. But his real attention is now reserved for the Umbrian school, which, like Sienese art, owes its recovery of reputation entirely to the advocates of Christian Art, who in this instance at least illustrated the fallacies of their critical theory by grossly over-praising its leading masters, Perugino and Pinturicchio. The original inspiration of mystical Christian art in Umbria Rio attributes to three paintings by Fra Angelico executed for Perugia and to Benozzo Gozzoli's frescoes at Montefalco. Gentile da Fabriano, the first master of the school, proves, consolingly, that mystical painting was still understood in Italy, and that 'it was not before the imitation of nature that men preferred to go into ecstasies'.[29] Umbria, fortunately for itself, possessed Assisi and Franciscanism: close to the tomb of St Francis Perugino and his pupil Raphael could imbibe the purest elements of Sienese and Florentine art, unsullied by any profane breath. Unfortunately, there was a difficulty with Perugino, who for Rio ranked second only to Angelico as a mystical artist. Vasari had recorded unpleasing traditions of his reputation for avariciousness and impiety among his contemporaries. Had Rio accepted that Perugino was an unbeliever, his whole glorious theory of the intrinsic and ineluctable association of true Christian art with sincere personal piety must have been irredeemably destroyed. Accordingly, he refutes these calumnies, using the works of local Perugian antiquaries, themselves, as pious subjects of the Pope, anxious to vindicate their great compatriot from such heavy charges against his character.

Having cleared Perugino he proceeds smoothly on his way. But to us it is more than obvious that once again he has allowed his judgement to be perverted by his assumption of unwavering moral purity and sincere piety in all artists whose art appealed to the pious art-lovers of the early nineteenth century. In fact Rio's standard was unconsciously an aesthetic one. The *dolcezza* Perugino's original patrons had admired in his art was a stylistic quality, even though it was transmuted by the early Romantics into a personal idealism in the painter in order to promote their own admiration of an idealistic style whose preferred characteristics were suavity, purity and grace, allied with ideal sentiment.

Rio also found a characteristic apology for the want of inventiveness with which the Florentines reproached Perugino:

> They did not comprehend that for an artist who seeks his inspiration outside the sphere of sensible objects, progress does not consist solely in the variety of his subjects or their more picturesque management, nor in the depth or fusion of his colours, nor even in the delicacy or purity of his line, but far more in the development and perfecting of certain types. These, after having been at first as it were in a latent state in the most hidden corners of his imagination, have imposed themselves on his brush as a long and religious task, and have ended by fusing there intimately with everything that was poetic and exalted in his soul.[30]

For Rio the art of Pinturicchio, too, has the true Umbrian 'vague tint of poetry and ecstasy'. Even though the artist was obliged to paint the Appartamento Borgia for Pope Alexander VI, thereafter he promptly retired to Perugia, where he painted an altarpiece of 'exquisite idealism' as a work of expiation.[31] Rio introduces into his account of the Umbrian school an excursus on the Bolognese school, which for him was also one of severe Christian art, culminating in Francesco Francia, whose pictures were 'mystical marvels' with their figures of exquisite purity and celestial expression.

But it was Raphael who became the 'prince of Christian art'. There has been some confusion among modern historians, who have tended to assume, quite wrongly, that the Romantic cult of the Gothic and the medieval ought to have entailed the rejection of the High Renaissance and of Raphael. At no time in the later eighteenth century or in the first decades of the nineteenth century was there any general rejection of the naturalistic canons of drawing, colouring and perspective whose culminating exponents had from the sixteenth century onwards always been regarded as the three great masters of the High Renaissance, Leonardo, Raphael and Michelangelo. It was Baroque conventions of composition, such as chiaroscuro, that were rejected, and the neo-classical cult of clarity of outline, transmitted to the Romantics through Flaxman's great outline compositions for Homer and Dante, was one of the underlying factors in the continuing vogue of Raphael. The advocates of Christian art also found in his art the highest expression of those qualities of purity, suavity and grace they so much admired, expressed with a temperate naturalism. But Rio introduced one significant change into the criticism of Raphael. Until his book it had been customary to admire Raphael's late works most highly. Connoisseurs and travellers went into raptures before the *Cartoons* (c. 1514–16) and the *Transfiguration* (1517–20), as being the highest embodiments in art of the painter's power of representing the affections by action, gesture and expression. It was this admiration, the natural consequence of the stress laid by classical Baroque critical theory on the dramatic representation of the affections, that was totally rejected by Rio.

His Raphael carries Christian art to its highest point of perfection, but only in his early works. From the time of his apprenticeship to Perugino, *c.* 1500, his art is marked by the mystic imprint of the Umbrian school, with the addition of his own inexpressible charm. He reaches his apogee as a Christian artist between 1505 and 1508. The works of this period ally the purity of inspiration of the Umbrian school with the grand style in drawing and legitimate progress in the technical parts of the art. Even in Florence his pencil remained unsullied by paganism. Again, as with Perugino, the want of variety in his types in these early works is set down as an expression of idealism. Raphael reaches a peak of his art in the Pitti *Madonna del*

Cardellino, which Rio calls the apogee of Christian Art. He still maintains this purity of achievement in his earliest works in Rome: Rio calls the figure of *Theology* in the Segnatura frescoes (1508) a high point of allegorical poetry in art. Raphael now reaches the limits of Christian Art in his rendering of expressions of celestial beautitude. But in his last ten years he deliberately breaks with the Umbrian tradition and abjures his old faith in order to embrace a new one. Rumohr had seen this change of style as made essentially for artistic reasons. From the linear harmonies of classic taste, still dear to the Umbrian school, Raphael moves on to a picturesque taste, emphasizing technical *tours de force,* to the fusion and harmony of colours, to chiaroscuro, to aerial perspective, to contrasts of masses of light and shadow, to fine gradations of tone. For Rio, the change is a spiritual one: there is something *seraphic* in Umbrian pictures that has nothing to do with classical qualities of composition. As we shall see, it was this revolutionary treatment of Raphael's art that was to cause the greatest sensation in England.

Rio now turns to Savonarola and his influence on the arts. Savonarola was a figure who acquired symbolic greatness in the nineteenth century: liberals identified with him as a supporter of Republican liberty, while to anti-clericals and Protestants he was a hero and a martyr for his opposition to Papal authority. It is significant that the exiled Mazzini thoroughly approved of Rio's chapters on Savonarola, while George Eliot's *Romola* (1863) testifies to the Friar's new significance as a cult figure. Rio, too, approves greatly of Savonarola, but from his own particular standpoint. To him the austere Dominican is a hero because of his opposition to the encroaching spirit of paganism which the Medici had encouraged in Florence. From the fatal time when Lorenzo the Magnificent had collected pagan sculptures and housed them in the gardens of his palace an insensible alteration had occurred in the ideal of beauty cherished till then by painters and sculptors. In Rio's pages Savonarola assumes the role of a champion determined to assure the triumph of a Christian art and poetry and music. For all Savonarola's lofty intellect and simple life in a monastic cell, he had, so Rio claims, an exquisite sense of beauty, and the lay-brethen of the perfect monastery he proposed to found in Florence were to occupy themselves with works of sculpture and painting.

We should perhaps note here and now that the figure of the monk-artist and monk-craftsman of the Middle Ages, not only as represented by Fra Angelico, but by lesser figures as well, miniature-painters, goldsmiths and their like, was to haunt the imagination of nineteenth-century antiquaries, painters, craftsmen and poets. Here, it seemed, were examples of that purity and dedication of purpose in the humble dignity of labours undertaken solely for the glory of God, which was one of the cherished ideals of the apostles of Christian Art. Unfortunately, in an excess of zeal, the nineteenth century often interpreted the 'fecit' with which medieval ecclesiastical dignitaries were wont to indicate that they had commissioned and paid for a building or shrine as evidence of actual manual labour by abbots and bishops. A particular offender in this respect was the Abbé Jacques Texier, of Limoges, who compiled for Migne's *Encyclopédie théologique* a *Dictionnaire d'orfèvrerie* (1857) which was filled with the names of ecclesiastics of this kind, as well as with much authentic information, for, in spite of this elementary error, Texier was a great and industrious scholar. The image of the monastic craftsman still hovered before Eric Gill in the 1920s and 1930s and its validity was still a live issue in the controversies of the same decades between G. C. Coulton and English Roman Catholic historians and publicists.

After his martyrdom, Rio continues, Savonarola's spiritualizing doctrines were cherished long into the sixteenth century by a small following of Christian artists who revered his memory—Lorenzo di Credi, whose monotony in his 'mystical representations' is, as usual, explained by the purity of his mystical inspiration, Fra Bartolommeo, whose original angularity of style was softened by contact with Raphael, from whom he learnt suavity and the art of giving a celestial expression to his Virgins, and Ridolfo Ghirlandaio, who continued the now isolated tradition of Christian art late into the century.

In his last section Rio combats the powerful Romantic image of Venice as a sinister city of secret tribunals, famous courtesans and ruthless Machiavellianism in politics and commerce. He points out that the history of the city had been written either in Latin or else by rationalist historians, and so was either inaccessible or distorted. Moreover, Venetian literature was essentially either local and popular in its use of dialect, or else learned or exclusive in its use of Latin, and consequently the real creation of the city, its legends, the primitive form of all poetry, had been disregarded. In the Venetian legends of saints Rio saw the richest flowering of Christian poetry, and with exact historical intuition he divined the influence of the strongly corporate mentality of Venice on its art, which he saw as an art at once national and religious. 'The works of painters, like those of poets when avowed, encouraged and praised by their fellow citizens, are a faithful mirror that reflects every successive modification of the national character'.[32] Venice for him was the most Christian of republics, preserving something of its earlier, purer traditions of religion even in its decadence and fall.

The glory of Venetian art, then, lies in its religious inspiration and in its representations of Christian legend, such as Carpaccio's great canvases of the *Legend of St Ursula*. For him its story begins only with the fifteenth century, and he first traces the history of the followers of Giotto in Padua until the advent of Squarcione in the early fifteenth century. Squarcione had a blind enthusiasm for paganism, and it was he who was to blame for the excessive absorption of his pupil Mantegna in the antique, an absorption, which, though counteracted in Mantegna's own works by other influences, led only to sterility in his followers, so proving yet again the wasting influence of pagan art where there is no vivifying influence of religion.

Rio recognized that the art of fifteenth-century Venice was exposed to many influences from outside the city, but he claims that the Venetians instinctively rejected all those that were not in accord with religion. Neither Lippi, who worked in Padua, nor Mantegna exercised any durable influence there. Instead the city linked itself with the pure and mystical school of Umbria, through Gentile da Fabriano, who worked in Venice, and through one of its own painters, Carlo Crivelli, who worked in Fabriano. Needless to say, this neatly systematic connection of his favourite Umbria with Venice has no historical foundation, but Rio, true to his own taste, fixed on just those Venetian painters whose tranquil suavity and grace represented his own ideals in religious art. He argues that Gentile da Fabriano's lessons in Christian art were handed down by his pupil Jacopo Bellini to his own two sons, Gentile and Giovanni. There also entered into Venice a healthy Christian influence from the art of Germany, the Rhineland and Flanders, as yet unspotted by any pagan influence.

These influences, when combined with lessons in geometrical perspective and foreshortening received from Padua and with the national and religious spirit of the Venetian public and its lavish patronage, gave rise to a school of Christian art that was grander and more magnificent than any other. Rio's favourite Venetian artist was

Giovanni Bellini, who for him had a deeply mystical soul, while his brother Gentile, though anxious to combine the more scientific side of the art with its transcendental purpose, had a more practical bent. Followers of Giovanni in his mystical aspects were Cima da Conegliano and Marco Basaiti; Vittore Carpaccio, on the other hand, recognized that he could never rise above the picturesque and legendary. In spite of the puissant example of Giorgione and Titian, in whom Venetian art deviated from the true path, some artists remained faithful to the Christian traditions of Bellini and his followers into the middle of the sixteenth century: Rio cites Mansueti, Vincenzo Catena, and Francesco and Girolamo Santacroce.

A final doctrine of his book appears in the late passage in which he declares that even when the human imagination has sunk from idealism in art, yet it may descend only one degree into naturalism, taking the word in its highest sense. Hence, in a period when decadence begins, nature can still suggest living and mysterious harmonies to the soul of the artist and poet and direct them in their choice of forms and colours, producing varied combinations which, if less sublime than those of the Umbrian school, yet occupy a first place in the history of art. Rio lays great emphasis on the importance of colour as an element in art: for him Florentine colour, which was generally reproached for its lack of richness and warmth, was poetic, not odiously sensual, like that of Titian and Giulio Romano.

Here, then, we have the doctrines of Christian idealism rigorously applied to the history of Italian art, and with the same explosive effect as the ideas Niebuhr was applying in the same decades to the study of another revered tradition, that of early Roman history. The power of some, if not all of these doctrines, is still felt in England, though probably unconsciously; certainly, they are never now traced back to their first and most eloquent exponent in Rio. What was the reception of his book on publication? At first it was more than disappointing: only twelve copies in all had been sold within five months of its appearance.[33] In fact the first extended notice of it appeared in England, in two long, enthusiastic and highly intelligent review articles published in the *Athenaeum* for May and April 1837. These are the first of a series of notices and publications that enable us to reconstruct the opinions and prejudices, some positivist, some religious, against which the doctrines of Christian Art had to make headway in England. The reviewer begins by saying that to English taste no word was 'more of an abomination' than mysticism, with its associations of Popery and Jesuitry, and that it required courage in an English reviewer 'to break a lance with the giant of materialist Art in defence of Mystical'. But he would do his best to contend with the ogre of ignorance and the fiend of prejudice. In reality he adroitly endeavours to weaken Protestant antagonism to the whole idea of mysticism by claiming, contrary to Rio's fundamental premise, that mysticism is present in pagan as well as in Christian art. Thus, the Elgin marbles, as an expression of pagan religion, can properly be termed mystical. Later, in fact, he draws a fundamental distinction, of which the passionately partisan Rio was incapable, between the 'mystical School' of Christian art and the 'Mystical style' which 'amalgamates . . . with all art, Heathen no less than Christian'.

He then proceeds to illustrate what is meant by the mystical style in art:

Mysticism in England is—Folly with her head among the clouds: on the continent—Genius with her head among the stars: no wonder if mysticism should be here an object of derision, there of admiration. True, the word has, with foreign-

ers, its derogative meaning also; but it is always understood by them, as regards the Fine Arts, in its dignified sense. The mystical style, to consider it most largely, is that which seeks to affect us in an eminent degree, through the medium of our sympathies and believed relations with another world. Thus, all productions of the pencil and chisel, involving religious mysteries, pagan as well as not, approximate more or less in the mystical style. For the sake of distinction, however, this title is limited to such representations as seek to affect us, in an eminent degree, by their religious spirit. Every religious picture is not therefore of the mystical style; nor one in one thousand. A 'Virgin and Child', by Carlo Maratti, or a 'Redemption', by Bronzino, may be only a frigid display of draping or drawing: Rubens's Last Judgments and Rembrandt's Crucifixions, though employed about the very sublimest of religious mysteries, are little beyond mere excuses for brilliant colouring and clair-obscure: most later works indeed, how scriptural soever their subjects, produce effect upon us by the beauty of their profane treatment alone. Paul Veronese's 'Miracle of the Wine', or *Cena*, is a gorgeous piece of arras, veiling, not representing the mystery: his 'Consecration of St Nicholas' (No. 12, Angerstein Gallery), makes one appeal to our spiritual affections, by the fervent humility of the Saint depressed into a dim portion of the middle-ground; but magnificence being the painter's chief aim, Heaven's messenger overhead flaunts like an oriflamme, and the rest of the picture is little else than a rich palette: this artist perpetually blots out any sentiment that would gleam through his subject, with lustrous touches thickening upon the canvas.

He censures Rio, however, for taking 'a most confined and cloistral view of his subject, in seeing none but certain monks, and devotee laymen, such as Fra Beato (*sic*), Perugino, Francia—as labourers in the ethereal fold of Mysticism. These are by no means restricted to Madonna-painters, and primitive artists of that class, however excellent.' To deny the title of mystical artist to Michelangelo is a flagrant injustice, and to call the painter of the Sistine vault and altar-wall a 'paganist' and 'naturalist' is like an astrologer denying the existence of Saturn among the planets. Michelangelo's Prophets and Sibyls, 'by their mysterious, ultra-mundane character and expression—by their amplification, so to speak, of the human form and movement, and virtual energy, seem to connect us, through these supernatural images of ourselves, with the beings of a higher sphere.' Yet he agrees that the distinction between mystical art and the mystical school means that Michelangelo cannot be termed a mystical artist in the narrow sense. 'Many works besides of Buonarotti's might be quoted (the Allegorical Statues of the Capella de Medici, for example), which prove him as fully inspired by the genius of mysticism, as Dante in a kindred art: still his works are all so remarkable for design and other profane merits, that scarce any of them can be accounted simply mystical, or he himself numbered with the adherents of this style.'

Within this broader context the reviewer accepts without questioning the existence of a school of Christian mystical art, though he does not accept all Rio's judgements uncritically. Perugino, for instance, 'designed, coloured, composed, as well as he could; it was not choice, but incapacity, made him give that meagreness to his forms, *cured* look to his flesh, and stiff architrave sameness to his ordonnance; Gian Bellini enriched his primitive, austere compositions with hues as resplendent, if not as mellow, as the most sensual Venetian, Giorgione, could have bestowed on his most

luxurious production; Fra Beato himself was an exquisite colourist for his time, most delicately adapting his pale, sweet-clear tints, like those of flowers seen by moonlight, to the seraphic nature of his subjects.' But it is true, nevertheless, that 'in the works of these masters the charm of their religious spirit, by which they affect us through our sympathies with another world, predominates much over their other attractions; and predominates so much more than the same religious spirit does in any other works— those of Michelangelo above mentioned, for example—that they are designated, *par excellence,* purely mystical'.

In his second article, reviewing the historical development of Christian art, he reproaches Rio with injustice to Cimabue as an innovator, and with neglecting the influence of Niccoló Pisano on Cimabue and Giotto. Pisano, indeed, rather weakened Rio's case; if his influence was acknowledged: 'behold our author's detested "paganism" exalting his beloved "Christian Art" and empowering mysticism to evolve its spirit! For Pisano drank *his* artistic inspiration from antique sarcophagi . . .' But he joins in Rio's enthusiastic admiration for Fra Angelico, who for him shares with Michelangelo alone 'the same high level . . . in mystical art'. They both were 'transcendentive intellects', but Angelico was the more ethereal of the two, the nearer to the skies, borne up to his visions of Paradise on 'a chariot of mysticism'. And yet 'there is not, we believe, a single fine specimen of Frate Angelico's painting in the British Empire, filled with "Dead-game" and other Dutch pictures to its roof'.

In England, he feels,

advocates of mysticism have much to contend with: prejudice against the name and thing; tendency in the public mind, perhaps also in the artistic, to a style quite the reverse of this—the sensual as to colour, the familiar as to subject; rareness of good specimens, total absence of fine ones, England being all but destitute of such Umbrian and earlier Venetian master-pieces as might recommend the mystical style among us, and inspire a taste for it, beside furnishing a nearer place of appeal for its defenders than the lagunes or the Apennines. Another obstacle is the light wherein our countrymen view the superstitious tenets, traditions, forms, and practices, of what is called Catholicism. They hold image-worship in mixed ridicule and horror: a feeling which they generalize from the idolaters to the innocuous pictures. Super-sanctification of the Virgin, apocryphal miracles, legendary mar- tyrdoms, are condemned by their purer creed, and scouted by their common sense; yet these very figments supply a great portion of its subject-matter to mystical art, which therefore must lay stronger claims to our English antipathies than affections. M. Rio justly observes, though with particular reference to lukewarm religionists of his own creed, that we cannot feel the full charm of works in this style unless we be penetrated with the faith that inspired them. Nevertheless, all these stumbling- blocks, were they as big as icebergs and as stubborn, should neither stop nor dismay us: we will proceed in our endeavour to naturalize the idea of mystical art among our contemporaries, and to create a nascent interest about it, because we think it may serve hereafter to exalt the British school of painting and sculpture. As regards the *Protestant* obstacle, perhaps no more but this need be said to smooth it down: admiration of mysticism in Italian Paintings requires the same kind of conversion to *Popery* that it does to *Polytheism* in the Elgin Marbles. Both may be regarded with a like esteem for their merits, and compassion—that gentle species of contempt—for their mistaken religious objects.

In France Rio's book was only fairly launched by a eulogistic review by Montalembert, published in August 1837 in the *Université Catholique* and deliberately written to bring the book into notice. In this it was partly successful, since Étienne Délécluze (1781–1863), one of the leading art critics of the day and a passionate advocate of the classicism of David, took the trouble to write three articles in the *Journal des Débats* of 1838 warning young artists against its doctrines. Rio complains that only one French artist, Henri de Triqueti (1804–74), was in favour of its teachings. In Germany and Italy, by contrast, the book's reception was most flattering. Rumohr appended notes to an Italian translation made by the Abbate Filippo de 'Boni and published at Venice in 1840. Manzoni, himself the author of profoundly Catholic works in literature, saluted the book in a letter to Montalembert as having opened his eyes to Christian idealism in painting. Tommaseo was equally enthusiastic. The German art historian Ernst Förster introduced it to the Marchese Pietro Selvatico, one of the leading art critics and historians of Venetian art during the mid nineteenth century, who was already an enthusiast for Giotto and his art, and became an eager propagandist for Rio's book.[34]

In the still international and cosmopolitan world of late Romanticism, all these reverberations were of importance in making Rio's reputation. Here in England there were old and new influences in the times that worked to ensure his success. In the great religious world the Tractarian movement was affirming the Anglo-Catholic position, reviving the High Church's old cautious admission into churches of certain forms of art, representational or symbolic, and adding to them its own revivals of medievalism. In the much smaller world of connoisseurship, the interest of certain English connoisseurs in the history of the arts had led them to form collections of early pictures—William Young Ottley, for instance, and Samuel Rogers, the Reverend John Sanford, the Reverend Walter Davenport Bromley, and James Dennistoun, the historian of Urbino, who was later to give his notes on early Italian art to the principal English apostle of Christian Art, Lord Lindsay.

Already, too, some artists, especially those with a religious bent, like Flaxman, or those anxious to paint grand historical pictures on religious themes, like Haydon, had felt a spontaneous admiration for certain works of medieval Italian architecture, sculpture and painting. On his Italian journeys in 1787–94, Flaxman had been struck with wonder at 'the architectural magnificence and singularity' of the Duomo and Campo Santo of Pisa, and, years later, in his lectures on sculpture to the students of the Royal Academy recalled for their benefit that 'this extraordinary scene in the evening of a summer's day, with a splendid red sun setting in a dark blue sky, the full moon rising on the opposite side over a city nearly deserted, affects the beholder's mind with such a sensation of magnificence, solitude and wonder, that he scarcely knows whether he is in the world or not'. He also admired Byzantine miniatures and Niccoló and Giovanni Pisano, in whose works 'are occasionally seen an originality of idea and a force of thought seldom met with when schools of art are in the habit of copying from each other'. And he praises 'the Gothic and simple grandeur of Andrea Pisano's reliefs on the bronze door of the Baptistery in Florence'.[35] Flaxman's lectures were, however, not published until 1829, and his opinions can have had only a small circulation among artists and connoisseurs. Later, Lady Callcott, publishing in 1835 her *Description of the Chapel of the Annunziata dell'Arena, or Giotto's Chapel, in Padua*, notes that Giotto's paintings, besides their truth of narration 'are eminent for a very peculiar expression and grace; qualities which Flaxman had long ago perceived

and acknowledged in the works of Giotto and his school in Italy, and to which his own designs, and those of Stothard, who, without a knowledge of the older masters, intuitively drew the same qualities from nature, their common source, have accustomed the intelligent among ourselves.'

Keats, too, in a letter of 1819, speaking of his own growth in 'perceptive power' of taste, writes: 'When I was last at Haydon's, I looked over a book of prints, taken from the fresco of the church at Milan, the name of which I forget. In it were comprised specimens of the first and second age in Art in Italy. I do not think I ever had a greater treat, out of Shakespeare; full of romance and the most tender feeling; magnificence of drapery beyond everything I ever saw, not excepting Raphael's, but grotesque to a curious pitch; yet still making up a fine whole, even finer to me than more accomplished works, as there was left so much room for the imagination.' Dante Gabriel Rossetti was to exclaim over this passage with joy when he read it in Monckton Milnes's *Life and Letters of John Keats*, published in 1848.[36] There can, however, be no doubt that such insights were confined to small circles of artists and of 'the intelligent', to use Lady Callcott's term. She herself was the wife of a painter who was President of the Royal Academy, and made her notes and sketches of the Arena chapel during a visit to Padua in November 1827. She remarks of her sketches that 'rigid Critics in Art will, no doubt, object to such renderings, from the absence of those peculiarities and even defects belonging to the age in which they were executed; but the features which mark an artist's strength and originality, and which constitute the beauty of his work, are essentially distinct from those which arise out of the accidents of the time in which he lived.' She calls the Arena 'a monument of the spirit of the early artists', who put out all their powers to achieve truthfulness of narrative. This she attributes to their sincerity of faith: 'they considered it a work of piety, to set before the beholders the true history of that Gospel which was to save them, and of those saints who were to act as mediators between them and their Redeemer.' In such an approach we are already moving towards a crystallization of the views that were to be given so emphatic a development and definition by Rio.

Lady Callcott singles out truth and grace of expression as already present in many of Giotto's compositions in the same degree as in 'the best works of the best masters', by whom she means, of course, the great painters of the High Renaissance, and to these she adds praises of 'a dignity and majesty' which is sometimes 'almost sublime'. Her criterion, however, is still the classical one of aptness of dramatic expression, tinged, but only tinged in its application, by the influence of piety. The defects she attributes to Giotto's art, mean and grotesque devils, shortcomings of perspective, faulty drawing, poor colour, show that while she could recognize and praise in him the qualities that were still generally perceived and admired only in much later painters, she could not accept his art as a historical whole, and was still bound by the orthodox critical scheme of the rise and progress of the arts.

Rio's book gave an impulse to a new seriousness that sought to pierce beyond the outer forms of picturesque medievalism to the inner feelings of the Middle Ages in order to understand how it had wrought its miracles of art. There was more in this than an aspiration to a deeper understanding of medieval art, there was a religious enthusiasm, too, which found a voice in Montalembert when he exclaimed in 1834 'we must penetrate in studying the Middle Ages beyond Romanticism, the superficial study of the purely exterior side of this great period: it is necessary to penetrate into the things that constituted the soul of Catholic society, necessary to believe what it

believed, to love what it loved, to feel as it felt. We must have a taste for its traditions, for its legends, which are the most flowering branch of tradition, of that tree of poetry . . . for which the Catholic faith was the trunk for all the nations before the reformation.'[37] Others, more practically, regretted the loss of the creative power and skill of hand of medieval artists and sought to account for it, and, this being the energetic Victorian age, to suggest a remedy.

The fashionable Irvingite Henry Drummond—known as 'one of the richest men, the most accomplished gentleman, the finest conversationalist, in England: worthy, learned, and aristocratic' according to Elizabeth Rigby, later Lady Eastlake[38]—was moved by Rio's book to pen in May 1840 *A Letter to Thomas Phillips, Esq., R.A. on the Connection between the Fine Arts and Religion and the Means of their Revival*. In this pamphlet he quotes the words of an ardent associate of Rio, Félicie de Fauveau, a French sculptress living in Florence who was, as we shall see, responsible for kindling an enthusiasm for Christian art in one of Rio's most important English followers, Lord Lindsay. 'When a celebrated French sculptress, who resides in Florence, was asked, Why she did not work more after the Models of the Apollo, Venus, Hercules, and other celebrated statues of antiquity? she replied, "If I am to seek to imbibe the spirit which produced those works of art, and not to be a mere servile copier of the outlines, I must seek it in my religion, as the authors of those statues sought it in theirs; those sculptors were full of devotion, and laboured in their vocation to serve God according to their light; their works were works of piety and of religious feeling: I can feel no devotion for Apollo, but I do for Him who is the object of my worship, and for the persons who are distinguished as having been faithful in His service".' Drummond claims that 'this is the true source of all that has been great in the arts in every period', justifying this claim by a historical survey drawn largely from Rio's book. The lesson is plain. Young artists must first be good Christians, and secondly labour at drawing. For, with a very Scotch severity, Drummond observes that 'the bane of all success is peculiarly prevalent in these days, which is to suppose that genius can supersede the necessity of study, and that genius is an excuse for idleness'. Finally, they must study nature, which has 'been abandoned for the affectation of the stage, until the imitators arrived at their climax of caricature in Fuseli and David'.

The historian Francis Palgrave (1788–1861), writing in the *Quarterly Review* of September 1840 on the 'Fine Arts in Florence', was moved to take issue with Drummond over this question, and through him with Rio, the Nazarener, and the Anglo-Catholics. Palgrave was a Jewish convert to Anglicanism, and his views are those of an orthodox Anglican with a distrust of Continental theorists and rhapsodists. On the one hand, he felt that 'there is no dissenting from the opinion that the deterioration and ultimate destruction of the medieval religious feeling, by the bigotry of modern classical taste, deprived the plastic and graphic arts of all their higher attributes and feelings . . . It may not be agreeable to know the truth, but all that Winkelmann and Visconti teach us to admire at Rome was denounced by the Apostle.' On the other hand, he cannot agree with the advocates of Christian Art, that restoration of the glories of medieval art depends on the restoration of medieval faith:

> We most fully and cordially agree in the position that, by the absence of religious feeling, art has lost its truest support. There is indeed no production of the human intellect respecting which the same truth may not be affirmed. Yet, at the same

time, in reprobating the pollutions of heathenism, we should equally avoid the equally strange error into which, we regret to say, the very pious and estimable individual whom we have just quoted seems in danger of falling, that the excellence of the early painters was actually a direct inspiration, and attainable only by and through such doctrine as is embodied in the tenets of the church of Rome. This notion, indeed, with so many unsound opinions, has been imported from Germany; where, in belief, there seems to be no medium between the polar circle of neology and the torrid zone of enthusiastic insanity. 'Such a work as this', said a sedate Berliner student to us, as we were standing before the Crucifixion by Frate Angelico, in the chapel of San Marco, 'could only have been effected, durch die kraft des heiligen Geistes'; and it is well known that Overbeck has passed over to the Roman communion, in the sincere conviction that otherwise he never could attain the devotional purity of design which he sought.

Even admitting, as he fully admits, that Fra Angelico's paintings 'are unquestionably the transcripts of the countenances which appeared to his imagination, nurtured in the trances of mystic divinity and asceticism', just as Blake's drawings are 'truly the representation of the things which he had seen in the visions', yet 'are we justified in substituting superstition for faith, in order to acquire pictorial skill?' Equally dangerous are the aspirations of some members of the Tractarian movement, who wish to introduce 'graven images and paintings' into the interior of churches because in the early church they had been regarded as books for the unlettered. The duty of the Church is to observe time-honoured custom in such matters, not to give offence by going beyond the limits within which it has admitted images, paintings and other visible symbols into its buildings.

The Romanists are, as Jeremy Taylor truly observed, full as much Marians as Christians. How thoroughly deluding is the influence exercised upon their minds through the medium of painting, may be best understood by adverting to the admission of the amiable and accomplished author of the 'Poetry of Christian Art', that images became 'an integral portion of religious worship'. Such a subject as the 'Coronation of the Virgin', which it is impossible to look at without pain and sorrow, is merely the last stage in the series of which the simplest Madonna is the first. And if we withhold from the Romanists the forcible testimony given by our abstinence from all approximation to these abuses in our places of worship, we deny them the best and most useful lesson which we can impart. It is by the silent protest of example, and not by mockery or scoffing, by fierce controversy and hard words and anger, by declamation on the platform, or vituperation in the newspaper, that the great schism which has rent the Church is to be healed.

The intellectual and pious Charlotte Williams Wynn (1807–69), who became a close friend of Rio in 1841, wrote to her friend Baron Karl August Varnhagen von Ense (1785–1858), a leading German biographer, diplomat and politician, that Rio's book had been much talked about. We can see from these quotations that she spoke true. The success of his book was probably helped by Rio's social gifts. Charlotte Williams Wynn calls him 'the most eloquent talker I ever heard, and speaks English better than most natives', while for Gladstone he was 'the most striking Frenchman I ever knew'.[39] Rio was introduced into English intellectual society by Monckton Milnes, who described himself as a 'Puseyite sceptic' and was known for his sympathetic attitude to Catholicism. He soon became a well-known figure and the

acknowledged spokesman for Christian Art. Through Milnes he met Henry Hallam. Lord Mahon, Macaulay, Samuel Rogers, Carlyle, Landor, Bulwer Lytton, Gladstone, Disraeli, Mrs Norton, Lady Blessington, and Wordsworth, who dedicated a sonnet to his adventures as a youthful Chouan. With Gladstone he became quite intimate, and provided him with letters of introduction for his famous Italian journey of 1838, on which Gladstone took Rio's book to serve him as guide and tutor. Most of these friendships lasted for life.

Rio's book also served Ruskin as a guide on his Italian journey of 1845. He was already reading *De la poésie chrétienne* in the November of 1843, while working on the second volume of *Modern Painters*, and was stimulated by it into resolving to go back to Italy and study the early Italian painters before he went any further with his own book. This tour was pivotal in Ruskin's career, since it directed his studies away from 'rocks and clouds' to the 'art of man', which now stood revealed to him 'in its full majesty for the first time'. Clearly Rio's book, as Ruskin avows in *Praeterita*, was the primary instrument of this revelation, and indeed Ruskin adopts its opinions with approval in *Modern Painters*, though not, of course, without his own corrections and modifications.[40]

The cult of religious sentiment and ideal art in Rio's book naturally endeared him to the many thoughtful, cultivated ladies who were such a feature of early Victorian England, indeed of Europe generally in the 1830s and 1840s. He himself comments on the number of his female admirers. 'In almost all the circles into which I was introduced there was always a woman who had read my book or who said she was impatient to read it.'[41] Mrs Jameson herself, though already an established literary figure, a recognized authority on art, and possessed of many contacts of her own with artistic Germany, was delighted to meet him in Paris in the autumn of 1841. 'The great event of my life here has been the meeting with Rio. I have introduced him to Mrs Forster and to her son-in-law, M. de Triqueti, and all parties are so delighted with each other . . . I have twice been at the Louvre with Rio and De Triqueti at my elbow, and have profited accordingly.'[42] Rio speaks of her as one of his most loyal English disciples, but Mrs Jameson also drew inspiration from two other Frenchman, Montalembert, whom we have already encountered, and Didron, the real founder of serious study of the iconography of religious art in the Middle Ages.

Montalembert's studies and enthusiasms had been intimately intertwined with Rio's from as early as 1829, as we have seen. In spite of the occasional quarrel, caused largely, it would seem, by Rio's hypersensitivity to the inferiority of his own humble peasant birth when compared with the aristocratic origins of his friend, the two remained the closest of companions. Rio frankly avows that originally he had little feeling for Gothic architecture, and confesses that in 1830 he had shocked Sulpice Boisserée when he told him he had never once visited the Sainte-Chapelle during his nine years' residence in Paris. Indeed, he could not agree with Boisserée that French High Gothic art was the true Christian art *par excellence*. It was through reading Hugo's *Notre-Dame de Paris* and under the influence of Montalembert that he became more open in his ideas. Montalembert himself had already admired Overbeck's *Entry of Christ into Jerusalem* at Lübeck on his way to Sweden in 1828, and a visit to Hugo while he was writing *Notre-Dame de Paris* kindled in him an enthusiasm for medieval architecture. From thence onwards he could never pass a Gothic church without entering it, and he acknowledged his debt to Hugo and his novel in two enthusiastic review articles in *L'Avenir*.

It was Montalembert who dragged Rio in 1831 on a visit to Monte Cassino and the Gothic churches of Naples. Before Italian painting he showed the same preferences as Rio for Fra Angelico, Perugino, Francia, Lorenzo Lotto, and the Nazarener. Foisset, his biographer, pithily summed up Montalembert's ideal of perfection in art as 'Overbeck's piety served by Raphael's brush'. During his visit to Munich in 1832 with Lammenais and Rio, he too met Görres and Boisserée, both of whom were 'animated to the highest degree with the spirit of proselytism' in their fervent advocacy of Christian and medieval art. On his return to Paris, Montalembert published in the number for 1st March 1833 of the influential *Revue des Deux Mondes* his celebrated clarion-call to the French government and public opinion to arrest the vandalism that was rapidly destroying the medieval monuments of France, 'Du vandalisme en France: lettre à M. Victor Hugo'. It is eternally to the credit of Montalembert and his friends that they aroused the French government and enlightened public opinion to a deplorable stages of things, so leading to the establishment in 1837 of the Comité Historiques des Arts et Monuments.[43]

Montalembert also struck the first major blow against the general attitude of contempt for medieval saints and their legends which was an inheritance from the Enlightenment. On an independent excursion during his tour of Germany with Rio in 1833, he visited Marburg and in the great Gothic church of St Elizabeth of Hungary saw the saint's shrine, a solemn and glittering masterpiece of thirteenth-century German goldsmith's work. He was deeply impressed by the sight, and even more by the history of this thirteenth-century saint as narrated in two cheap almanacks which he chanced to buy and read in his postchaise as he jolted on his way to Frankfurt. What he had discovered was the poetry and the naïveté of medieval hagiography. So overwhelmed was he by his discovery that he determined to write the life of St Elizabeth and settled in Munich from 12th December 1833 to 9th October 1834 to carry out the necessary researches. Here he renewed his friendships with Boisserée, with the sculptor Schwanthaler, and with the Catholic painters Hess, Schlottauer, Cornelius and Julius Schnorr, who was then painting his frescoes from the *Niebelungen* for the palace of King Ludwig. He also came deeply under the influence of the mystical piety of Görres, and simultaneously made the discovery of medieval popular piety and of some of its survival into modern times—he was deeply moved by a Passion play he attended at Mittewald in the Tyrol; that of Oberammergau still had to await Anna Mary Howitt's description of her visit in 1850 for its first celebrity.[44]

On Montalembert's return to Paris in 1835 he set himself to rehabilitate the Middle Ages, still despised in general opinion as an epoch of ignorance and barbarism. He sought also to damn the Renaissance, which by contrast was regarded as a golden epoch of the revival of the arts and learning, by stigmatizing it as a movement of debasing paganism. In the famous introduction to his *Histoire de Sainte Elisabeth* (1836) he exalts the thirteenth century as one of the great ages of humanity: for many of his admirers, indeed, he was never to surpass the fire and eloquence of that introduction.[45] The book itself, with its ardent rhetoric, its force of conviction, its richness of illustrations specially executed in the manner of the Nazarener for Montalembert by Edward Caspar Hauser (1807–64), was deliberately designed to popularize the simple faith and piety of the Middle Ages, to exalt the freshness, naïveté and innocence of its saints, and so to vindicate for the centuries before the Reformation a claim to be regarded as the true Age of Faith, when Catholic belief was purest and sincerest. In France Montalembert began a vogue for medieval hagio-

graphy and for writing the lives of medieval saints. In 1837 he followed up the bio-graphy itself with an album of plates, entitled *Monumens de l'histoire de Sainte Elisabeth* (1837–40), reproducing pictures of the saint's life. This was intended to supply a collection of models from the 'masters of the old Catholic centuries' and from 'the new German school' for all those artists who wished to dedicate themselves to religious art. These works would show 'how, even in the midst of the moral and intellectual anarchy of our times, one can attach modern art to the purity and holiness of ancient thoughts.'[46] Among the paintings illustrated were works by or attributed to Taddeo Gaddi, Orcagna, Fra Angelico, and Botticelli, while from north of the Alps Montalembert reproduced a stained glass window from Cologne Cathedral, a minia-ture attributed to Memling, a painting of the Cologne school, and another by Lucas van Leyden. Among the modern German works were a picture by Friedrich Müller of Cassel, a sculpture by Schwanthaler, and a drawing by Overbeck, specially executed for the work.

In England the *Histoire de Sainte Elisabeth* had a real influence. It was translated into English and published in 1839 as *The History of St Elizabeth of Hungary* by Ambrose De Lisle Phillips (1809–78), a Leicestershire squire who had become a convert to Catholicism in 1824, at the age of fifteen, and who made in 1835 a gift of land in Charnwood Forest for the foundation of a Cistercian monastery, so restoring the order in England. In 1839 Montalembert visited Phillips at Gracedieu, the Tudor manor-house he had built for himself, in order to make the acquaintance of 'a kindred spirit', and together the two of them visited the sites of the earliest English Cistercian abbeys. Although the English version was handsomely produced, it evidently appealed at first only to a Catholic public: as yet its spirit was too daring for Protestant England, and on publication it was sedulously ignored by the leading reviews. Nevertheless, it worked its way and had an influence on such figures as Mrs Jameson.

Although Montalembert had consulted original authorities, his purpose was to present his saint's life as a form of popular poetry, for which the appetite of that Romantic age, nurtured on the rediscovery of early ballads and songs, of medieval romances and chivalric poems, was insatiable. Adolphe-Napoléon Didron (1806–67) set himself the task of unravelling medieval symbolism by a truly scholarly investiga-tion of its sources and meaning.[47] He had been preceded in this task by one pioneer, Désiré Raoul Rochette, whose brief *Discours sur l'origine, le développement et le caractère des types primitifs qui constituent l'art du christianisme* appeared in 1834. Didron was the true founder of the tradition that leads to Émile Mâle and represents the appearance of scholarship and learning in fields that had been first dug by enthusiasm and fancy. In some ways his early education had equipped him better than many of the Romantic generation of the 1830s to understand medieval symbolism, for he went to school first at the *petit séminaire* of Meaux and then at that of Rheims, catching a knowledge of theology and the Bible from the clergy who were his teachers. From the windows of the seminary of Rheims he could see the towers of the cathedral and he would often say that even as a boy he used to try to discover the hidden meaning of its sculptures. In 1826 he went to Paris in order to continue his studies. Here he encountered Victor Hugo, whose influence and kindly encourage-ment determined his vocation too for the investigation of medieval art.

Didron was an assiduous student of the Bollandists and of the great French antiquaries of the late seventeenth and early eighteenth centuries, but he quickly saw that their chief interest had been in history, not in art, and that they had done little to

classify and date the styles of medieval art. From his scrutiny of medieval monuments and of medieval literature, chronicles and documents, he soon came to perceive the grandeur of the Middle Ages and was one of the first scholars, as opposed to religious enthusiasts, to recognize in the thirteenth century one of the great periods of western civilization. He did much to destroy in France the prevalent illusion, derived as we have seen from Boisserée and his like, that Gothic was a German style, deliberately evoking the sombre colonnades of a German forest, and claimed as its true place of origin the Île-de-France. His official role as secretary to the Comité Historique des Arts et Monuments, established in 1837, enabled him to take part in the extraordinary impetus this government body gave to the preservation and study of medieval art. Under its auspices he took part in the preparation of an immense monograph on Chartres in which his share was to be the compilation of a description of the cathedral. Although never published, his researches, conducted with the aid of the *Speculum Universale* of Vincent of Beauvais, established the true subjects of the sculptures and windows for the first time.

Didron was also the first person to realize something of the beauty of Byzantine art and of the significance of its iconography for the study and comprehension of Western medieval art. In order to acquaint himself with Byzantium more thoroughly, he visited Greece and Constantinople from July 1839 to February 1840, and during a month's stay on Mount Athos managed to arrange for a copy to be made of the *Painter's Guide* composed by Dionysius the Monk, which he subsequently published in translation at Paris in 1845, in an edition sponsored by the French government and dedicated to Victor Hugo. His iconographical researches were to have culminated in an *Iconographie chrétienne*, or grand survey of the whole of Christian iconography: in the event only the first volume, a stout quarto entitled *Histoire de Dieu* appeared in 1845, dealing with the three Persons of the Trinity. In the preface to this great work Didron had the merit of indicating some of the principal iconographical sources for the study of medieval art, the Bible, the *Legenda Aurea*, and the great encyclopaedic works of the twelfth and thirteenth centuries, the *Historia Scolastica*, the *Bible historiée*, and the *Speculum Universale*. In 1844, he founded the *Annales archéolo- giques*, a journal which appeared until 1867 and is still a fundamental source for the study of medieval art. Finally, he took a positive step for the revival of medieval crafts by founding, in a picturesque ancient turreted house off the rue Hautefeuille, a manufactory of stained glass in medieval style. It was a success from the first: his clients 'were well aware that in coming to Didron they were certain of obtaining windows that were not merely irreproachable as regards style and manufacture, but also compositions completely impregnated by the traditions of the Middle Ages'.[48] A bronze-foundry he established in 1858 to do the same for church metalwork was less successful: Didron found that the cost of the chasing required to produce work up to the quality of finish he desired was too great. For students of Victorian art he also has another interest; he produced two books on Venice and Padua in collaboration with the English architect William Burges.

Montalembert and Didron can be said to have restored legend and symbolism to their rightful place in the study of medieval art, for both the cultivated public and the learned world at large. A movement to introduce the English public of the 1840s to the sacred and legendary in art was under way by the middle of the decade. On 11th January 1845 Mrs Jameson began publication in the *Athenaeum* of her first timid essays on these subjects, which she was to make peculiarly her own.[49] She was aware

of the danger of arousing Protestant feeling, peculiarly inflammable on the subject of representations of the Divine persons, of Mary and of the saints, and here, as throughout all her later books, is careful to emphasize that she presents her studies of their iconography during the centuries of Christian art solely from the artistic and picturesque point of view, as explaining the subjects of paintings every traveller will see in Continental churches and galleries. She insists, too, that 'of late years, with a growing passion for the works of Art of the Middle Ages, there has arisen among us a desire to comprehend the state of feeling which produced them, and the legends and traditions on which they are founded'.[50]

But a deeper passion for legend and symbolism as living forces shaping all expression of medieval religious art informs the pages of Lord Lindsay's *Sketches of the History of Christian Art*, like Rio's book a fragment, but, unlike his, a fragment in three volumes, published in 1847. Alexander William Crawford Lindsay (1812–80), Earl of Crawford and Balcarres, was a nobleman of a sort that only the early Victorian age could have moulded, at once an austere religious enthusiast and an idealistic lover of chivalry, of books and pictures and heraldry and genealogy, who spent his life dreaming dreams of art and learning and philosophy and religion in the great library he collected at Haigh Hall in Lancashire.[51] He was the most important of Rio's disciples, though he did not adopt all Rio's views, and was at pains to make his own observations and construct his own philosophy of art history. To this he was impelled by a certain independence of mind and by the natural difficulty he found as a convinced Anglican in adopting Rio's views wholesale. That he could come to terms with them at all is a testimony to the sentimentalism which softened, for many in the early nineteenth century, the dogmatic rigours of earlier controversy, as well as to the transmuting power exercised by Romantic medievalism and earnest Victorian piety.

On a youthful visit to Paris in 1828–9, Lindsay's taste was still a conventional one—he records his admiration for Raphael's *Belle Jardinière* and Poussin's *Deluge*. However, during this same visit he began making a collection of prints 'to form a little history of the art of engraving, beginning from the early periods'.[52] Plainly, his interest was awakening in the history of the arts, just as the collection of incunabula he had already begun as a schoolboy at Eton shows a similar interest in the history of printing. Both interests were essentially continuations of late eighteenth-century antiquarian tastes in collecting, and when Lindsay went on to make his first Italian tour in 1830, his response to Italian painting was still conventional. Thus, in the Tribune of the Uffizi, he admired most, like almost all his contemporaries, Leonardo and Raphael's late works. It was only during his second visit to Italy in 1839 that he was converted to the doctrines of Christian Art. His conversion took place when he was given Rio's book to read, appropriately enough on the road from Rome to Assisi. The copy he was lent belonged to Félicie de Fauveau, who was later to help and advise him with his own book. The completeness as well as the suddenness of his conversion appears from the entry in his journal for 20th May 1839, describing his visit to Assisi, 'the picturesque old convent of the Franciscans, and peculiarly interesting in the history of art as the cradle of that pure and religious school of painting, which beginning with Giotto, and carried on by Fra Angelico, Benedetto Gozzoli and Perugino, found its highest development in Raphael'.[53]

On his return journey he went to Munich, the fountain-head, as we have seen, of the Romantic Catholic philosophy that had provided Rio with a firm aesthetic framework for his book and also a centre of Nazarener art and Romantic medieval-

ism. Here Lindsay, like Rio, studied the paintings of Cornelius, Schnorr, and Hess, significantly admiring most the 'tenderness, purity and holiness of Hess', in other words that same style of suave, sentimental idealism that to Rio also had seemed the truest expression of a truly religious inspiration.[54] In this spirit he painstakingly evolved late in 1839 the first of his characteristic abstract schemes of art history, a moral classification of painting, founded on a distinction between Nature, Humanity, and the Degradation of Humanity, and 'settling the precedency of the several departments of art by a reference to their moral elevation'. Religious art naturally occupied the highest division, while into the lowest he put the Dutch painters of low life. Yet Lindsay, again like Rio, was careful not to confuse sentiment with achievement in art: he expressly disclaimed any intention of maintaining the position 'that an indifferent religious painter should, *in reference to his individual merits*, be placed above a master in landscape'. From the late seventeenth century, English collectors of pictures had been divided between the advocates of an ideal taste in painting, represented by the Italians and above all by the Bolognese, and those who admired the exactness of Dutch imitations of nature, much to the disgust of the admirers of the ideal. Lindsay advanced a truly Victorian resolution of the debate, transferring it from the domain of the imagination to that of morality.

There was now floating in his mind a plan for 'a work on Art to lead men to the true moral and religious dignity and object'.[55] He again set out for Italy in 1840 to begin collecting materials for his book, later to become the *Sketches*, staying with his cousins James and Anne Lindsay at the Villa Torrigiani, just outside Florence. Here he now met Félicie de Fauveau, who was making a bust of Anne Lindsay.[56] In the preface to the *Sketches* Lindsay acknowledges 'a debt of warm and affectionate gratitude' to Félicie, whose society added 'the charm of enthusiasm and genius' to his tour and 'whose suggestions, let me add, have since been most useful to me in guiding my researches and qualifying my judgment'. Félicie de Fauveau (1802–86), who was, it will be remembered, one of Rio's most ardent disciples, had been known to him and to Montalembert since they had first visited her studio together in 1832. She was in fact an exile from France because her ardent legitimist convictions had led her to join the abortive uprising of 1834 in the Vendée. Félicie had been encouraged in her early fervent admiration for the Middle Ages and medieval art by the painter Paul Delaroche, her first instructor. After the failure of the uprising of 1834, she and her brother retired to Florence, where she opened a studio as a sculptor and addicted herself passionately to the study of the primitives, whose art she delighted in introducing to her many visitors. Among her discoveries was San Gimignano, to which she sent Lindsay, who had coloured drawings made of some of Benozzo Gozzoli's frescoes of the *Life of St Augustine*. She was to remain his friend and protegée until his death.

After this visit of 1840 Lindsay came to the conclusion that it would not be enough to write only of painting in his projected book, as Rio had done. 'If an attempt is to be made to bring men back to its right object and principles, one must begin with the architecture of the Middle Ages—Sculpture and painting were its children and must be considered in relation to it and with each other.'[57] Accordingly, late in 1841 he set off for yet another visit to Italy and made a fresh tour of the peninsula, collecting notes and drawings. Sharing, as he did, the stout Victorian view of England as the guardian of true Christianity, he had now decided on the mission of his book. A Christian country should carry Christianity 'into every department of genius, every walk of

life';[58] his book would carry Christianity into art, and so would be written, not as a formal, lengthy history, but as a simple series of letters to a young Italian traveller—artist or friend. In the end he dedicated them to his young cousin Coutts Lindsay, whom he had adopted as a pupil in 1840, and took with him to Italy at the end of 1841. Like all Anglican Protestants, he was nervous of appearing to lend any support to the claims of Popery or Puseyism by his enthusiasm for the religious spirit of medieval art, all the more so because he went further towards Rome on some points than most Protestants. However, he did not allow this to disturb him in his purpose of firing some Anglican artist into inaugurating a revival of religious art. In this sense his book is an Anglican counterpart of the Catholic propaganda of Rio and Montalembert.

Begun in their final form in the autumn of 1842, Lindsay's *Sketches* were completed by February 1846. The book is a much more scholarly and extended work than Rio's, surveying painting north of the Alps, not only in Italy, and taking in architecture and sculpture as well. Its range of period is also different: the first volume is devoted to a survey of early Christian and Byzantine art. Lindsay saw, apparently of his own accord, the injustice of the conventional view of Byzantium as an effete civilization. For him it was the Byzantines who had preserved the Christian religion and the Christian legends, ceremonies and superstitions which were subsequently interwoven into the fabric of Western Christianity, and vitalized by Teutonic inspiration. He is the first English writer on art to acknowledge the originality of Byzantine architecture, even if he regards it too philosophically as an expression of the contemplative East, in opposition to the practical West. But his survey of medieval Christian art confines itself to those forms of art and those artists accepted by Rio, Montalembert and their followers as truly Christian. First he traces the rise of Christian art and architecture from the conventions of Italo-Byzantine art. Then follow sections on Niccoló Pisano and his school, on Giotto and the Giotteschi, on Sienese painting, on Orcagna and Fra Angelico, and on the primitive school of Bologna. Here terminates the survey of Italian art, and the book concludes with a survey of painting and sculpture north of the Alps during the later Middle Ages and the Renaissance, a survey largely confined to Germany and the Netherlands.

The primacy of Christian art is founded by Lindsay on a grand metaphysical scheme of history, in which man steadily progresses towards restoring that harmony which was lost at the Fall among the three elements composing the nature of man, his Spirit, his Intellect, and his Sense. He treated this theme philosophically in a separate essay, *Progression by Antagonism*, which he published in 1846, and sets it out again at the beginning of the *Sketches*. His essential dogma is the primacy of the moral sense as the agent of man's spiritual elevation. In Lindsay's scheme, man's intellect is now subdivided into two elements, Reason and Imagination, which are at variance. Yet man's moral sense is not dead, but still responds to what is pure, holy, and fitting: the struggle between imagination and reason reveals to the calm intelligence the vision of Truth immortal, abstract, and universal, inclusive of that particular truth and beauty which is falsely deemed Truth's enemy—in other words, it reveals the Ideal. The three great branches of the Human family express each of these three elements of man's nature at distant intervals of time. That of Ham cleared the earth of primeval forests and monsters, built cities, created empires, invented the mechanical arts and gave full expansion to the animal energies. It developed Sense. The Greeks, who were the elder branch, Japhet, developed the Intellect in both her faculties of Imagination and Reason. The race of Shem, the Jews and their successors, the

Christian nations, who form the Spiritual Israel, represent the Spirit, having been elevated in spirit to as near communion with Deity as is possible in this state of being.

Art corresponds exactly in her three departments of architecture, painting and sculpture to each of these three periods of development, and so illustrates even more clearly than literature the all-important truth that men stand or fall according as they look up to the Ideal or not. Thus, the Pyramids and temples of Egypt, cumbrous and inelegant, but imposing in their vastness and gloom, express the Ideal of Sense or Matter, elevated and purified, indeed, and nearly approaching to the Intellectual, but Material still. We think of them as of natural scenery, in association with caves or mountains or vast periods of time. Greek sculpture is the voice of Intellect and Thought, communing with itself in solitude and yearning after Truth. Painting is the voice of Christendom, of an immortal spirit conversing with its god. These are the three typical arts of the three ages, Architecture of that of Sense, Sculpture of that of Intellect, Painting of that of Spirit. In the first two ages the other arts were unformed: so sculpture and painting in Egypt, and painting in Greece are as younger sisters. Only in Europe are the three found linked together, in equal stature and perfection. 'You will not now be surprised at my claiming superiority for Christian over Classic art, in all her three departments. If Man stand on a lower or higher plane in the scale of being according as he is Spiritual, Intellectual or Sensual, Christian art must excel Pagan by the same rule and in the same proportion.' As with Rio, Lindsay's arguments in favour of Christian art are essentially not concerned with art as form. They are historical and moral and idealistic, not aesthetic. 'As men cannot rise above their principles, so the artists of Greece never rose above the religious and moral sentiments of the age. Their Ideal was that of youth, grace and beauty, thought, dignity and power: Form consequently, and the expression of Mind, was what they chiefly aimed at, and in this they reached perfection.' Lindsay was anxious, indeed, not to be thought insensible to classical art; he still cherished his memories of Greece and Palestine: 'I cannot speak coldly of the Elgin marbles, of the Apollo, the Venus, the Dying Gladiator . . . But none of these completely satisfy us. The highest element of truth and beauty, the Spiritual, was beyond the soar of Phidias and Praxiteles.'

Christians have the advantage of starting from a higher point. For Lindsay, revealed religion entails an enhanced spiritual nature which in turn entails a higher and better art.

> It is not, in a word, symmetry of Form or beauty of colouring, apart or conjoined, that is required of us and that constitutes our prerogative, but the conception by the artist and expression to the spectator of the highest and holiest spiritual truths and emotions—and in this the vantage of the Bible over the Iliad is not more divided than that of Christian over Classic Art—than the depth, intensity, grandeur and sweetness of the emotions at the command of Christian artists, as compared with those elicited by the ancients. Few will dispute this who have ever soared into the symbolic heaven of a Lombard or Gothic Cathedral—renewed their vows of chivalry before the S. George of Donatello—or shared the cross and the palm, the warfare and the triumph of the Church of all ages in the sympathy of the Spirit, while contemplating the old Byzantine heads of Christ, the martyrdoms of the Lombard Giotteschi, the Paradises of Fra Angelico, the Madonnas of Perugino, Leonardo and Bellini, the 'Dispute' of Raphael and the Last Judgments of Orcagna and Michel Angelo.

Unlike Rio, who was absorbed in sentiment, Lindsay took a deep interest in medieval iconography, symbolism and legends, though carefully terming them 'Christian mythology', in order to associate them with the well-known term 'pagan mythology' and so avoid arousing Protestant susceptibilities. He had made a fine collection of printed legendaries and collections of lives of the saints, appreciating their importance for the understanding of medieval art and its spirit. Though well aware of the usefulness of the *Legenda Aurea*, he preferred to it the *Catalogus Sanctorum* of Petrus de Natalibus, a Venetian compilation of the lives of the saints made *c.* 1390 and printed in 1493. Indeed, on his Italian journey of 1842 he had carried about with him an old folio edition of this work, studying it in front of the frescoes and paintings in churches. At the beginning of his book, as an introductory sketch of the world of medieval religious art, he gives a sketch of the medieval universe, of the heavenly hierarchies, of legendary Old Testament history, of incidents from the apocryphal gospels. To these he adds lives and legends of various saints extracted from Petrus de Natalibus and other sources. Lindsay was a learned and intelligent scholar, and far from unaware of the origin of some of these beliefs and legends in the ancient pre-Christian East or of their parallels in other religions, such as Buddhism. Moreover, widely read as he was in medieval popular and Romance literature, he cites parallels from Dante, from mystery plays and from Mandeville, as well as from Petrus Comestor's *Historia Scolastica* and medieval Latin hymns. Yet, for all his real scholarship, he had an addiction to speculative symbolism, of a very fanciful sort, such as is found in extremer and more arbitrary form in Hawker of Morwenstow and other Victorians with leanings to the poetical and figurative interpretation of medieval church art, who imposed on it concepts which are purely nineteenth-century in their abstractness of idealism. Thus he can declare that Lombard church architecture, with its round arches and horizontals, figures an infinity of Rest, while Gothic with its soaring, pointed arches and intricate service, figures an infinity of Action, in the adoration and service of God.

Nevertheless, his book blends a history of style with a history of iconography and symbolism, so enforcing the new conception of early Christian and medieval art as embodying profound thoughts in forms pregnant with significance. In this, his approach to the subject is profounder, as he himself recognized, than such a book as Franz Kügler's *Handbook of the History of Painting*, first published in 1842 under the editorship of Charles Eastlake, with its exclusive insistence on the history of style. The *Sketches* attracted much attention, and received a long and careful review from Ruskin himself, newly returned from his Italian tour, in the *Quarterly Review* for June 1847. Ruskin, like Phillips, was conscious of a failure of inspiration in modern art, though with his stronger sense of the practical necessities governing the historical evolution of art he was not so sanguine that an ardent revival of Christian idealism would resuscitate the glories of the past. Indeed, it was his consciousness of the concrete circumstances that account for so much in the development of styles— climate, geographical position, availability of materials, technical improvements, social and religious factors—that led him to dismiss Lindsay's philosophical scheme of the history of art as altogether arbitrary, corresponding neither to the facts of human nature and human history nor to those of art and art history. To Ruskin's acuter insight, Linday's canon of an ideal balance of sense, intellect and spirit was nothing but old-fashioned Bolognese eclecticism clad in a new metaphysical guise, and he rather tartly points out Lindsay's inconsistencies in applying it. The *Athenaeum's*

reviewer also viewed Lindsay's 'reasoning on the Ideal' as 'another instance of the metaphysical and involved tendencies with which the dilettanti of our day approach the consideration of the Arts. An enthusiastic Christian, Lord Lindsay is not content with the simplicity which is the great element of beauty in them all—but must invest them with the pomp and circumstance of religious and symbolic mysticism or theologic hypothesis.' And this reviewer, too, rejects Lindsay's metaphysical scheme and his attempt to 'appropriate' art solely for the exclusive use of the Church. 'Axioms like his we have had enunciated to us personally by more than one German artist of celebrity—who holds the true exercise of his calling to consist in spiritualizing aspirations, and looks upon its employment in history, poetry, or romance as the prostitution of powers which God has given for the sole purpose of glorifying himself.' Accordingly, praise is refused to the 'dreamy and mysterious' part of Lindsay's book, and accorded only to its positive aspects.

In spite of the cavils entered by reviewers against Rio's and Lindsay's doctrines, there can be no doubt that they made great headway among artists and critics generally. Indeed, Ruskin himself was later to call Lord Lindsay 'his first master in Italian art', inaccurately it is true, as this honour belonged to Rio. It could hardly be otherwise, given the overwhelming preoccupation of the Victorians with religion, and with the spiritualization of life and all its activities. The vogue of Christian Art led Miss Ellen Millington to translate in 1849 for Bohn's Library, a sort of more solemn Victorian version of Everyman's Library, Didron's *Histoire de Dieu* as *Christian Iconography*. In the same year she also issued in the same Library Friedrich von Schlegel's early letters on the pictures he had seen in Paris in 1802 and his account of his tour through France, the Netherlands and north Germany to study Gothic buildings. Significantly, she entitled them *Letter on Christian Art* and annotated them with extracts from Rio. Again, when Miss Mary Wells, a lady personally unknown to Rio, issued an English translation of his book as *The Poetry of Christian Art* in 1854, her purpose was to publish his doctrines beyond the 'comparatively narrow circle of readers' who had been able to read them in the original French. She cited the encomiums of Mrs Jameson, who speaks in the introduction to her *Sacred and Legendary Art* (1848) of referring to Rio's 'charming and eloquent description of Christian art' with 'ever-fresh delight'. And she noted that Rio was one of the few authors cited with approval by Ruskin in the second volume of his *Modern Painters* (1846). But the triumph of Rio's narrow view of Christian art was lamented in a review of Miss Wells's translation in the *Athenaeum* of 10th February 1855 by the same reviewer who had written at such length on the original edition in 1837.

It is now nearly twenty years since we first drew the attention of the English public to the excellencies and defects of Rio's opinions on the mysticism of Art. Long before Mr. Ruskin had begun to carry out the opinions existing in their germ in Rio's book we had earnestly directed attention to the simple piety of these patriarchs of Art, to the beauty of Fra Angelico's colour, to the sublimity of Orcagna, and the devotion of every touch of Giotto:—at the same time we warned Rio's disciples against the narrow bigotry that in pardoning the child-like errors of Cimabue should turn with disgust from the aberrations of Michael Angelo. We regret to say we spoke in vain. In Mr. Ruskin's works we find all the stern fanaticism of Rio, heightened with greater eloquence and still more intolerance. We find a wilful blindness to the fact, that Greek mysticism in Art, if it did not

originate the mysticism of early Italian Christian Art, at least carried it forward and gave it its stronger impulses.

We think it due to ourselves to remember that we were the first pioneers in this now triumphant cause. We were the first to point at the mysticism of early Art as a source of pure inspiration, superior to that of the Greek statue or the Grecian frieze,—to show that it was more adapted to our Gothic spirit, to our climate, our religion, and our manners. We regret that we were the first and last to warn the Art-student against too violent a reaction. . . . A perusal of this book will remove an impression of the originality of Mr. Ruskin's views of Art. His hatred to naturalism, his distrust of many of Raphael's works, his love of the gothic spirit, his contempt of the antique, his apotheosis of Fra Angelico, are all foreshadowed here.

It must by now be more than plain that many of the most important trends in Victorian aesthetics were inaugurated by the apostles of Christian Art. They continued to exercise a profound influence, though subsequently Rio and Montalembert modified some of their extremer views concerning Raphael and Michelangelo. Rio later completed and revised *De la poésie chrétienne*, which appeared in its final form in 1861–7 as *De l'art chrétien*, while Lindsay's *Sketches* were reprinted as late as 1885. Indeed, during the rest of the century here and on the Continent the flow of books and periodicals devoted to the propagation of Christian Art was continuous and vast. Nor was the influence of its apostles transient. Even in the 1930s Berenson could acknowledge to Rio's biographer, Sister Mary Bowe, that Rio and Lindsay had been among the prime background influences in his intellectual formation, and that he looked on them both, together with Lanzi, Schnaase, Mrs Jameson and Ruskin, as 'among the pioneers and creators of the Universe into which people like myself were born'.[59] The influence of the ideals of Christian Art, of the self-dedication of the artist to moral and religious truth, to honesty and humility of labour, also pervaded many of the more important art movements of the later nineteenth and early twentieth centuries, if only because of the powerful image they had shaped of medieval artists and craftsmen as men who had actually lived after this pattern.

So early as 1854 Dr Gustav Waagen, the internationally revered German connoisseur and art historian, was protesting in a letter to the *Times* of 13th July that the Pre-Raphaelites were being led into error by such doctrines.

Within a few years a school of painters has arisen in England whose aim it is to elevate the character of modern art, not only by the treatment of sacred subjects, but by the adoption of the more or less undeveloped forms of the 15th century: . . . I need hardly say that I sympathize entirely with the painters of this class, both German and English, in the exceeding attractiveness of that pure and earnest religious feeling which pervades the works of Fiesole and other masters of the 15th century. I also comprehend the liability in their minds to identify the expression of that feeling with the forms peculiar to those masters. At the same time, it is no less true that this identification, and the efforts, however well meant, to which it has led are totally mistaken, and can only frustrate that end for which these painters are so zealously labouring. Guided by this erroneous principle, they have sought to transfer to their pictures not only the beauties, but the defects of their great models; unmindful of the fact, which a general survey of the history of art does not fail to teach, that those early masters attract us not on account of their meagre drawing,

hard outlines, erroneous perspective, conventional glories, &c., but, on the contrary, in spite of these defects and peculiarities. We overlook these simply and solely because, in the undeveloped state of the scientific and technical resources of painting at that period, they could not be avoided. But it is quite another thing when, under the false impression that the feeling they emulate can be better reared by ignorance than by knowledge, we see these defects and peculiarities transferred to the works of modern artists, who purposely close their eyes to those scientific and technical lights which have now become the common property of art, and retrograde to a state of darkness for which there is no excuse.

It must be also borne in mind, that the whole style of feeling proper to those early masters, deeply rooted as it was in the religious enthusiasm of their times—of which it may be considered as the highest and most refined fruit—cannot possibly be voluntarily recalled in a period of such totally different tendencies as the present. It stands to reason, therefore, that the pictures even of the most gifted modern artists, produced by such a process, can at most be considered but as able reminiscences of the middle ages, but by no means as the healthy expositors of the religious feeling, now, thank God, greatly revived and proper to our age, or of the resources of art so plentifully within their reach; while those of the less gifted, able only to counterfeit the defects, but not to emulate the spirit of the olden time, present a scene of misplaced labour the most painful a true lover of art can well behold.[60]

Time has not justified Waagen's fears, which were those of a historian rather than of an artist. Instead, we may feel that the doctrines of Christian Art provide yet one more proof that there is no need for artistic dogmas to be wholly valid historically or philosophically for them to inspire styles of originality and achievement.

Acknowledgement

I wish to thank Mr Clive Wainwright, F.S.A., for help and discussions.

NOTES

[1] L. Dickins and M. Stanton (eds.), *An Eighteenth-Century Correspondence* (1910), xx.

[2] See T. Wilson, *The Ornaments of Churches Considered* (1761); H. F. Westlake, *St. Margaret's, Westminster* (1914), 89–90, 118–20.

[3] F. Borromeo, *De pictura sacra* (1625), *passim*.

[4] See R. Lightbown, 'England and Italian sculpture', in *Apollo*, lxxx (July, 1964), 16; B. Fothergill, *The Mitred Earl* (1975), 146, 177. The classic study of this antiquarian movement is G. Previtali, *La fortuna dei primitivi dal Vasari ai neoclassici* (1964).

[5] For Wackenröder and Tieck see Robson-Scott, *The Literary Background of the Gothic Revival in Germany* (1965), 113–28.

[6] F. von Schlegel, *The Aesthetic and Miscellaneous Works*, trans. E. Millington (1849), xix. These letters, first published in Schlegel's *Poetisches Taschenbuch auf des Jahr 1806*, were reissued in revised and enlarged form as *Grundzüge der gothischen Baukunst* in vol. vi of his *Sammliche Werke* (Vienna, 1823).

[7] A. W. von Schlegel, *Mariae Kronung und die Wunder des heiligen Dominicus von Johann von Fiesole* (1817).

[8] See note 6 and p. 36 below.

[9] For the Boisserée brothers and their collections see Robson-Scott, *op. cit.* (note 5), *passim*; for

their links with France see Moisy, *Les Séjours en France de Sulpice Boisserée, 1820–25. Contribution à l'étude des relations intellectuelles franco-allemandes* (1956).

10 Pugin, *Contrasts*, 2–3.

11 *Ibid.*, 27.

12 Hugo, *Notre-Dame de Paris*, III.1; v.2.

13 The principal source for Rio's life is his autobiography, *Épilogue à l'art chrétien*, 2 vols. (1870). The only modern study, chiefly interested in Rio from the literary point of view and as a Catholic apologist, is Sister Mary Camille Bowe, *François Rio: sa place dans le renouveau catholique en Europe (1797–1874)* (Paris, 1938) (in the series *Études de littérature etrangère et comparée*).

14 Rio, *Épilogue*, I, 337–8.

15 *Ibid.*, 339.

16 For Rumohr, see below.

17 Rio, *Épilogue*, I, 367–8.

18 Rio, *Épilogue*, II, 5.

19 Lady Malcolm was the wife of the great Sir John, for whom see the *D.N.B.*

20 Rio, *De la poésie chrétienne* (1836), 2–3.

21 *Ibid.*, 68 n.

22 *Ibid.*, 69.

23 *Ibid.*, 81.

24 *Ibid.*, 96.

25 *Ibid.*, 148.

26 *Ibid.*, 160–1.

27 *Ibid.*, 167.

28 *Ibid.*, 193.

29 *Ibid.*, 207.

30 *Ibid.*, 235–6.

31 *Ibid.*, 266.

32 *Ibid.*, 527.

33 Rio, *Épilogue*, II, 274–5.

34 See Rio, *Épilogue*, II, 393.

35 J. Flaxman, *Lectures on Sculpture* (1829), 304–5, 307–8.

36 Vol. I, 256.

37 Foisset, *Le Comte de Montalembert* (1877), 155.

38 *Journals and Correspondence of Lady Eastlake*, I (1895), 171.

39 *Memorials of Charlotte Williams Wynn* (1878), 9–10; for Rio's admiring comments on her see *Épilogue*, II, 408–9; for Gladstone's comment see Bowe, *op. cit.* (note 13).

40 Ruskin, *Works* (1903–12), ed. E. T. Cook and A. Wedderburn, vol. IV, xx, xxiii–iv, xxx, 340; vol. xxv, 341; cf. also his letter to his father of 15th February 1852 (*ibid.*, vol. XXXVI, 131).

41 Rio, *Épilogue*, II, 408.

42 Geraldine Macpherson, *Memoirs of the Life of Anna Jameson* (1878), 176.

43 Montalembert's essays on art are collected into his volume *Du vandalisme et du catholicisme dans l'art (fragmens)* (Paris, 1839), itself a tribute to the doctrines of Christian Art, with its frontispiece by Overbeck and its title in Gothic type. They are reprinted in the Abbé Esprit-Gustave Jouve, *Dictionnaire d'esthétique chrétienne, ou théorie du beau dans l'art chrétien* (Paris, 1856), along with other writings on Christian art: this volume is vol. XVIII of series 3 of Migne's *Encyclopédie théologique*.

44 Foisset, *op. cit.* (note 37). Foisset's ch. 2 is fundamental for Montalembert's attitude to art and for the *Histoire de Sainte Elisabeth*, and I have used it extensively here.

45 See the introduction by Léon Gautier to the edition of Tours (1878), ix.

46 *Du vandalisme* (edn. of 1839), 263–8.

47 The best account of Didron is still R. de Guilhermy, *Didron aîné: notice biographique* (1868).

48 *Ibid.*

49 I do not cite Mrs Jameson's later, much better-known works, as they fall outside the time-scope of this study.

50 Anna Jameson, 'Sacred and legendary art; I, Introduction', in the *Athenaeum*, no. 898 (11th January 1845), 45; cf. also continuations in later numbers, pp. 73, 97, 98, 125, 153, 175, 200, 224, 248, 1201, 1224, 1278.

[51] Of all the figures discussed here Lindsay is the only one to have received a modern study, in Hugh Brigstocke, 'Lord Lindsay and the "Sketches of the History of Christian Art" ', in *Bull. John Rylands Library*, lxiv (1981), 27–60. This is my source, except where I cite other literature and discuss Lindsay's own works, and I wish to acknowledge my obligations to it.

[52] *Ibid.*, 31.

[53] *Ibid.*, 32.

[54] *Ibid.*, 33.

[55] *Ibid.*, 34–5.

[56] For Félicie de Fauveau see the very enlightening article by Coubertin, in *Gazette des Beaux-Arts*, ser. 2, xxxv (1887), 512–21; Rio, *Épilogue*, II, 423; Brigstocke, *op. cit.* (note 51), 35–6, 48–50, quoting an extremely interesting letter from Anne Lindsay about Rio.

[57] *Ibid.*, 38.

[58] *Ibid.*, 45.

[59] Letter to Sister Bowe, printed without date, *op. cit.* (note 13), 245.

[60] Cited by Leslie, *Hand-Book for Young Painters* (1870), 29–31.

The Norman Revival

Timothy Mowl

I am not being flippant, nor am I undervaluing my theme, when I begin by insisting that the most significant fact about the Norman Revival is that it never really happened. As all revivalism is a gesture of protest against contemporary architectural options, what are we to say of a revival that failed, and failed not just once, but with a melancholy consistency over a period of at least 200 years? For that is the remarkable feature of the neo-Norman; it is better described as a chronic condition than as an architectural revival. What I want to suggest are some of the reasons for this strange cyclical condition of allure and rejection.

If it is allowed that Gothic always survived in some form or another, then the Norman was the earliest of all the revivals made after the Renaissance had broken the native tradition of building in Britain. Because the authentic Norman of the Middle Ages had been an attempt to revive Roman forms, it must have seemed fatally accessible to classical architects of the seventeenth century, with the illusory familiarity of its round arches. If Inigo Jones cannot be set down as the first actual practitioner of neo-Norman, then some evasive and cumbrous term such as the first Norman Responder must be invented to suit him.

The south front of the White Tower of the Tower of London is not normally accepted as one of the capital's surviving Inigo Jones façades, but that is what it is. The White Tower's fenestration was refaced in Portland stone and radically reshaped in 1637–8.[1] The mason in charge was William Mills, but the Surveyor of the Works who must have supervised Mills, and approved and roughed out the design to which he worked, was Inigo Jones. And that design, the toy fort tower which still survives, was a conscious Stuart preservation of the Norman character of a nationally revered monument. The earlier rhythm of buttresses and relieving arches was maintained and the narrow-splayed Norman windows were enlarged and emphasized, some without the classicizing detail of keystones.

Another instance of Stuart conservatism is the Upper Ward of that extraordinary lost palace fortress, Hugh May's Windsor Castle.[2] Only here the uneasy term Norman Response must be dropped and Norman Revival used tentatively for the first time, because all the courtyard ranges were Gothic before May put in his severe round-headed windows. As an architect of the new classical practice, May clearly felt

41

happier with round rather than pointed windows when working on a royal palace which was also a many-towered garrison and a setting for the revived Garter ceremonies. The Paul Sandby watercolour of the interior of the Upper Ward illustrates this uneasy compromise of Norman suggestion and classical symmetry.[3] Only two of the windows that were the basic unit of May's Windsor survive in the Lower Ward.[4] A classical balustrade divides the mezzanine from the first floor, but there is no attempt to classicize the deep splay with a keystone or a flat architrave.

Shirburn Castle, Oxon., is a later instance of this instinctive unscholarly eo-neo-Norman treatment.[5] At Shirburn it was applied to a modest late Plantagenet castle. The wide, romantic moat seems to have inspired the first Lord Macclesfield's unknown architect, working between 1716 and 1725, to produce a vague Norman image in place of the earlier Gothic or Tudor. There is no kind of authenticity of nook-shafts or chevroned orders around the windows at Shirburn.

Vanbrugh's connection with this chain of experimental round-arched castle-style buildings is well known. He admired the 'Castle Air' of May's Windsor and chose personally to live in Vanbrugh Castle, in a veritable new housing estate of middle-class residences akin to his castellated Elton Hall designs. The Board of Ordnance, already linked with the chain by the Tower and May's Windsor, developed its existing round-arched house style with Vanbrughian feeling in buildings like the Great Store at Chatham dockyard.

Stainborough Castle, a 1734 folly in the West Riding, more sizeable than many real castles, demonstrates by its juxtaposition of a Wren-style rusticated doorway and round-arched tower windows how naturally and easily these early medieval revivalists conceived of the Middle Ages in Norman-classical terms.[6] Another folly, Dunstall Castle, Worcs., of 1748, combines round and pointed arches quite indiscriminately, while the Duke of Cumberland's later folly tower at Virginia Water, the earliest Fort Belvedere of 1757, was wholly round-arched rugged to suit its owner's martial image.[7]

But these last are trivia. The important development on Vanbrughian lines came a little later, between 1771 and 1791 and in Scotland, with its native tradition of compact tower houses. Robert Adam described Vanbrugh's designs as 'rough jewels of inestimable value'.[8] What he may have meant is best demonstrated in his own finest round-arched castle house, Seton, dating from 1789 to 1791.[9] Seton is that mature fusion of medieval and classical which could so easily have been taken up in England. It is a tragedy that the Duke of Norfolk's Arundel, almost contemporary in date, should have intruded into the neo-Norman line.[10] Seton is compact, symmetrical, yet vibrant with towered forms; even its Venetian window is unobtrusively Normanized. Arundel, in contrast, is also symmetrical, but awash with correct, yet jumbled, medieval detail, like an old classical tart bedizened with trinkets. The 11th Duke's Arundel, and he was his own architect, was built between 1791 and 1815. The new century was at a turning point, and it had a clear inspirational choice.

Just before Arundel's entrance front comes, in 1794, James Wyatt's Broadway Tower, with some semi-authentic Norman detail on its balconies, yet as compact and masculine as Adam's Seton, with its three faces and confident thrust (pl. Ia). Wyatt's house by the Solent, Norris Castle, Isle of Wight, built in 1799, again while Arundel's ill-assorted five façades were going up, is simple, unpretentious and fine, a link between the round-arched castle style and the Board of Ordnance coastal forts.[11] It is no great jump from the unadorned solids of Norris to twentieth-century modernism. Even as late as 1812 the Adam round-arched castle line was not dead. Smirke's

PLATE I

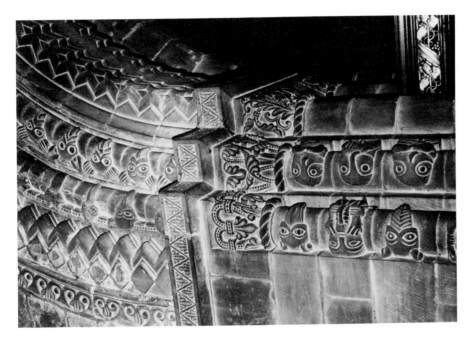

b. Chancel arch, St Chad. Stafford

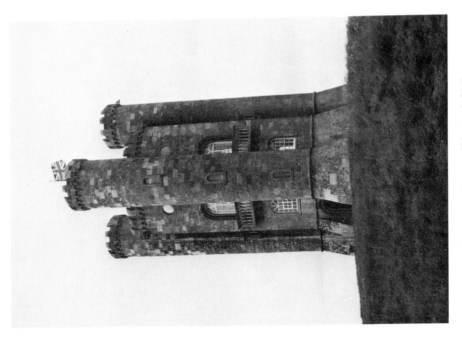

a. Broadway Tower, Worcs. (1794)

PLATE II

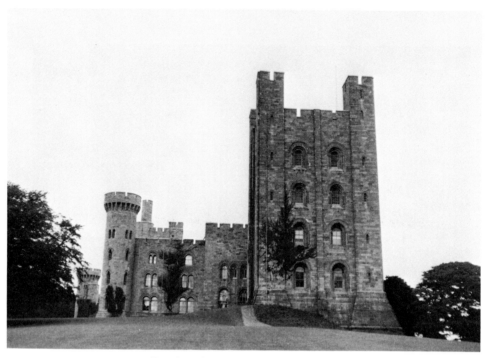

a. Penrhyn Castle, Gwynedd (1822–37)

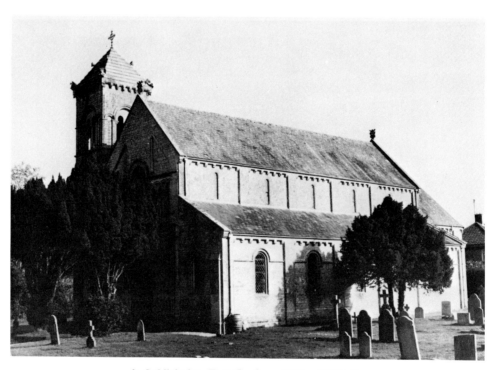

b. St Nicholas, East Grafton, Wilts. (1842–4)

Eastnor Castle, Herefords., has its compact plan, but where Adam's interiors are invariably Adam-classical in decoration, Smirke risked a Great Hall, now overlaid, of austere Norman simplicity.[12]

But it was the Arundel-type combination of antiquarian scholarship and Regency eclectic panache which won the battle. John Carter's unexecuted designs for Lea Castle, Worcs., of 1816 point the way for Thomas Hopper's Gosford and Penrhyn castles.[13] The exterior of Carter's Lea, like Hopper's first Norman essay, Gosford, begun in 1819, is an ill-composed concentration of borrowings from several real medieval sources. Carter's bold but uneasy neo-Norman interiors demonstrate the problem which Hopper was to tackle cautiously at Gosford and then resolve triumphantly at Penrhyn, which was built after 1822 for the owner of a slate quarry with an inexhaustible reserve of skilled and underpaid craftsmen.

Penrhyn is both a masterpiece and a disaster. Mocked by Evelyn Waugh and consistently ignored apart from a stale joke about the huge slate neo-Norman bed made for Victoria, who would not even sleep in it, Penrhyn is, like Blenheim, too splendid and commanding a palace ever to delight the sensibility of a nation of democratic shopkeepers. With an eastern range so extended as to escape even the widest-lensed photography, and a keep to rival Hedingham or Rochester, its composition is masterly (pl. II*a*). Hopper skilfully placed his elements across an extended ground plan and delighted in a dextrous eclecticism which avoided the basic domestic inconvenience of the Norman splay by a whole range of Gothic and Venetian devices and inventions. This is Udolpho achieved in stone by sheer confidence of attack in massing and accuracy of carved detail. The interior is just as overwhelming, with staggering spatial effects, particularly in the Great Hall, and a mass of Romanesque carving, most riotous on the Grand Staircase.[14]

But Penrhyn was a dead end for Victorian inspiration. It only managed to spawn a few tame progeny and its neo-Norman style was rejected as an unsuitable form for the next great castle palace to be designed, George IV's Windsor Castle. Wyatville's crudely detailed Gothic was chosen and the neo-Norman Windsor which might have succeeded Hugh May's grudging elevations is faintly suggested by John Nash's unexecuted design of 1824 for a bridge over the Long Walk.[15]

When the competition for the new Palace of Westminster was opened in 1835, a Romanesque design would have been quite outside the deciding committee's permitted range of styles. William Burn's neo-Norman scheme for Knowsley, Lancs., of the same year was unexecuted;[16] only far out in the Celtic west at Glenstal, Co. Limerick, was the last restrained and convincing essay in the neo-Norman conceived and carried through after 1838.[17] After that the style was almost abandoned by the gentry. Grittleton House, Wilts., was, typically, designed first in neo-Norman, but completed in the more urbanely ornate Italianate.[18] Thereafter the Norman style was generally reserved for prisons, where its grim suggestions of impenetrable dungeons must have seemed an appropriate iconography, and it was these associations which banished it forever from mild and civilized deployment.

The neo-Norman castle style emerged naturally as one experimental and far from successful strand of late eighteenth-century revivalism. The evolution of neo-Norman ecclesiastical architecture is another story entirely.

The 1840s were the high tide of revived Norman church building. Perhaps as many as 200 were built in this one decade, a significant number, even when opposed to the 600-odd Gothic churches of the same decade.

The leading motivation behind neo-Norman church building seems to have been a low church Protestant suspicion of the Catholic connotations of the Gothic. Early buildings like P. F. Robinsons's Christ Church, Leamington Spa, of 1825,[19] and Daniel Robertson's St Clement's, Oxford, of 1825–8, were intended to suggest the stern simplicities of earlier Christianity stripped of Mariolatry and side chapels for the mass.[20] The churches were also cheaper per congregational place than their Gothic equivalents because they had no expensive window tracery or carving at the capitals. However, the flaw in this formula for a new Protestant medievalism was that the Protestant service centres upon the sermon and its churches need to relate a large congregation closely to the pulpit. Authentically fat Norman pillars are liable to block half a congregation from viewing their favourite preacher and, in fact, the pillars of Christ Church had to be slimmed down, leaving the wide capitals uneasily overhanging. At St Clement's a solution was achieved, but at the cost of reducing the church to a wide hall with a slight Norman trim.

Similarly, at Holy Trinity, Birkenhead, of 1837–40 the interior, though round-arched, was fined down to a kind of Regency Perpendicular and the exterior was essentially a classical town church with a highly unauthentic Norman tower in place of a St Martin's in the Fields type of belfry.[21] Designs and ground plans for neo-Norman churches published by F. J. Francis in 1841 illustrate how everything was subordinated to producing a preaching space.[22]

Here we are at the heart of what I see as the essential failure of most Victorian church building. Victorian architects could think and work in linear terms and riot in applied carving. Hence the attraction for them of blousy Northamptonshire village churches with Decorated window tracery and spires. Only very rarely, and late in the century, could they design spatially, and Norman churches at their best are spatial in their effects; their darkness and mystery would be perfect settings for the intimate magic of the mass. The misfortune of revived Norman was that Pugin rejected it after a spindly attempt in southern Ireland.[23] But, of course, Pugin was essentially linear in his design and in his decorative effects. The same could be said of Ruskin's approach to architecture. Mid-Victorian aestheticism was decorative in its response and superficial and unsubtle in its polemic writing. No one wrote persuasively to analyse the nature of Norman effects or to demand them in a church.

There were a few successful neo-Norman churches. C. R. Cockerell's Killerton Chapel, Devon, is an early (1838–41) version of St Joseph's Chapel at Glastonbury: compact, handsome, even authentic, but manifestly a collegiate chapel and not a church.[24] T. H. Wyatt's 1844 Holy Trinity, Dilton Marsh, Wilts., is as satisfying in its exterior massing as Benjamin Ferrey's Christ Church, Melplash, Dorset, is satisfying in the grand proportions and restraint of its interior. But were the Victorians interested in proportion and restraint? The record of neo-Norman church building suggests that they were not.

One curiosity is that Victorian church architects seem to have been unaware of the distinction between Norman and Angevin churches. The sumptuous carving of later Romanesque churches like Kilpeck and Barfreston should have been exactly the inspirational force Victorian designers were looking for, with their feeling for the applied rather than the organic. Only one or two instances of such inspiration exist. At Armitage in Staffordshire Henry Ward, when he came to rebuild the much-decayed church of St John, found wildly exotic images of pagan gods and zodiacal beasts on the old south door, and, inspired by these, he re-created both the door and a

churchyard cross with brilliant gusto and feeling. He did the same at nearby St Chad's, Stafford, where the great tower arch, half gateway to altar and half heathen totem-pole, is wholly his rebuilding and one of the unacknowledged masterpieces of Victorian carving, perhaps because it is almost invisible in a very dark church (pl. I*b*). St Chad's must be considered a quintessentially Victorian inspirational church—seventeen years later it infected Sir Gilbert Scott with its crumbling Angevin sandstone and he produced a superb neo-Norman west doorway. Unfortunately, the monstrous invention and wit of Angevin carving seems to have been at a register apart from the repetitive bearded saints and epicene angels that are strewn about the average Victorian church.

But by this time, 1873, the battle of the styles was long lost. And if any single building represents the strategic defeat of the Norman Revival it is St Nicholas, East Grafton, Wilts. (pl. II*b*). Here, though the exterior is a gaunt and thinly detailed rectangle, Benjamin Ferrey was attempting the essential Norman spatial effect of a vault. The chancel was vaulted easily enough in stone. Then, in September 1842, Ferrey attempted to vault the wider nave in the same material, and on 1st December brought a party of influential clergymen and gentry to view the triumph of his first bay. Even as they gazed admiringly upward the entire bay collapsed upon them, killing the Revd Montgomery outright. From this kind of publicity the neo-Norman never really recovered, and it is a story to be borne in mind when the Victorians are being hailed as engineers and technicians. As late as 1842 the expertise for building stone vaults hardly existed in England; hence the wide and unsatisfactory proportions of so many wooden Victorian Gothic roofs. A cross of brass upon the guilty pillar at East Grafton still marks the crushing point of the Revd Montgomery. It marks also the grave of a hopeful stylistic venture.

NOTES

[1] H. M. Colvin (ed.), *The History of the King's Works* (London, 1963–), III: *1485–1660*, pt. 1, 276.

[2] Hugh May's rebuilding of the castle is discussed in *King's Works, v: 1660–1782*, 314–41.

[3] Sandby's watercolour is illustrated in *King's Works*, v, pl. 44b.

[4] One of these surviving windows is illustrated in K. Downes, *Vanbrugh* (London, 1977), pl. 44.

[5] For a detailed analysis of Shirburn see T. Mowl and B. Earnshaw, 'The origins of 18th-century neo-medievalism in a Georgian Norman castle', *J. Soc. Architect. Hist. U.S.* xl, no. 4 (December 1981), 289–94.

[6] Stainborough Castle overlooks Wentworth Castle in *Vitruvius Britannicus*, IV (1739), pls. 56 and 57–8. It is mentioned in *Country Life*, 25th October 1924, and a further illustration is given in B. Jones, *Follies and Grottoes*, 2nd edn. (London, 1974), 87.

[7] For the original design for Fort Belvedere see *Country Life*, 3rd March 1960, correspondence, and the *Connoisseur*, April 1961, 219. For further information on Flitcroft's work at Virginia Water see *Country Life*, 19th November 1959.

[8] *Works in Architecture of Robert and James Adam*, 3 vols. (1900, repr. of 1778 edn.), I, preface, 2, n.2.

[9] For illustrations of Seton see *Country Life*, 30th May 1968.

[10] The Duke of Norfolk's work at Arundel is covered in two excellent articles by J. M. Robinson in the *Connoisseur*, March 1978, and in *Country Life*, 7th July 1983.

[11] For Norris see A. Dale, *James Wyatt* (Oxford, 1956), 160–1 and pl. 58.

[12] The Buckler watercolour of the original decoration of the Great Hall is illustrated in *Country Life*, 14th March 1968, pl. 7.

[13] For the Lea Castle designs see T. Mowl, 'Designs by John Carter for Lea Castle, Worcestershire', *Architect. Hist.* xxv (1982), 47–55 and pls. 21a–23d.

[14] Interior views of Penrhyn are given in *Country Life*, 21st and 28th July 1955.

[15] The Nash design is in the R.I.B.A. Drawings Collection, E4/119.

[16] Burn's designs for Knowsley are in the R.I.B.A. Drawings Collection, Catalogue Vol. B, 133.

[17] For an account of Glenstal see *Country Life*, 3rd October 1974.

[18] An illustration of the original neo-Norman design for Grittleton is given in the *Builder*, xi (1853), 279–81.

[19] Robinson's church was demolished in 1960–1, but a comprehensive photographic record can be found in the National Monuments Record.

[20] St Clement's is discussed in the V.C.H., *Oxon.* v (London, 1957), 264–5.

[21] Holy Trinity, Birkenhead was demolished in 1975–6. There are photographs in the N.M.R.

[22] F. J. Francis, *A Series of Original Designs for Churches and Chapels in the Anglo-Norman, Early English and Perpendicular English Styles of Ecclesiastical Architecture* (1841).

[23] At St Michael the Archangel, Gorey, Wexford. It is illustrated in P. Stanton, *Pugin* (London, 1971), 66–72 and pls. 36–41.

[24] For Killerton see D. Watkin, *The Life and Work of C. R. Cockerell* (London, 1974), 178–81.

Early French Gothic

J. Mordaunt Crook, F.S.A.

When All Saints, Margaret St, was eventually finished in 1859, it was still the talk of London society: it still seemed *avant garde*. 'The church this week', wrote Beresford Hope, is 'the great fashionable fact. Ever so many people were talking to me about it at Lady Derby's ball last night.'[1] But to architects it was already old-fashioned.[2] In their search for a Victorian Style, the young Goths had already moved on, from Anglo-Italian to Early French. From 1854 onwards, Viollet-le-Duc replaced Ruskin as the Gothic Revival's leading pundit. From 1855 onwards, Burges replaced Butterfield as the movement's rising star. 1854 was the year of the publication of the first volume of Viollet-le-Duc's great dictionary. 1855 was the year of the competition for Lille Cathedral, won against international odds by a new figure in the Gothic Revival—William Burges (working at this point with Henry Clutton). The chief model for the design, fairly freely adapted, was the church of Notre-Dame at Châlons-sur-Marne. Early French had replaced Ruskinian Gothic.

What was the basis of this new enthusiasm for thirteenth-century French Gothic? In the first place it began as a reaction against the excesses of Ruskinian Gothic: its 'pitiless polychromy'; its apparently anti-structural aesthetic. 'No man's works', noted Burges, 'contain more valuable information than Mr. Ruskin's, but they are strong meat, and require to be taken by one who has [already] made up his mind. . . . [For] to one in search of a style, and just beginning his architectural life, [Ruskin] is almost destruction.'[3] Street came to agree with Burges. 'This hot taste', he concluded, 'is dangerous'.[4] The new Victorian Style would have to stem from a style which was more 'natural', 'truthful', and 'real': Early French. Now Burges's flight from Italian to French Gothic can be seen very clearly in the development of one design, his scheme for the Crimea Memorial Church in Constantinople.[5] Between 1856 and 1863 his design (pl. III)—alas, unbuilt—became not only smaller and cheaper, it became more French and less Italian; it lost its polychromy and assumed a style which was harder, sterner and self-consciously plainer. His model had changed, from St Andrea at Vercelli, to Noyon or St-Germain l'Auxerrois. Ruskin had been supplemented by Viollet-le-Duc.

Around the time of the 1862 Exhibition Burges was typical of his generation in believing that Early French represented 'the best ... escape from our present

difficulties'.[6] In its development lay the road to modernity. Architects, he was delighted to see, were at last moving backwards, from the luxury and decadence of Decorated to the primitivism and vigour of an earlier phase. 'Our architecture', he wrote, 'tends [now] to simplify itself by adopting the sterner French types, such as Chartres and Laon.'[7] The square abacus was replacing the round. Now 'the decoration is obtained by sculpture [as at St-Remi at Rheims] rather than by foliage [as at Lincoln];[8] thus necessitating the massing of rich ornament instead of spreading unmeaning leaves over the whole surface. . . . Opponents of the [Gothic Revival] are always taunting [us] with the massiveness and grandeur of Pagan art . . . and they . . . point out that the works, *par excellence*, of the present century, viz. the bridges, viaducts and other engineering works, although ugly in their details, are conceived on a scale of magnificence worthy of the Romans. [But] by taking the massive and severe Early French, such as we find at Chartres [or Châlons-sur-Marne], we can give a satisfactory reply . . . for we have here an art as grand and as simple as that of Greece or Rome, and infinitely better suited to our habits and climate.' If we are looking for the basis of a Victorian style, says Burges, English thirteenth-century Gothic (as at Lincoln) 'certainly won't do'. It is Early French (like Laon or Chartres), or Transitional (i.e. between Romanesque and Gothic) which offers the greatest scope for modern adaptation. German Gothic—and, again, here Street agreed with Burges—lacked the necessary 'nervous manliness'.[9] Not so Early French. 'It is an architecture of great broad masses—it requires few or no mouldings, it employs round and pointed arches indifferently, it is capable of any amount of carving or sculpture . . . [more in fact] than any architecture since ancient Greece.'[10] Here we have a basis, a springboard for the architecture of the future. Medieval *English* builders 'delighted in small pretty [churches], with delicate details, which would be out of place in our smoky atmosphere. In *French* art everything is upon a larger scale, and it is usually suited to our larger warehouses and for high houses, such as are being sown broadcast in old London.'[11] Compare Soissons and Exeter. 'The mouldings in English thirteenth-century work', Burges notes, 'are far more beautiful in their sections than successful in their perspective, looking too much like bundles of reeds separated by hollows.' Whereas 'the French architect of the same period looked more to effect and less to the section, he left more plain surfaces . . . thus his mouldings, when he did use them, have a more telling effect.'[12] French Gothic seemed nobler, cheaper to produce and—this is the crux—more characteristic of the modern age. 'The distinguishing characteristics of the Englishmen of the nineteenth century', wrote Burges in 1861, 'are our immense railway and engineering works, our line-of-battle ships, our good and strong machinery . . . our free constitution, our unfettered press, and our trial by jury . . . [no] style of architecture can be more appropriate to such a people than that which . . . is characterized by boldness, breadth, strength, sternness, and virility.'[13]

Rheims, he thought 'rather overdone'. Similarly, Street objected to its 'prettiness'. 'There is an exquisite grace about this work', Street noted, 'but an entire lack of that stern character which makes Chartres the grandest of French churches; there is prettiness where there should have been majesty; and in parts a nervous dread of leaving a single foot of wall free from ornament, which reminds one much more of the work of an architect of the nineteenth century than one of the thirteenth century.'[14] For Burges, Beauvais was perfection. Remember, it was at Beauvais that two Oxford undergraduates—Burne-Jones and Morris—heard High Mass, and vowed to change the face of English art.[15] Apart from the psychological implications of this obsession

PLATE III

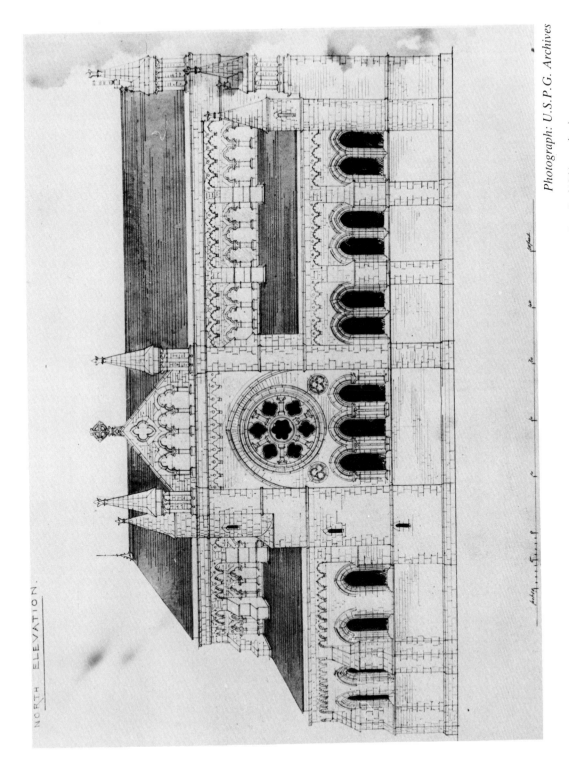

NORTH ELEVATION.

Photograph: U.S.P.G. Archives

William Burges, unexecuted design for the Crimea Memorial Church, Constantinople (1861 version)

PLATE IV

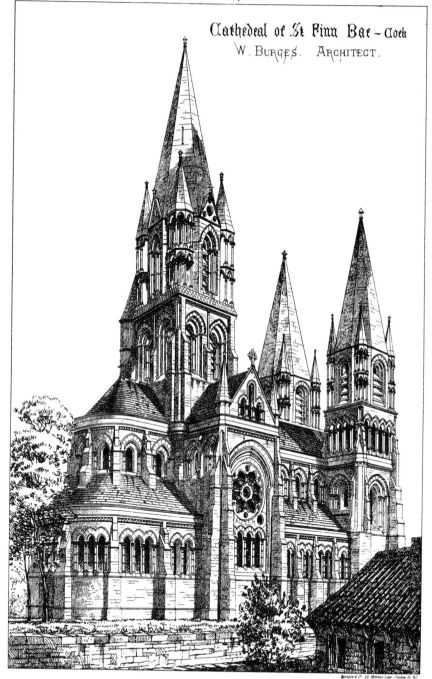

The Architect. April 8th 1882.

Cathedral of St Finn Bar - Cork
W. BURGES. ARCHITECT.

William Burges, St Finbar's Cathedral, Cork (1865–83)

with strength, it is interesting that Burges equated muscularity with Liberalism. Robert Kerr seems to have had the same idea. He described England as 'the very home of rough and ready muscularity'.[16] And Viollet-le-Duc, whose instincts were secular and republican, admired Laon even more than Beauvais because of its '*democratic*' roughness and plainness.[17] Marx and Engels took a rather different line. In their *Communist Manifesto* they equated muscularity with reaction: what 'the reactionary forces so greatly admire about the medieval period', they claimed, is its 'brutal expression of strength'.[18] Still, what Burges chiefly had in mind was the adaptability of Early French to nineteenth-century conditions: Cork Cathedral (1865–83), for example (pl. IV); or Knightshays, Devon (1869–73). Those who felt like him, round about 1862, were Street, Clutton, E. W. Godwin, Goldie, Seddon and Slater; *early* Nesfield, Shaw, Pearson and Bodley; and (peripherally) Somers Clarke and R. J. Withers.[19] Butterfield and Woodyer stayed aloof. All in all, the bulk of the rising generation now looked to Early French—monochrome, primitivistic, muscular, archaic—not as a model for 'slavish reproductions', but simply as a point of departure.[20] Seddon at the future University College, Aberystwyth (1864–90),[21] Bentley at St Francis of Assisi, Notting Hill, London (1861),[22] Withers at the Municipal Buildings, Cardigan (*c.* 1856),[23] Street at St Philip and St James, Oxford (1859–65)[24]—all these demonstrated the power and flexibility of the new fashion. Of course Early French was seldom used in pure and simple form. Especially in secular works, it merely formed the *basis* of a style, mixed with Italian, English, and—in Burges's case—even with Islamic elements. It was the framework for a new eclecticism.

The progress of this new fashion—first ecclesiastical, then secular: Early French supplementing Italian Gothic—accelerated during the 1860s. 'Just now in secular buildings', noted James Thorne at the end of 1861, 'our younger architects are all aiming to produce something Venetian, Florentine, or, at any rate, Italian Gothic.'[25] In ecclesiastical architecture the situation was rather different. 'Everything Gothic done at this moment is French', complained one correspondent in the *Builder* of 1863, '... or would-be French'.[26] Three years later, both English and Italian Gothic had been quite eclipsed: 'No one speaks of *Vernacular Gothic* now. We have changed all that. We get our churches as we get our farces—from France.... The churches not only are foreign, but, somehow, they look so ... they won't assimilate with their surroundings.... [A fashionable church interior may be] rather trying to the nerves of one who has not matriculated in the new school of ecclesiological design; but [such things] raise to ... heights of ecstasy the minds of adolescent ecclesiastics.'[27] When it came to the great Law Courts competition of 1867, Early French was certainly in the ascendant. Led on by Burges and Seddon—'Young Gothland'[28]—the architectural profession had eagerly diluted Ruskin with copious draughts of Viollet-le-Duc. Everywhere, in town and country alike, there was the mark of the new trend: the *ogival primitif*.[29] And the earlier French the better: some even thought Chartres 'a little too late'.[30] Of course, there were protests. Early French Goths—like their Pre-Raphaelite friends—seemed almost addicted to ugliness. 'Crude Art of all kinds is very much in fashion just now', noted the *Architect* in 1871. 'The learned professors of the twentieth century [will conclude with] astonishment [that this is] the first time in the history of Art [when] crudity has been directly and laboriously sought out for ... its own ... sake.... Never before ... has refinement been positively discountenanced as imbecility. [All the arts are suffering from this] self-denial of taste, [this cult of]

severity ... archaism and ... asceticism. [Such a] preference for the Crude [is understandable as a reaction against Regency taste, a revolt against Picturesque composition and] the principle of the fictitious. ... But ... how far is it to go?'[31]

Besides Burges, who were the evangelists of Early French? In France they were three members of the Didron family—Adolphe, or Didron the Elder, founder and editor of *Annales archéologiques*;[32] his brother, the publisher Victor Didron; and Adolphe's adopted son Edouard. These three together played the educative and controlling role of the Ecclesiologists in Britain; and they paved the way for the greatest of French Goths, Viollet-le-Duc. It was the elder Didron in particular who gave the Early French movement its first major triumph when he made sure that Lille Cathedral would be built in the style of thirteenth-century France.[33] 'All so-called modern designs', he announced, 'will be rejected out of hand. Nor will Romanesque, which is but an embryonic form of Gothic, or the fourteenth and sixteenth-century styles, which are a morbid and moribund form, be acceptable; the only, I repeat only, style that is desired is thirteenth-century, pure and powerful.'[34] In other words, what Geoffrey Scott later called the Biological Fallacy had been shifted one stage backwards, from fourteenth-century Decorated to thirteenth-century Early French.

Annales archéologiques began publication in 1844, two years after the *Ecclesiologist*, and ceased in 1870, again two years after its rival.[35] From the start, however, its emphases were very different. Its chosen field was thirteenth-century rather than fourteenth-century; its expertise was symbolism rather than liturgy. Its interests were not only architectural but decorative: the minor arts—metalwork, needlework, tiles, enamels, woodcarving—these were all treated seriously and at length. Above all, it was Catholic, not Anglican. Monstrances, thuribles, chrismatories and reliquaries were all permitted. Viollet-le-Duc and Lassus[36] were among the earliest contributors. The Abbé Texier[37] and Felix de Verneilh[38] wrote regularly in the 1850s and 1860s. Pugin and Willement were subscribers from the start. So was J. H. Parker of Oxford. So were antiquaries like Thomas Stapleton, Albert Way, Thomas Wright and Roach Smith. Before long Whewell and Willis of Cambridge were on the subscription list along with Beresford Hope. Publications were exchanged, information shared. The *Annales* carried regular commentaries on the state of medieval studies in England.[39] In a sense, the movement of the *Ecclesiologist* towards thirteenth-century Europe, and away from fourteenth-century England, was a measure of the influence and success of its French rival.[40] Beresford Hope's progression is typical: he begins as a Puginian apostle of 'the real thing', and ends as the Pope of eclecticism.

Like the *Ecclesiologist*, Didron's *Annales* were essentially ecclesiastical. For secular Early French precedents the most influential publicist was undoubtedly Eugène Viollet-le-Duc. Burges made no secret of his admiration for Viollet-le-Duc, at least as regards the Frenchman's scholarship. He regarded the *Dictionnaire*—'that wonderful monument of human knowledge and human industry'[41]—as quite invaluable. The speed of research and illustration amazed him.[42] The woodcuts were *tours de forces*.[43] However, 'he draws too well for a practical architect', Burges complained, 'for a man who has this fatal gift makes his designs look so well on paper', that they far outshine the final result.[44] Burges regarded an architectural drawing as essentially a diagram—in the medieval manner. Burges was also critical of Viollet's *Entretiens*: he thought the woodcuts 'excellent', but the essays 'long-winded' and some of the theories about geometrical composition positively pernicious.[45] He certainly felt little sympathy with Viollet's fantasies of metallic vaulting.[46] Nevertheless, Viollet's

volumes were really Burges's Bible. 'We all crib from Viollet-le-Duc', he admitted disarmingly, 'although probably not one buyer in ten ever reads the text.'[47] Burges's final judgement on Viollet-le-Duc, delivered in public at the R.I.B.A., was characteristically candid: he was a great scholar, an average architect, and a disastrous restorationist.[48] Posterity has endorsed his verdict.

In one respect, however, Burges—like most of his contemporaries—underrated Viollet-le-Duc's importance: he underplayed the Frenchman's pursuit of architectural rationality. By the 1860s Viollet-le-Duc was convinced that architecture in its traditional form was dying. The historicist process had produced mere simulacra: 'bodies without souls, the fragments of some departed civilization, a language incomprehensible even to those who employ it.'[49] Unlike Pugin, Viollet-le-Duc conceived of Gothic as a tectonic system independent of religion. Unlike Ruskin, he envisaged an evolving language of architectural form based on—but ultimately independent of—the structural aesthetics of medieval Gothic. When Pevsner came to trace the origins of the Modern Movement, he, too, devalued Viollet-le-Duc. Pevsner's thesis was almost a case of 'Hamlet without the Prince', Summerson remarked; for 'Viollet-le-Duc ... was the alchemist who produced a workable concept of rational architecture out of romantic archaeology'.[50]

Now Viollet-le-Duc's aesthetic was in many ways the opposite of Ruskin's. Ruskin was chiefly concerned with surface—expression, symbol, association;[51] Viollet-le-Duc was concerned, above all, with structure. In the first edition of the *Seven Lamps* (1849), Ruskin maintained that ornament must be subordinate to architecture. In the second (1855), this position was reversed. 'It gradually became manifest to me', he explained, 'that the sculpture and painting were, in fact, the all in all of the thing to be done; that these, which I had long been in the careless habit of thinking subordinate to the architecture, were in fact the entire masters of the architecture; and that the architect who was not a sculptor or a painter, was nothing better than a framemaker on a large scale ... what we call architecture is only the association of [sculpture and painting] in noble manner, or the placing of them in fit places. All architecture other than this is, in fact, mere *building*; and though it may sometimes be graceful ... or sublime ... there is in ... it no more assertion of the powers of high art, than in the gracefulness of a well-ordered chamber or the nobleness of a well-built ship.'[52] Now the aesthetics of ship-building—fitness for practical purpose—held a perennial fascination for Gothic revivalists, from Pugin, through Webb, to Lethaby. Structure meant much to Burges, too, but Burges became, in fact, a Ruskinian despite himself: he became an art-architect. Not so Viollet-le-Duc.

But apart from a few big names—Lassus, Didron, Viollet-le-Duc: 'that brilliant knot of art-writers', as Beresford Hope called them[53]—it was not the French who led the field in pursuit of Early French, but the English: Burges, Clutton, Street, Norman Shaw, W. E. Nesfield, R. J. Johnson, T. H. King and W. Galsworthy Davie.

Clutton's *Domestic Architecture of France ... from Charles VI to ... Louis XII* (1853), for which Burges supplied several drawings, could only loosely be categorized as Early French: it was concerned with fifteenth-century work, and by 1852 fifteenth-century French domestic architecture already seemed 'comparatively debased'.[54] Clutton's book, however, was well received in France.[55] So was Norman Shaw's *Architectural Sketches from the Continent* (1858). But this time the sources of inspiration had been firmly pushed back to the thirteenth century. And the plates themselves—unlike Clutton's—are expository rather than illustrative. They lack,

however, the diagrammatic clarity of Burges's own *Architectural Drawings* (1870).

Nesfield's *Specimens of Medieval Architecture* (1862) covered much the same ground.[56] So did Johnson's *Specimens of Early French Architecture* (1867)[57] and Galsworthy Davie's *Architectural Sketches in France* (1877).[58] These concentrated on buildings of around 1200 in the Île-de-France and Champagne. J. L. Petit's *Architectural Studies in France* (1854) had done the same for Romanesque churches of the south-west. But none of these was nearly as popular as the works produced by Thomas Harper King. King was almost the John Britton of this post-ecclesiological phase of the Gothic Revival: the man who brought Early French to the drawing-boards of a whole generation. An English Catholic convert, King spent most of his life in Bruges, translating Pugin into French and collecting drawings for publication. His four-volume *Study Book* (1858–68), contained a mass of examples, all carefully drawn to a uniform scale.

Such were the principal published sources for Early French. As a short-cut, Burges recommended the following: Willis on the east end of Canterbury; Parker on Glastonbury and the great hall at Oakham; Viollet-le-Duc on Poitiers, Angoulême, Arles, Vezeley and Moissac.[59] But any 'thirteenth-century man' worth his salt would undoubtedly go on pilgrimage himself, to Normandy, to Picardy and to the Île-de-France: Bayeux, St-Quentin, Amiens, Noyon; to Charters, Notre-Dame in Paris, Soissons, Rheims—the cathedral *and* the church of St-Remi—to Laon, Châlons-sur-Marne and Beauvais. Those were the high points of Early French, singled out, for example, by George Edmund Street.[60] 'The stern, solemn majesty of Laon', Street concluded, 'is just what we modern men ought to . . . impress ourselves with.'[61]

NOTES

[1] Hope to Webb, 1859: H. W. and I. Law, *The Book of the Beresford Hopes* (London, 1925), 177.

[2] The *Ecclesiologist*, xx, n.s. xvii (1859), 185; A. J. Beresford Hope, *The English Cathedral of the Nineteenth Century* (London, 1861), 234–5.

[3] In O. Shipley (ed.), *The Church and the World* (1868), 581. 'I do not for one moment wish to deny the wonderful massiveness, beauty, and strength of the larger Italian works . . . but the details of Italian Gothic are worse than useless. For the most part they are executed in marble, which requires just as different a treatment to stone as stone does to brick'—whereas 'modern Italian Gothic' confounds the mouldings of all three (the *Builder*, xxv (1867), 386). 'I shall never forget my horror on coming upon a Venetian bank in freestone, in a quiet, dull cathedral town [National Westminster, Wells?]—it was simply an impertinence, and one felt all that even Mr. Warington Taylor might be supposed to feel under the circumstance' (*Building News*, xii (1865), 606).

[4] The *Ecclesiologist*, xxii, n.s. xix (1861), 354; xxiii, n.s. xx (1862), 16. He had previously made much of the adaptability of Italian Gothic (e.g. *ibid.*, xvi, n.s. xiii (1855), 299–305).

[5] Plans and correspondence, United Society for the Propagation of the Gospel Archives, and Victoria and Albert Museum, P. & D., Q.4 b.; Hope, *op. cit.* (note 2), 91; R. P. Pullan, *Architectural Designs of William Burges: Stonework* (London, 1887), 1–7. For details, see J. M. Crook, *William Burges and the High Victorian Dream* (London, 1981), 175–9.

[6] In Shipley, *op. cit.* (note 3), 582.

[7] The *Ecclesiologist*, xxiii, n.s. xx (1862), 336–7.

[8] 'Foliage came to be copied directly from Nature, but with an instinctive sense of the necessity of adapting it to the structural purposes which is very remarkable. In a capital, for instance, though the detail was natural, the arrangement of the natural forms was strictly architectural. In a spandrel, where it was simply meant for ornament, an absolute imitation of Nature is allowable, and was freely indulged in. . . . Everywhere the work of the sculptor is called in to adorn the work of the architect, and so harmoniously is this done that no one can tell where the office of either began or ended' (G. E. Street, 'Thirteenth-Century Architecture: France', Royal Academy lecture, 28th February 1881; *Memoir*, ed. A. E. Street (1888), 420–1).

[9] G. E. Street, *Unpublished Notes and Reprinted Papers*, ed. G. G. King (New York, 1916), 317–29.

[10] *Building News*, xii (1865), 606. Street noted that in English thirteenth-century Gothic, 'sculpture plays a remarkably subservient part' ('Thirteenth-Century Architecture: England', Royal Academy lecture, 3rd March 1881; *Memoir*, ed. A. E. Street, 433).

[11] The *Builder*, xxv (1867), 386. As an example of the superiority of Early French—as a model—over Early English, Burges cited one architect's work in Oxford (Early French) and the same architect's work in Bishopgate, London (Early English). See *Building News*, xii (1865), 606.

[12] Before the reign of King John, France and England were one empire, with one architectural style. After that date, England 'drifted into a distinctive architecture ... with its conventional three-foil foliage, its lancets, its triplets, its round abaci, and its reedy mouldings. ... We find no height in the churches; on the contrary, they are low, and have long and irregular plans. They are admirably suited to small towns and for small, pretty landscapes. ... The mouldings are always very small, so are the window spaces ... [until] at last we come to such productions as the West front of Windsor Chapel Royal—a most dreary specimen of architecture. ... We have nothing like the great Town Halls of Flanders, and our cathedrals are very second-rate affairs after those on the continent' (the *Builder*, xii (1865), 577, 605). In later years Street, however, came to prefer the interior of Exeter to Amiens ('Thirteenth-Century Architecture: England', Royal Academy lecture, 3rd March 1881: *Memoir*, ed. A. E. Street, 430).

[13] The *Builder*, xix (1861), 403. For comparison, cf. E. Sharpe's lectures on 'Early French', *Building News*, xxvii (1874), 745, 790–4. Burges is here echoing Beresford Hope, *op. cit.* (note 2), 45.

[14] The *Ecclesiologist*, xx, n.s. xvii (1859), 332–3.

[15] G. B.-J[ones], *Memorials of Edward Burne-Jones*, I (1904), 113–14.

[16] *R.I.B.A. Trans.* xxxiv (1884). See N. Pevsner, *Some Architectural Writers of the Nineteenth Century* (Oxford, 1972), 296.

[17] *Dictionnaire*, II (1854), 309.

[18] Cited in G. German, *The Gothic Revival in Europe and England* (London, 1972), 163.

[19] C. L. Eastlake, *A History of the Gothic Revival* (1872), ed. J. Mordaunt Crook (Leicester, 1978), 328.

[20] *Building News*, xii (1865), 605–6.

[21] *Building News*, xiii (1866), 870–1; *R.I.B.A. Papers*, 1870–1, 148; Eastlake, *op. cit.* (note 19), no. 253. Designed originally as an hotel.

[22] *Ibid.*, no. 209.

[23] *Building News*, vi (1859), 830, 840; the *Builder*, xiv (1856), 661, and xvii (1859), 486.

[24] The Oxford Architectural Society (i.e. E. A. Freeman) disliked its 'foreign ... horizontalism' and 'frightful' polychromy (the *Ecclesiologist*, xx (1859), 418; *Oxoniensia*, iv (1939), 187); the Cambridge Camden Society (i.e. Hope) admired its 'original' approach as an 'eclectic development' (*ibid.*, 390).

[25] *Companion to the Almanac* (1862), 279.

[26] The *Builder*, xxi (1863), 447.

[27] *Ibid.* xxv (1867), 146–7.

[28] *Ibid.* xxvi (1868), 140.

[29] *Ibid.* xxvii (1869), 233–4.

[30] J. J. Stevenson, R.I.B.A. Conference, 1874 (the *Architect*, xi (1874), supp. 9).

[31] 'Crude architecture', the *Architect*, vi (1871), 1–3.

[32] Obit. *Ann. arch.* xxv (1865), 124, 377–95. He edited the first 25 vols.

[33] Burges on Didron, *Building News*, xv (1868), 31.

[34] *Ann. arch.* xiv (1854), 385. Competition drawings, Lille Diocesan Archives, and R.I.B.A. Details: *Ann. arch.*. xvi (1865), and the *Ecclesiologist*, xvii, n.s. xiv (1856), *passim*.

[35] 'Avis', *Ann. arch.* xxvii (1870), 409.

[36] Obit. *ibid.* xvii (1857), 307–13.

[37] Obit. *ibid.* xix (1859), 314–27.

[38] Obit. *ibid.* xxiv (1864), 324–9.

[39] e.g. Daniel Rock, 'L'archéologie catholique en Engleterre' *ibid.* xi (1851), 137–41; [Great Exhibition publications] xi (1851), 292–316; Beresford Hope, 'L'art religieuse en Engleterre', xiii (1853), 332–7, and his obituary of R. C. Carpenter, xv (1855), 207–8.

[40] In 1850 Didron correctly predicted that English architects would abandon the fourteenth century and go back to thirteenth-century models (*ibid.* x (1850), 283–4). In 1851 he noticed that even Pugin was 'moving towards the thirteenth century, although too slowly for our liking' (*ibid.* xi (1851), 292–4).

[41] In Shipley, *op. cit.* (note 3), 582.

3

[42] 'When we consider not only how much he writes, but the knowledge, and, above all, the research involved in what he writes, his productions become simply wonderful. Had he only lived some five centuries back, the German critics would most certainly have discovered that there were at least three distinct Viollet-le-Ducs . . . if he had not got three heads and three pairs of hands, at least he ought to have them' (*Gentleman's Mag.* ccxv (1863), 675).

[43] e.g. the upper part of the pediment of the central portal at Rheims, or the hourds applied to the upper part of the Donjon at Courcy.

[44] *Gentleman's Mag.* ccxv (1863), 6. Perhaps Burges was thinking of his old master Blore: 'one of the most minute and beautiful architectural draughtsmen that the world has ever beheld', but an architect whose works often disappoint in plan, silhouette and detail (Burges, *Art Applied to Industry* (1865), 110).

[45] *Gentleman's Mag.* ccxv (1863), 677.

[46] *Viollet-le-Duc* (Grand Palais, Paris, 1980), 248–59.

[47] *Building News*, xii (1865), 115. See also *ibid.*, xii (1865), 225.

[48] The *Builder*, xxxi (1873), 1001, following a paper on Pierrefonds by Phéné Spiers. Burges's criticisms were supported by Horace Jones, Benjamin Bucknall and C. F. Hayward.

[49] *Entretiens sur l'architecture*, Discours x, trans. B. Bucknall (1877), pt. 1, 466 *et seq.*

[50] *R.I.B.A. Journal*, lv (1947–48), 515; 'Viollet-le-Duc and the rational point of view', *Heavenly Mansions* (London, 1948), 135–58. For a structuralist interpretation, see H. Damisch and P. Bouden in *Viollet-le-Duc* (Architectural Design Profile, 1980).

[51] For Ruskin's definition of 'surface Gothic', see *Works*, ed. E. T. Cook and A. Wedderburn, x, 261–2.

[52] *Ibid.*, viii, 10–11.

[53] Hope, *op. cit.* (note 2), 45. For contemporary French examples of Early French, see *Gazette des architectures et du bâtiments*, n.s. iii (1865), 69, and iv (1863), 310–14.

[54] *Arch. J.* x (1853), 264. Clutton specifically disclaimed any absolute excellence in the domestic architecture of fifteenth-century France: 'I by no means consider it either as the very best development of the domestic art of the Middle Ages, [nor do] I wish to recommend it as a perfect model for imitation' (Clutton, *Domestic Architecture of France* (1853), 63).

[55] *Ann. arch.* xiii (1853), 280.

[56] e.g. Amiens, Bayeux (Armoire), Bourges, Châlons, Chartres, Coutances, Laon, Montreale in Burgundy, Noyon, Sens, Vezelay. Nesfield also offered a few Italian models, e.g. Orvieto, Padua, Pisa, Viterbo (fountain).

[57] *Building News*, xxxiii (1877), 610–11.

[58] Although dedicated to Butterfield, it was really Burgesian in inspiration, with detailed studies of carvings and mouldings drawn from the usual thirteenth-century French prototypes. The Bayeux armoire also appears (pls. 8–9). There was a copy in Burges's library.

[59] *Building News*, xii (1865), 605–6.

[60] The *Ecclesiologist*, xix, n.s. xvi (1858), 362–72; xx, n.s. xvii (1859), 18–26, 91–100, 178–84, 322–40. He also adds, Rouen, Meaux, Troyes, Montes, St-Lou, St-Germer (which he especially admired), Senlis, St-Étienne at Beauvais, Fécamp, St-George de Boscherville, Limay, Gassiecourt, Champagne, Bourges, Seez and Coutances. Street expressed the credo of 'a thirteenth-century man' with a passion equal to Burges. In 1858 he praised thirteenth-century Gothic for its 'energy, life, purity of form and colour, and rigid truthfulness in the treatment of every accessary in every material'. Then he adds: 'Who that really has worked heartily at his work will venture to deny that in stonework and the science of moulding; in sculpture—whether of the figure or of foliage; in metal-work—whether iron or silver; in embroidery, in enamelling, and in stained glass, the northern art of the thirteenth century is infinitely more pure, more vigorous, and more true than the work of later times? . . . its great lesson to us is that of earnestness and reality . . . just the kind of earnestness which will enable men possessed of its principles to grapple with the difficulties of nineteenth-century inventions and thoughts in the most real and simple manner—just the kind of art which will impress itself upon a practical age like the present' (the *Ecclesiologist*, xix, n.s. xvi (1858), 240). It was, moreover, a style equally applicable to secular and ecclesiastical purposes: 'in those good days there was no distinction [in quality or even in form] between domestic architecture and ecclesiastical. . . . This is the lesson of the thirteenth century' (Royal Academy lecture, 3rd March 1881, *op. cit.* (note 10). For Street's 1855 tour notebook, see Street, *op. cit.* (note 9), 99–126.

[61] *Ibid.*, 172. Beauvais he found rather too 'coarse' (*ibid.*, 151).

Victorian Sculpture and its Sources[1]

Benedict Read

In certain respects sculpture has its own rules and conventions as an art, and with respect to its sources in the Victorian period—particularly the earlier Victorian period—this was peculiarly so. The decades around the year 1800 featured the cultural phenomenon usually known as Neo-Classicism, whose main thrust was a reference to Greece and Rome in various forms. The main surviving moveable relics of antiquity on which such reference could be made consisted of sculpture, and Britain as well as other countries in Europe revelled in genuine original pieces of classical sculpture, the climax coming in this country in 1815 with the acquisition by the nation of the Elgin Marbles, now in the British Museum. Because of this unique degree of presence and immediacy of such relics, the art of sculpture's bias to the classical was particularly strong at this time, and persisted in Britain with force and without serious rivalry from other stylistic polarities through the early and middle decades of the nineteenth century.

In addition to the influence of the formal language of classical art, certain ideas arose from and were reformulated by the new experience of antiquity. Thus the idea of public commemoration in sculptural form, which increased spectacularly when the Napoleonic Wars provided numerous casualties to be memorialized, must have received much backing from a perusal of Pausanias' description of an Ancient Greece studded with public statues. The combination of classical ideas and form may have produced somewhat startling results—see Thomas Banks's 'Captain Burges' of 1802 in St Paul's Cathedral, London, where classically derived heroic nudity and à modern military subject are not entirely happily married. But the strength of this classical tradition in sculpture is illustrated by the position held by John Gibson in Victorian sculpture. He spent most of his life in Rome holding forth on the unquestionable superiority of The Antique until his death in 1866. Concrete examples of his credo include the national memorial to Sir Robert Peel of 1852 in Westminster Abbey (pl. V*a*). The toga-clad figure of the first merchant-class Prime Minister in a Gothic setting may seem inappropriate—indeed the whole idea of representing a public

59

figure as 'Cicero in his nightshirt' was criticized, but Gibson and others claimed that for sheer timelessness there was no substitute for the sculptural language of Greece and Rome. Gibson's Royal Academy Diploma Work of 1838, in other words his formal demonstration to his colleagues of the qualities of his art, is called 'Narcissus', an entirely naked youth whose subject is justifiable in terms of the Antique myth the figure impersonates. Nevertheless, Gibson himself offered an additional defence by claiming that this work was based on observed Nature—in other words the union of Classicism and Nature was the summit of art (in his view).

It was part of Gibson's belief—and one shared by others—that the Ancients coloured their sculpture, and not just the architectural sort. The latter aspect was debated intermittently during the 1830s and 1840s, but it was not until the 1850s that Gibson produced his spectacular demonstration of the principles of polychromy, the 'Tinted Venus' of 1851–6. This has really to be seen to be believed (at the Sudley Art Gallery in Liverpool). Her hair, eyes, lips, jewellery and (occasional) clothing are all coloured, while the main areas of the body are not white, but waxily flesh-coloured marble. This may all seem unbelievable, but Gibson claimed theoretical backing from antiquity. And in the 1950s, a century later, a vindication of his beliefs and practice was uncovered at Pompeii, a marble Aphrodite, hair, eyes, flesh, etc., all tinted, even down to the use of gold leaf for highlights, a device Gibson had also employed.

Other sculptors than Gibson also used the repertory of the Antique, though not necessarily in so blatant and determined a fashion. John Graham Lough's 'The Elder Brother from Comus' of 1856 (pl. V*b*), one of a series of statue subjects from British literature in the Egyptian Hall, Mansion House, London, is a modern—as opposed to an ancient—subject, drawn from Milton; formally, though, it is simply and basically the Apollo Belvedere in reverse.

By contrast with neo-classical sculpture, neo-Gothic is rather surprisingly infrequent, and when it does appear is rather unspecific in relation to original sources. The architect C. R. Cockerell, when writing in 1851 on the sculpture of Wells Cathedral, comments on the neglect of medieval sculpture versus the enthusiasm for its architecture, 'repudiating the speaking statue, while we invest the dumb edifice with hallowed imagination'. It is true that much original source material for sculpture had through various historical circumstances disappeared—there is nothing easier than toppling idolatrous statues in an outburst of frenzied religious vandalism, whereas a building could still retain some usefulness. For the major Victorian programme of neo-Gothic sculpture at the Houses of Parliament, we know that Barry sent his chief stonecarver, John Thomas, off to Belgium to look at late Gothic town halls. But few of these retained, if they ever had, much statuary; major examples like Oudenarde and Leuven only received their complement later in the nineteenth century, and Thomas's inspection must have been to get a general impression, in particular of the carved stone ornamental sculpture. For particular figures in Thomas's vast assembly of kings and queens on and in the building, historical sources (not necessarily sculptural) would be available for, say, a likeness of Queen Anne. But there was next to nothing that could serve for the medieval monarchs, only Queen Eleanor possibly offering in the records of the medieval Eleanor Crosses a faint image to serve for the others.

Pugin had his own sources for the sculptural elements featuring in his work on the furniture and fittings at the Houses of Parliament, for instance the House of Lords throne. Here, and indeed generally in his own work, Pugin referred to and sometimes

PLATE V

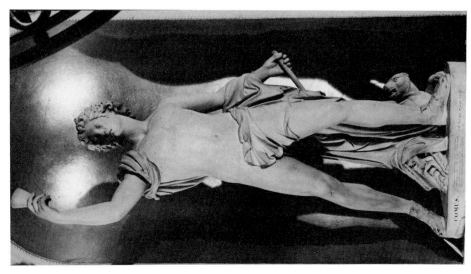

b. John Graham Lough, 'The Elder Brother from Comus', Egyptian Hall, Mansion House, London (1856)

a. John Gibson, Sir Robert Peel, Westminster Abbey (1852)

Photographs: Courtauld Institute of Art

PLATE VI

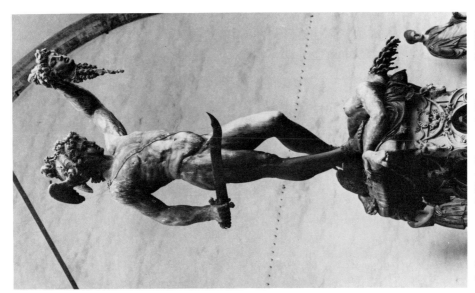

b. Benvenuto Cellini, 'Perseus', Florence (1533)

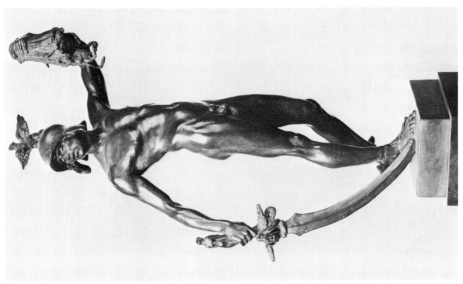

a. F. W. Pomeroy, 'Perseus', Laing Art Gallery, Newcastle upon Tyne (1898)

Photographs: Courtauld Institute of Art

incorporated items of genuine fifteenth-century Continental sculpture (e.g. as at Oscott). It is interesting that this Puginian context may have contributed to an element of Pre-Raphaelite sculpture, in that Alexander Munro, Rossetti's friend and P.R.B. associate, had worked at the Houses of Parliament in Pugin's woodcarving department. And I believe that in that Munro's 'Paolo and Francesca' of 1851 (Birmingham, City Art Gallery) displays a 'Pre-Raphaelite', that is pre-Renaissance, 'early' style, a sculptural equivalent to Pre-Raphaelitism in painting, it may be based on Pugin's practice, with its sources in original Gothic material.

It is *de rigueur* to mention Alfred Stevens when dealing with Victorian sculpture, although I have the temerity to hold a rather different estimation of his position than is normally assigned; an argument can be put forward that he was basically a glorified interior decorator with an (in the circumstances) unusual commitment to sculpture. He is, though, interesting for his sources. In the two main allegorical groups in his Wellington Monument (St Paul's Cathedral, London), namely 'Truth Overcoming Falsehood' and 'Valour and Cowardice', while there is a clear general derivation from Michelangelo for the forceful poses and modelling, the actual vocabulary of 'Truth Overcoming Falsehood', one figure plucking out the tongue of another, is drawn from medieval imagery, one of a series of small voussoir figures around the doorway into the Chapter House at Salisbury Cathedral, which we know Stevens drew, in fact to illustrate lectures by C. R. Cockerell. There are mixed elements, too, in the derivation of the overall design of the monument: various Italian Renaissance sources have been suggested (the Scaliger tombs at Verona, for instance), but these are at best generalized prototypes. More exact sources for the type of mixed architectural structure and sculptural figure work can be found in such works of the English Renaissance as the Monument to Mary Queen of Scots at Westminster Abbey of *c.* 1602–12.

In the last quarter of the nineteenth century a different outlook became apparent in sculpture, particularly with regard to materials, techniques, scale and subject matter. Bronze statuettes, uniquely cast in the lost-wax method, automatically conjure up new images of source material, particularly in the work of Italian Renaissance masters such as Giovanni da Bologna. Certainly, outstanding works like Alfred Gilbert's 'Perseus Arming' (1882) and 'Icarus' (1884) contain a general reference back to Italian work of the sixteenth century, though we should remember (particularly with Gilbert, who spent some time in Paris early in his career) that there was a flourishing school of French neo-Renaissance sculpture that precedes the English, as typified by Antoine Mercié's 'David Vainqueur' of *c.* 1872. But Gilbert's 'Eros' of 1886–93, familiar to most, I hope, from its position in Piccadilly Circus, clearly owes much to Giovanni da Bologna's 'Mercury', while, slightly later, F. W. Pomeroy's 'Perseus' of 1898 (pl. VI*a*) is indebted to the 'Perseus' of Benvenuto Cellini of 1533 (pl. VI*b*). It is obviously far from a straight copy; there is about the Pomeroy a quality of *fin-de-siècle* decadent sensuousness of body, let alone ecstatic pleasure in feature, that speaks its age as clearly and distinctly as Cellini's rumbustiousness does his.

Alfred Gilbert, without much doubt the greatest of all the Victorian sculptors, became, as he matured, more complex in his use of the art of the past. His magnificent Clarence Memorial at Windsor (basically of 1892–9) has had various sources assigned to it—German Renaissance (Vischer), Italian Renaissance (Torrigiano), and others. But when we come to a work of such formal and aesthetic richness, sources, if identifiable, are really becoming slightly irrelevant; it is more what the artist makes of

the work that should be of interest. However, that Gilbert did look widely and perceptively at other sculpture can be seen in such works as his seated marble figure of 'Joule' in Manchester Town Hall of 1893, where a small detail like Joule's dangling slipper clearly echoes a similar feature in Roubiliac's 'Handel' of 1738. Here peer speaks to peer—good artists borrow, great artists steal, and there is no lessening of stature if they get rumbled.

I do not wish in any way to end on a sour note, but a final serious question must be asked in the context of sources of Victorian sculpture. To put it simply, what has all this to do with the mainstream of Victorian sculpture? In essence, I think, and with certain notable exceptions that we have seen, the answer is, not a lot. When E. H. Baily did a bust of the Prince Consort in 1841, it may well have been that Baily was the principal pupil of Flaxman, the great British sculptor of the neo-classical movement. It may have been that Baily dressed the Prince Consort in classical gear and thus created an image we should associate with previous representations of rulers and heroes going back to Pericles or Hercules. But this was a context that became less and less emphatic in the full flood of Victorian portrait busts, which became more and more generalized and unspecific until a uniform contemporary setting prevailed. This was also particularly true with public statues, where, in spite of Gibson's strict neo-classical stand and an at best very general reference back to antiquity for the basic idea, a new situation arose that was without precedent, the commemoration of contemporary heroes to an extent not previously known, and in contemporary terms—the Peels, Wellingtons, Alberts and so on that proliferated over Victorian cities and towns from the 1840s to beyond the turn of the century.

In this context there was no true parallel in sculpture to the architectural debate, in what style shall we build? The sculptors saw a modern situation requiring a modern solution, and it is their relative incoherence that is responsible for the absence of any notable debates; indeed, it could be said that the only live issue involving Victorian public statues revolved around the tightness of the trousers of those represented. This left, though, scope for some true scuptural talents to emerge, unfettered, if you like, by too much reference to the past, let alone other theorizing. Foley's 'Viscount Hardinge' of 1858 may owe something ultimately to Donatello's 'Gattamelata', but it was the force and power of the contemporary image that gave rise to its acclaim as the greatest equestrian figure of the age. Woolner's bust of Tennyson of 1857, like most of his portrait busts of eminent Victorians, represents the sitter with a truly Pre-Raphaelite degree of Truth to Nature—both the physical resemblance and the character are recorded for all time. We should really judge Victorian sculpture on its inherent terms, as here, where the art has achieved a separate dimension from its sources.

NOTE

[1] See further B. Read, *Victorian Sculpture* (New Haven and London, 1982).

The Albert Memorial

Nicola Smith

The Albert Memorial (pl. VII*a*) needs little introduction—it is one of London's most familiar landmarks as well as the best-known monument of the Gothic Revival. For sculptors it was the most prestigious commission of the whole Victorian period, and it presented an exceptional opportunity to display their talents on a grand scale. For the architect, George Gilbert Scott, it was a chance to design—and see to fruition—a public monument of such richness and splendour that parallels for it have to be sought in the jewellers' architecture of medieval shrines and altar canopies. Scott himself acknowledged this and some years later described his idea as being 'to erect a kind of ciborium to protect a statue of the prince ... designed in some degree on the principles of the ancient shrines'.[1] He went on to claim that 'this was an idea so new, as to provoke much opposition', but in this he was not so accurate, for although doubts and objections were raised against his scheme, these were on the whole concerned with the technical difficulties presented by the lavish enrichments, rather than with the fundamental concept. Indeed, the idea of a canopied monument enclosing a figure was not in itself original. The form had been established in Britain twenty years earlier with the monument to Sir Walter Scott in Edinburgh, but in 1850 it had fallen abruptly from public favour when canopied monuments were erected to commemorate two highly controversial figures, the Protectionist politicians Henry Handley and Lord George Bentinck.[2] The implication was broadcast that the 'protection' afforded by such structures in some way represented the politics of Protection and for ten years subsequently no memorials of this type were put up in Britain. From about 1860, however, the form crept back into favour, at first in minor provincial schemes,[3] but the most important precedent for Scott's design is another Albert Memorial—that in Manchester (pl. VII*b*). Although not yet erected when Scott was thinking up his scheme, the design, by Thomas Worthington, had already been published. The Prince Consort had died on 14th December 1861 and early in 1862 Worthington had been asked to produce a plan for a canopy to protect a Carrara marble statue of the prince by Matthew Noble which the Mayor of Manchester wanted to present to the city. He produced two alternative designs, one based on the Temple of the Winds at Athens and the other, which the committee decided to adopt, more or less identical to the monument as erected. This was published in the *Builder* on 8th

65

November 1862. Although the Manchester Albert Memorial was by no means the earliest canopied statue, the form was still unusual enough for the Bishop of Manchester to suggest to Worthington in 1863, when the competition for the National Memorial was imminent, that he should have an engraving published to establish his claim to be the first to design such a monument to the Prince Consort. Worthington replied that he did not think such a course of action worthwhile as 'a large number of photographs were in circulation'[4] and, furthermore, his design had been published in the *Builder*. He was, perhaps, unwise—the reputation of the Manchester Albert Memorial has been somewhat eclipsed by that of its more ambitious successor.

Scott's monument was not, however, the original choice of the committee appointed to take care of the scheme for the National Albert Memorial. Initially an obelisk had been planned—for this was what Prince Albert would have chosen for a momument to mark the site of the Great Exhibition of 1851—but it was felt that such an obelisk ought to outdo all previous examples and, of course, should be monolithic. It soon became apparent that it was going to prove impossible to quarry a large enough piece of stone, and the idea had to be dropped. In the meantime, innumerable suggestions for various kinds of monument had been put forward by the public. It had become clear, however, that a growing body of opinion was in favour of combining the memorial with something more practical. This could not be ignored and, in May 1862, when seven distinguished architects were asked collectively to put forward ideas, they were required to keep this in mind and to consider a memorial 'in connection with an institution of arts and sciences'. The architects agreed on little, apart from the site for the monument, and the next step was to consult them individually. Each was asked to produce designs both for a monument and for an 'institute', and to bear in mind the limit of the funds available—at that point, some £60,000.[5]

Queen Victoria considered their designs in Feburary 1863. There were only two which she thought were at all suitable and she reserved judgement between these until she had consulted her eldest daughter, Victoria, Crown Princess of Prussia, who was due to arrive in England later in the month. These two were those of Scott and of Philip Hardwick, who submitted a plan for a colossal gilded bronze statue on a pedestal carrying figures representing Peace, Art and Science, above a formal terraced garden with fountain pools and obelisks. Hardwick's was the only scheme submitted which could be carried out for the sum available—his estimate was £48,000. The Crown Princess evidently preferred Scott's design and it was duly selected. The only problem which remained was one of finance, as Scott's estimate was £110,000 for the memorial alone. The plan for the 'Hall of Science and Art' was therefore shelved, and it was left to private enterprise to realize this, as the Royal Albert Hall. Extra funds were still needed for the memorial, however, and it was not until Parliament voted £50,000 towards it in April 1863 that things could get under way.

Scott accompanied his design with a text outlining the reasoning behind it. He began by saying, 'I have not hesitated to adopt in my design the style at once most congenial with my own feelings, and that of the most touching monuments ever erected in this country to a Royal Consort—the exquisite "Eleanor Crosses".'[6] The Albert Memorial is an open canopy enshrining a single statue, unlike the Eleanor Crosses, which are solid structures incorporating several figures at a higher level, in niches. In the nineteenth century the term 'Eleanor Cross' was often used very loosely, to describe almost any free-standing Gothic monument, but Scott's use of the

PLATE VII

Photograph: Courtauld Institute of Art

b. Thomas Worthington, the Albert Memorial, Manchester

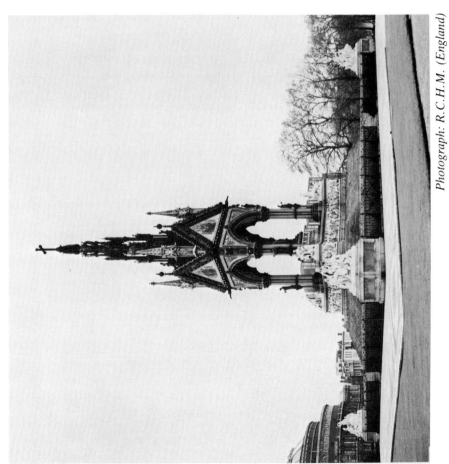

Photograph: R.C.H.M. (England)

a. George Gilbert Scott, the National Albert Memorial

PLATE VIII

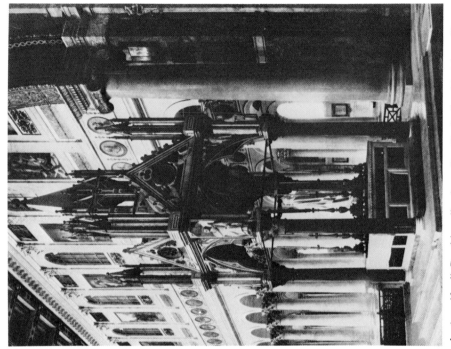

b. Arnolfo di Cambio, ciborium, San Paolo fuori le Mura, Rome

Photographs: Alinari

a. Andrea Orcagna, Shrine of the Madonna, Or San Michele, Florence

PLATE IX

b. Henri de Triqueti, effigy of the Prince Consort, Albert Memorial Chapel

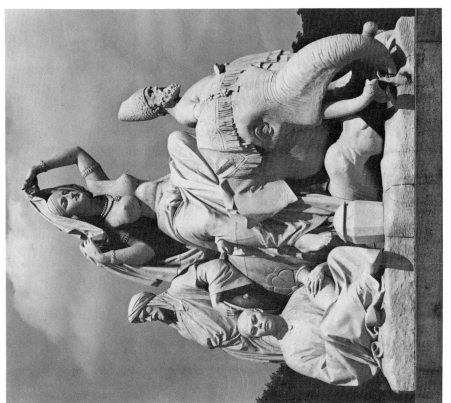

a. J. H. Foley, *Asia*, National Albert Memorial

Photographs: Courtauld Institute of Art

expression here is particularly misleading, because he was well known for designing that very type of monument and, when his text was published without an illustration,[7] people got quite the wrong idea about what was planned. Scott had made his name in 1840 as a result of winning the competition for the Martyrs' Memorial in Oxford with a design based on Waltham Cross, one of the three crosses surviving from the twelve put up by Edward I after Queen Eleanor's death in 1290. Scott had gone on to design other similar memorials, such as the monument to Mary Watts-Russell in Ilam, Staffordshire.[8] The historical parallels between Prince Albert and the much-loved consort of Edward I had led some people to propose that an Eleanor Cross would be an appropriate form for the Albert Memorial. The *Civil Engineer and Architect's Journal* had pointed out that this form was 'almost sacred to religious and marital memories' and suggested that 'Victoria of England might repeat ... for Albert of Saxony what Edward of England did for Eleanor of Castile'.[9] But whilst some people were pleased with the idea, others were disappointed to discover that, as a writer in the *Builder* put it, when 'wanting an Albert Memorial', the country was to be 'forced to take an Eleanor Cross'.[10] Scott continued the explanation of his design more accurately, declaring, 'The great purpose of an architectural structure, as a part of the Memorial, is to protect and overshadow the statue of the Prince. This idea is the keynote of my design, and my next leading idea has been to give to this overshadowing structure the character of a vast *shrine*, enriching it with all the arts by which the character of *preciousness* can be imparted to an architectural design, and by which it can be made to express the value attached to the object which it protects. The idea, then, which I have worked out may be described as a colossal statue of the Prince placed beneath a vast and magnificent shrine or tabernacle.'[11]

Not long after the selection of Scott's design, Captain Francis Fowke remarked on its resemblance to the fourteenth-century Shrine of the Madonna by Andrea Orcagna in the Or San Michele in Florence (pl. VIII*a*). They are certainly similar in general outline, but a much closer parallel seems to have passed unnoticed. The Albert Memorial is similar to the thirteenth-century ciborium by Arnolfo di Cambio in the church of San Paolo fuori le Mura in Rome (pl. VIII*b*), not only in its general form, but also in a number of telling details, such as the shape of the main arches and their cusping, the figures in the spandrels above, and the statues in little niches on the angles, above the capitals. Scott admitted in his *Recollections* (which appeared in 1879, after his death) that 'the form is the same' as 'the ciboria which canopy the altars of the Roman Basilicas', but he denied that it had been derived consciously.[12] This was probably a prudent assertion, because the use of altar canopies had recently become a controversial issue. In 1873 the church of St Barnabas, Pimlico, had been refused permission to erect an altar canopy (designed by Scott's former pupil George Edmund Street) as the opposition convinced the Consistory Court that 'the real object of that application was to ... erect a monument of Popish superstition'.[13] The decision was widely publicized and generally approved, so it would not be surprising if Scott wanted to play down his dependence on such a structure in the formation of his Albert Memorial scheme.

But what of the sculpture? All the sculptors were required to follow Scott's basic design, set out in models by Henry Hugh Armstead. Carlo Marochetti, who was working on the Prince's effigy for the Royal Mausoleum at Frogmore, was chosen by the Queen to carry out the main figure. Marochetti, however, was not happy about working within the confines imposed by Scott, and in any case he thought that the

figure should be an equestrian, rather than a seated, one. He made two models, neither of which was considered successful, and was working on a third when he died, suddenly, in 1867. The Queen hoped that this third model could be completed by another sculptor, but she was advised that it was not good enough and a personal visit to the studio confirmed this. No illustration of Marochetti's model is known to survive, but it is interesting that his seated figure of the prince at Aberdeen (which it may have resembled) was, among the two dozen or so public statues of Prince Albert, the only one to be severely criticized in the press—one reviewer describing it as 'oppressed by wardrobe and upholstery'.[14] The statue of the prince on the National Albert Memorial was eventually carried out by the Irish sculptor John Henry Foley. It shows Prince Albert wearing Garter robes and holding a catalogue of the Great Exhibition, and a squat effect is avoided by representing him leaning forward 'as if taking an earnest and active interest in that which might be supposed to be passing around him'.[15]

The theme of the frieze around the base of the monument was, as Scott himself admitted, derived from Delaroche's *Hémicycle des Beaux-Arts* in the École des Beaux-Arts in Paris.[16] Scott's arrangement 'avoids selecting either of the three commonly received fine arts (... Painting, Sculpture and Architecture) for the foremost place—but it places Painting and Sculpture on the two flanks united in front by Poetry as their *ideal* bond of union and by Architecture behind as their *material* bond of union'.[17] The frieze was carried out by Armstead and John Birnie Philip, and contains 169 figures. Enormous care was taken to achieve accurate portrait likenesses wherever possible—Armstead's surviving notebooks, with their meticulous copies of busts and engravings, are testimony to this.[18] Equal care went into the allegorical groups representing Continents at the four corners of the memorial, both in accurately delineating the various racial types and in making every detail have some symbolic significance. The allegorical references, however, are often laborious and obscure—for example the portrayal of Asia unveiling herself (pl. IX*a*) turns out to be 'an allusion to the important display of the products of Asia, which was made at the Great Exhibition of 1851'.[19] The *Saturday Review* remarked that Asia's action was more likely to suggest to the average spectator that the young lady was removing her dress for a dip in the Ganges.[20] The comment underlines the fact that even the allegorical figures were treated in a wholly straightforward way. Perhaps this was necessary in the case of the various racial types, but the other allegorical figures—such as Agriculture, Commerce, Manufactures and Engineering at the base of the canopy—are just as realistic. The Gothic style embraced so wholeheartedly in the architecture of the Albert Memorial was positively shunned in its sculpture. Many people still seem to have regarded Gothic sculpture in a way that their grandparents might have regarded Gothic architecture. The *Builder* even issued a warning with respect to the sculpture for the Albert Memorial, saying, 'We must have no working *down* to Medieval quaintness but a working up to the highest style of art .. : We must have no wilful distortion or studied incompleteness, but the best possible art that the century is capable of.'[21] John Clayton, who was responsible for the mosaics on the Albert Memorial, had the difficult task of adjusting his design away from the style of the architecture to harmonize better with the work of the sculptors, who, as he said, 'are perhaps necessarily avoiding all Gothicism of character'.[22] Whereas in architecture the choice was understood to be between various styles, in sculpture the choice was seen to be between stylized or realistic representation, and even when Gothic

forms such as the recumbent effigy were used, at this period it was in conjunction with a naturalistic portrait. Henri de Triqueti's effigy of Prince Albert in the Albert Memorial Chapel at Windsor (pl. IX*b*) is perhaps the most medievalizing sculpture of its date, and certainly a very rare, if not unique, example of an effigy of this period which represents a contemporary person in medieval armour; and yet even here the treatment of the figure is too naturalistic to be described as Gothic. What is Gothic is the compositional framework, and that is also true of the Albert Memorial, which on the one hand can be seen as the epitome of the Gothic Revival in architecture, but on the other hand poses the question as to whether there can be said to have been a parallel Gothic Revival in sculpture.

NOTES

[1] G. G. Scott (ed.), *Personal and Professional Recollections by the late Sir George Gilbert Scott, R.A.* (London, 1879), 225.

[2] The Handley Memorial in Sleaford, Lincolnshire, by William Boyle, and the Bentinck Memorial in Mansfield, Nottinghamshire, by T. C. Hine.

[3] For example, the monument to the poet John Leyden at Denholm, Roxburghshire (1861) and that to the Protestant martyr Bishop Hooper in Gloucester (1862).

[4] Thomas Worthington, Memories, unpublished typescript reminiscences.

[5] The committee of architects comprised William Tite, Sydney Smirke, Philip Hardwick, Matthew Digby Wyatt, T. L. Donaldson, James Pennethorne and Scott. Tite and Smirke declined to compete individually and so Charles Barry and his brother Edward Middleton Barry were invited to submit plans in their place.

[6] Royal Archives Add. I/17A.

[7] The *Builder*, xxi (1863), 276–7.

[8] See N. Smith, 'George Gilbert Scott and the Martyrs' Memorial', *J. Warburg & Courtauld Institutes*, xlii (1979), 195–206.

[9] *Civil Engineer & Architect's J.*, 1st April 1862, 94.

[10] The *Builder*, xxi (1863), 233.

[11] Royal Archives I/17A, reprinted in the *Builder*, xxi (1863), 276–7.

[12] Scott, *op. cit.* (note 1), 263.

[13] The *Builder*, xxxi (1873), 869.

[14] *Aberdeen Journal*, 21st October 1863, 8. For a fuller discussion of this and other Albert Memorials, see E. Darby and N. Smith, *The Cult of the Prince Consort* (London and New Haven, 1983).

[15] Royal Archives Add. H2/2398A, quoted in *Survey of London*, xxxviii: *The Museums Area of South Kensington and Westminster* (London, 1975), 162.

[16] See F. Haskell, *Rediscoveries in Art* (London, 1976), ch. 1.

[17] Royal Archives Add. H2/675, quoted in *Survey of London, op. cit.* (note 15), 163.

[18] They are in the Royal Academy of Arts, London.

[19] *The National Memorial to His Royal Highness the Prince Consort* (London, 1873), 59.

[20] *Saturday Review*, 13th July 1872, 51.

[21] The *Builder*, xxi (1863), 361.

[22] British Museum Add. MS. 38994, f. 53, quoted in *Survey of London, op. cit.* (note 15), 169.

The South Kensington Museum

John Physick, F.S.A.

Nikolaus Pevsner has written of the South Kensington Museum that its style is a Lombard Early Renaissance, the material purple brick and terracotta. It was, he said, chosen by Captain Fowke under the influence of Gottfried Semper, who had lived in London as a political refugee and was much esteemed by Prince Albert.[1] Is this so?

The earliest buildings of the South Kensington Museum, dating from 1856, now form part of the Victoria and Albert Museum, but are discernible only internally. I am going to concentrate on the quadrangle, begun in 1862, the only portion to have any architectural or decorative pretensions.

When discussing the Museum and what has become known as the South Kensington style, several points have to borne in mind:

1. The institution was the major part of a government department, Science and Art, the Permanent Secretary of which, Henry Cole, was also Director (or General Superintendent) of the Museum.
2. Cole's official architectural activities for the Department of Science and Art, such as the Industrial (now Royal Scottish) Museum at Edinburgh, the Royal College of Art, the Royal College of Science, and the South Kensington Museum, are inseparable from his private architectural schemes at South Kensington—the 1862 Exhibition, the 1864 proposal for the Natural History Museum, the Horticultural Society's gardens, the Royal College of Organists, and the Royal Albert Hall.
3. The purpose of the South Kensington Museum was to instruct and inspire students, designers, manfacturers and the general public.
4. It depended upon the benevolence of the Treasury, and for the first three years was regarded as an experiment, in a suburb somewhat removed from London.
5. Because of controversy and opposition to the Prince Consort's proposal for a great centre devoted to purposes of science and art, the Museum was forced to begin its life in an iron shed provided by the Royal Commission for the 1851 Exhibition.
6. Cole had a generally poor opinion of the architectural profession.

It is important that any consideration of the development of the South Kensington style should take heed of the chronological sequence of events, in which, indeed, the Museum comes quite late.

While waiting for the argument to be resolved as to whether the Royal Academy, the Society of Antiquaries, the National Gallery, and other institutions would move to the 1851 Commissioners' Estate, Albert, in 1855, asked Semper to provide him with a scheme for the Victoria and Albert Museum's 12-acre site, of buildings round a quadrangle with shops and galleries, which would be self-financing. He sketched his ideas on blotting paper, which was characteristically removed from his desk by Cole, and is now in the Victoria and Albert Museum Library. Semper produced a drawing and a model, but neither seems to have survived. The scheme came to nothing, but, instead, Albert erected the Iron Building.

To the north of this temporary affair, the government built a gallery in 1856 to house the paintings given to the nation by John Sheepshanks, long before thought had been given to any permanent scheme of building. It was designed by a Royal Engineer, Francis Fowke (whom Cole had met in connection with the Paris 1855 Exhibition); and was a simple red brick box, which was toplit (pl. X*a*). Richard Redgrave, Cole's right-hand man, explained that 'our object is to fit for use and decorate afterwards. This is not only the case with reference to the exterior; it is the same with the interior.' Though it could not be seen by the public, a former art student[2] decorated the west wall with engraved layers of coloured plaster, inspired perhaps by Semper.

A year or two later, Fowke added additional rooms to the north, for the National Gallery of British Art, which included the Turner collection. This building, run up in only three months, was entirely utilitarian, without any ornamentation at all.[3] The Sheepshanks Gallery, with its double rounded-headed arcading at first-floor level, could well have influenced Fowke when permanent Museum buildings were eventually designed. But its outer wall was swept away in 1900 by Aston Webb when he rebuilt this eastern side of the quadrangle on a different alignment and with an additional storey, in order to match the other three sides.

By 1858 Semper had long returned to Germany, and any influence he might have had on later developments would have come only through Prince Albert. In that year Albert, as president of the 1851 Commission and also of the Horticultural Society, was considering buildings for the Gardens on the site of what is now the Science Museum and all other buildings as far north as the Albert Hall. These, he stipulated, were to be either Italian or Renaissance. He appointed Cole, Redgrave and Fowke to form a committee, together with Sydney Smirke, to provide him with designs. This was on 16th July.

Fowke went to Paris, and from there, on 20th July, he wrote to Cole that 'There are some good photographs of the entire new courts of the Louvre and also of the Hotel de Ville and of some street architecture that I think would be useful to us in some of our buildings.' In the same letter he stated he was glad that the Prince had decided that the work was to be done by an architect and thought well of Smirke.[4]

Then, only four days later, on 24th July, the Board of the Science and Art Department asked the Treasury to authorize Fowke to design the Edinburgh Museum (pl. X*b*).

Three months after this, Cole, who was in Italy, wrote to the Prince's Secretary, Charles Grey, saying that he was very struck at Venice, Padua, Verona and Bologna

PLATE X

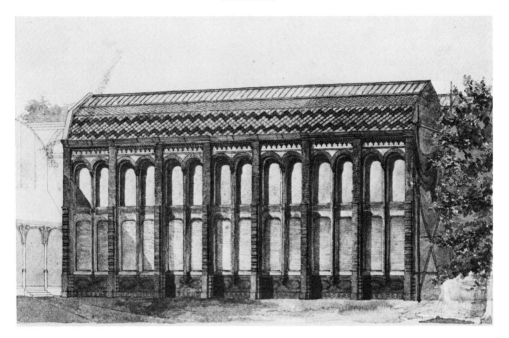

a. The Sheepshanks Gallery, east wall, now the interior west wall of the Medieval Tapestry Court, Room 38, Victoria and Albert Museum. Anonymous artist, *c.* 1858 (V. & A., E.353–1956)

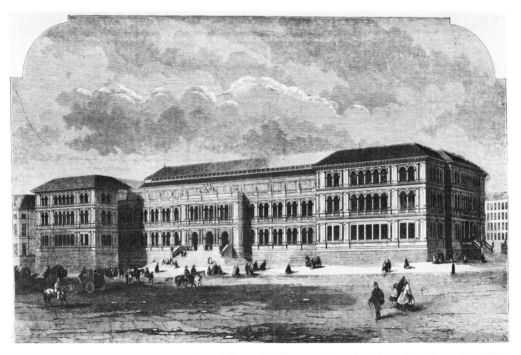

b. The Royal Scottish Museum, Edinburgh (from the *Illustrated London News,* 21st December 1861)

Photographs: Victoria and Albert Museum

PLATE XI

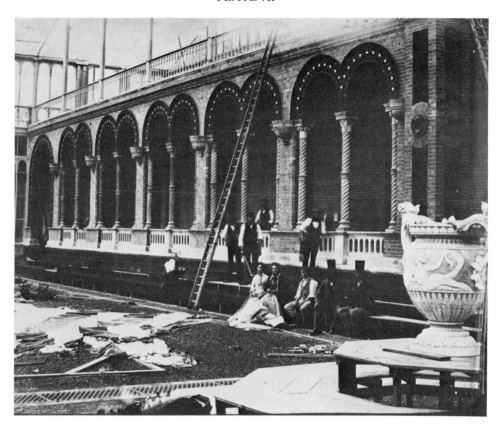

a. Arcades, Horticultural Gardens, in 1861

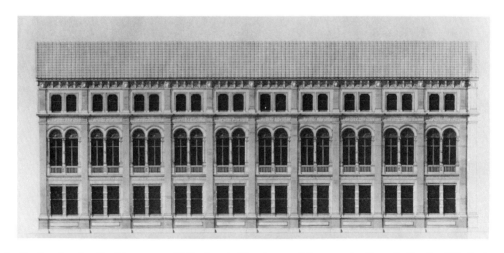

b. Design for the Residences, *c.* 1861, South Kensington Museum, by Francis Fowke (V. & A., E.1026–1927)

Photographs: Victoria and Albert Museum

PLATE XII

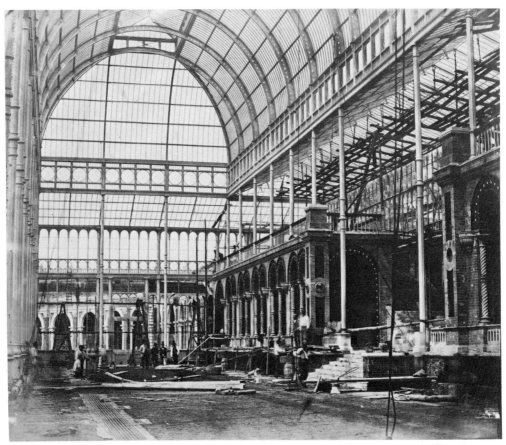

Photograph: Victoria and Albert Museum

The Conservatory, Horticultural Gardens, in 1861

with all kinds of architectural suggestions 'which wd. be useful in preparing the plan for S. Kensington & I really think it wd. be worthwhile if Capt. Fowke cd. be sent for 3 or 4 weeks by the Commissioners at their expence to see these places and make notes.' Cole hoped that he would be able to stay on to meet Fowke. After visits to Turin, Genoa, Pisa, Florence and Mantua, Cole went south to Rome, from there writing again to Grey: 'I see many things here which are very suggestive for Kensington. Will you ask H.R.H. if I may get some photographs made of details of buildings? . . . the outlay not exceding £25.'

Shortly afterwards, in January 1859, the indefatigable Cole recorded in his diary that he had been 'to see the two tombs, the property of Mr. Fortunati and one of which had only been discovered last April . . . This tomb has been constructed of fine brickwork, the mouldings and ornamental parts of light buff, the other parts red. A rather large building in the same field showed this treatment more plainly. The pilasters were of red brick, but the Corinthian capital not cut, but moulded before baked. I hope we shall adopt this system at Kensington rather eschewing the use of stone, except where stone would be decidedly best.' He also examined mosaics, noting that 'the old art and real purpose of mosaic seem almost to have gone out'.

So there we have the first glimmerings, I submit, of the South Kensington style—north Italian, red brick, terracotta and mosaic—coming from Cole himself.

Until his death in 1861, Prince Albert had everything referred to him, Cole regularly going to Windsor, Buckingham Palace or Osborne, and the Prince was a constant visitor to Kensington, frequently offering suggestions through Grey—as on 23rd July 1859: 'I am sorry to say that the Prince does not much like the designs for the Arcades. He thinks the sort of Pilasters . . . that carry the columns weak and poor. The capitals to the Columns he also thinks want more boldness. You will see that H.R.H. has added to two of them in pencil. The Arches he also complains have no keystones which gives them an appearance of weakness.' Further drawings were sent, but even these did not satisfy Albert. 'The Prince thinks that the keystone . . . as drawn in the amended design, may be too large and go too high up, extending considerably beyond the Arches of which they are supposed to be the key, but that, without something, the fine clear line of the outside stone arch, with the equally fine line of the Cornice which rests upon it gives an unpleasant feeling of insecurity. The colouring and details of ornamentation would also require much consideration.'

No doubt, H.R.H. adjudicated when Fowke and Cole argued about style, Fowke wanting Venetian or Romanesque. After the arcades round the Horticultural Garden were built in 1861, the *Builder* called the northern ones Albani, those in the centre, Milanese, and those across the southern ground, Lateran. Everything has now been demolished, unfortunately without adequate photographic record (pl. XI*a*).

The ornament was something neither Cole nor Fowke could deal with themselves, so in 1859 Godfrey Sykes, a pupil of Alfred Stevens, was brought from Sheffield School of Art as designer, and it was he who formally became the fourth member of the South Kensington team of Cole, Fowke and Redgrave, in July 1861, at the high salary of £8 per week. He was joined shortly afterwards by two fellow students at Sheffield, James Gamble and Reuben Townroe.

This early period was one of great activity. The foundation stone of the Edinburgh Museum, of which Fowke had produced the design in 1859, was laid by the Prince in 1861. Fowke was at the same time busy with his design for the 1862 exhibition, and following encouragement in the middle of 1860, when a Select Committee on the

South Kensington Museum recommended that permanent buildings should be financed by the Treasury, Fowke had also to get down to work on a building to cover the 12 acres of ground.

Thus, by the time the first building—the houses for Cole and senior officials of both Museum and Department of Science and Art (the western side of the Museum's quadrangle)—was begun in 1862 (pl. XI*b*), all the ingredients had been settled. There remained only details; Sykes had been sent to Florence to sketch in 1861 and the scheme of decoration was left to him to determine.

We have seen how Cole had been impressed by terracotta when in Rome in 1858. Although Fowke began the Museum with Portland stone dressings, Cole, because he had to make the Treasury's money stretch as far as he could, decided that if the art students modelled from Sykes's designs, these could be reproduced over and again in terracotta at a fraction of the cost of carved stone. Therefore, this is what he ordered.

It so happened that Fowke was also the Curator of a section of the South Kensington Museum—the Museum of Construction—so the Museum buildings themselves became an exhibit. A portion of the decoration was carved in Portland stone, and the label contrasted its higher cost with the lavish, but cheaper, mass-produced terracotta on the new buildings.

What else was needed? Cole decided to revive the use of mosaic, externally and internally. Again, this could be done by art students—and was considered most suitable for the ladies. So, in July 1862, the Science and Art Board agreed that space 'for female students to witness the mosaic process, and themselves perform', should be found in the Museum. On the same day Sykes's pay was raised to £10 a week. The *Survey of London* has said that Sykes 'clothed Fowke's ingenious but rather uninspiring compositions with the craftmanship and humanistic idealism of the Renaissance as taught by Stevens',[5] and we know that Stevens, always referred to by Sykes and his team as The Master, was frequently in the South Kensington design studio during the 1860s and until his death in 1875. His influence shows most immediately, perhaps, in the original main doors of the Museum,[6] once gilded, which were based so closely on those Stevens had designed for the Geological Museum.[7]

To conclude, one must presume that Fowke had an architectural adviser behind the scenes, as he was essentially an inventive and resourceful engineer, happier with iron and glass. In 1860 he had designed a large iron and glass hall for Edinburgh. In the same year he worked on plans for the huge conservatory for the Horticultural Gardens (pl. XII), and the roof of 10,000 square feet to cover a garden court (the North Court) in the South Kensington Museum, and had enlarged his Edinburgh Museum hall design into Cole's proposed 30,000-seat concert hall[8] for the 1862 Exhibition (for which Fowke also produced glass domes slightly larger than that of St Peter's in Rome).

To whom would he and Cole turn when dealing with bricks?

There was one, and only one architect, on intimate terms with Cole for some thirty years: an architect who had visited the Paris exhibition with Cole in 1849 for the Society of Arts; who had served with the 1851 Exhibition Executive Committee side by side with Cole; who had been with Sykes in Florence in 1861 looking at decoration; who had written for Cole's *Journal of Design;* who had—as early as 1847—spoken on mosaic and architectural decoration; who was an iron and glass enthusiast; who was one of the circle round the Consort; who designed the Royal Engineers Crimean War Memorial in 1861; and indeed one of whose own buildings—Addenbrooke's Hospi-

tal, Cambridge[9]—looks not far removed from an undecorated South Kensington carcass. I suggest that a far greater influence at Kensington during the 1850s and 1860s than has been recognized was Sir Matthew Digby Wyatt.

Acknowledgement

Permission to quote from Sir Henry Cole's letters and diaries in the Victoria and Albert Museum was given by Mrs Elizabeth Bonython, who holds the copyright.

NOTES

[1] *The Buildings of England, London,* ii (1952), 253.

[2] Andrew MacCallum.

[3] A photograph of *c.* 1899 is fig. 33 in J. Physick, *The Victoria and Albert Museum: the History of its Building* (London, 1982).

[4] Cole's letters and his diary are in the Victoria and Albert Museum Library.

[5] Vol. xxxviii, *The Museums Area of South Kensington and Westminster* (1975), 103.

[6] Physick, *op. cit.* (note 3), fig. 128.

[7] Stevens's drawing is in the Victoria and Albert Museum Print Room.

[8] *Survey of London, op. cit.* (note 5), pl. 30b.

[9] For illustration see N. Pevsner, *Art, Architecture and Design, Victorian and After* (London, 1982), 102.

Holford, Vulliamy, and the Sources for Dorchester House

D. J. Watkin, F.S.A.

It may be helpful to regard much of what we think of today as 'neo-classicism' as really the consequence of a passion for Italy, whether in an attempt to fulfil the ideals of the Renaissance or simply as a love affair with Italian warmth, colour and romance. Seen in this light, the visits to Italy of Burlington and Kent may be difficult to distinguish from that of Robert Stayner Holford. This approach enables us to see the continuity between the eighteenth and nineteenth centuries, so that figures as apparently dissimilar as Winckelmann, Burckhardt, Ruskin and Pater are all united in their passion for Italy. The close relationship with Italy of Burlington and Kent is paralleled in the nineteenth century by that of Holford and Vulliamy and, in Bavaria, by Leo von Klenze and his patron, Crown Prince Ludwig, King of Bavaria from 1825. Ludwig's passion for Italy knew no bounds. However, it was entirely compatible with his passion for Greece inherited from eighteenth-century neo-classicists. Thus, in 1816 von Klenze was busy with designs for the neo-Greek Walhalla and also for the Palais Leuchtenberg in Munich, modelled on the Palazzo Farnese. This was the first of the many buildings with which Ludwig and Klenze tried to turn a modest Electoral Residence town into a European cultural capital inspired by Renaissance Italy. The Leuchtenberg Palace was built in 1816–17 for Napoleon's step-son, Eugène de Beauharnais, who had married the sister of the Crown Prince of Bavaria and was created Duke of Leuchtenberg. His enormous palace housed his art collection, which included Italian sixteenth- and seventeenth-century paintings as well as modern ones. The idea of using the Renaissance palazzo as a type could itself be considered French, because Percier and Fontaine had published line engravings of Roman palaces and villas from 1798. Their achievement was followed and developed by Paul Letarouilly in his three-volume study published in 1840 as *Édifices de Rome moderne*, a book which may have been used as one of the sources for Dorchester House.

Sir Charles Barry was, of course, the architect whom we can regard as the von Klenze of England, beginning with his St Andrew's, Hove, of 1827, and his Travellers' Club, designed in the following year. His Reform Club of 1837 and Bridge-

water House of 1846 onwards helped establish the unshakeable centrality of the palazzo style in nineteenth-century architecture. Bridgewater House is important for us as the most immediate source for Dorchester House and one which we know from the correspondence between Holford and Vulliamy that they had looked at very carefully. This correspondence, which amounts to about 400 letters, means that Dorchester House, with its slow process of design and execution, is a singularly well-documented building.[1]

Robert Stayner Holford, born in 1808 and educated at Oriel College, Oxford, was Conservative M.P. for East Gloucestershire from 1854 to 1872, and an amateur architect and landscape gardener. He became a multi-millionaire as a young man for reasons which are not entirely clear, though the usual explanation is the large family holding of New River shares which suddenly acquired high value at that time. He employed the architect Lewis Vulliamy (1791–1871) more or less continuously from 1839 to 1871 on many projects, including his town mansion and his country house, Westonbirt (1863–70), in Gloucestershire, rather as a German princeling would employ a court architect. A talented pupil of Smirke, Vulliamy won medals at the Royal Academy and was sent with a scholarship on a four-year tour of Italy from 1818 to 1822. He designed in every possible style, beginning with Smirkean neo-classicism in the Law Society's Hall in Chancery Lane in 1828 and the façade of the Royal Institution in Albemarle Street in 1838. One of his classical country houses, Shernfold Park, Sussex, designed in 1853 around the same time as Dorchester House, is a ham-fisted work which suggests that much of the architectural quality of Dorchester House is due to the guiding hand of Holford.

The last of the great private palaces of London to be built, Dorchester House (pls. XIII, XIV*a*) was designed to house in visually and historically appropriate settings Holford's fabulous art collection, which included works by Titian, Tintoretto, Velasquez, Van Dyck, Murillo, Rembrandt, Claude and Rubens. It seems that Holford may have begun by thinking of a Genoese palazzo as a model, for amongst his papers there are a number of drawings[2] made in 1846–7 by J. H. Porter, Vulliamy's assistant, of about a dozen palaces in Genoa and one or two in Rome and Florence. In Genoa there are drawings of the Palazzo Doria (1529), by Giovanni Montorsoli, with its attractive frescoed loggia; of the Palazzo Durazzo-Pallavicini (1619), by Bartolommeo Bianco, with its great picture collection and its late eighteenth-century staircase by Andrea Tagliafichi; and, significantly, of Bianco's Palazzo del'Università (1630–6), with its dramatic linking of vestibule, cortile and staircase. Of special interest are two interior views showing the picture gallery at the Palazzo Corsini in Florence, designed in 1656 by Silvani and Ferri, and the drawing-room of the Palazzo Mignanelli in Rome, of which Porter even includes a furniture plan.

The first and most obvious Italian source for Dorchester House is Peruzzi's Villa Farnesina in Rome of 1508, a *villa suburbana* built for a banker to provide an elegant setting for entertainment, decorated by Raphael and Giulio Romano. It must have seemed a not inappropriate model for a nineteenth-century collector of Italian paintings using a commercial fortune to build a palace for his collections and for entertaining, overlooking the pastoral greenness of Hyde Park from its substantial site in Park Lane. But as a model it had three disadvantages: being two-storeyed, it was too small for Holford's purposes and, moreover, the principal reception rooms were on the ground floor; being a pre-Baroque building it did not have a grand staircase, which would be necessary if the principal reception rooms were to be on the

PLATE XIII

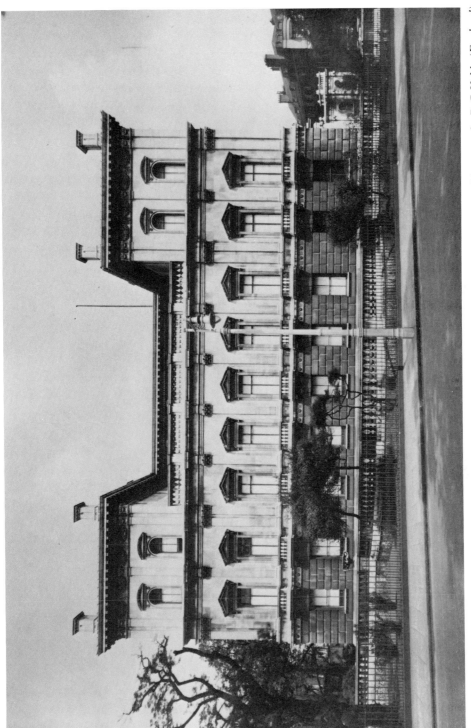

Photograph: R.C.H.M. (England)

West front of Dorchester House

PLATE XIV

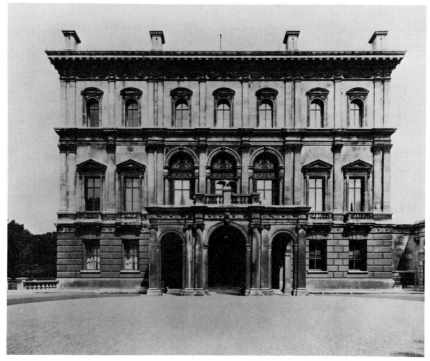

Photograph: R.C.H.M. (England)
a. South front of Dorchester House

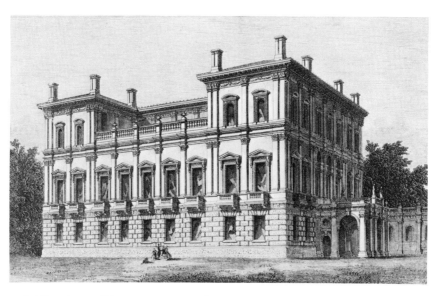

b. West front of Dorchester House (from the *Builder,* 28th August 1852, 551)

PLATE XV

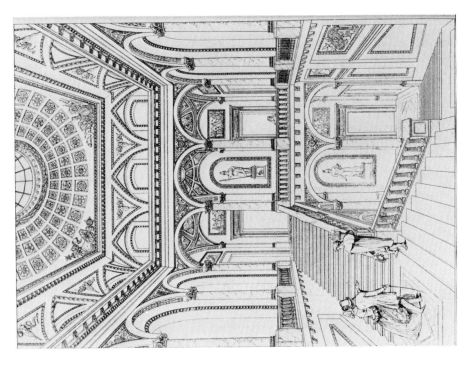

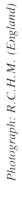

b. Palazzo Braschi, Rome: the staircase (from P. Letarouilly, *Édifices de Rome moderne* (1840), pl. 196)

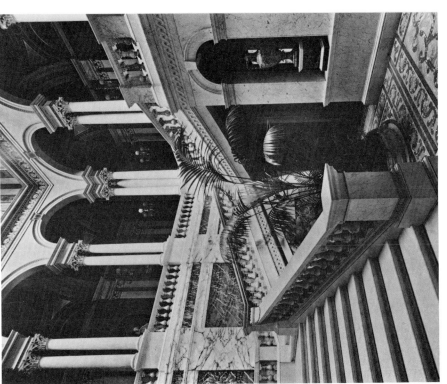

Photograph: R.C.H.M. (England)

a. Dorchester House: the staircase

PLATE XVI

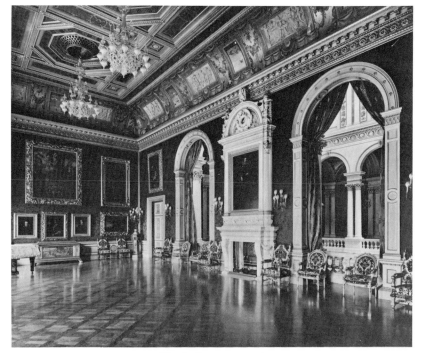

a. The ballroom, or saloon

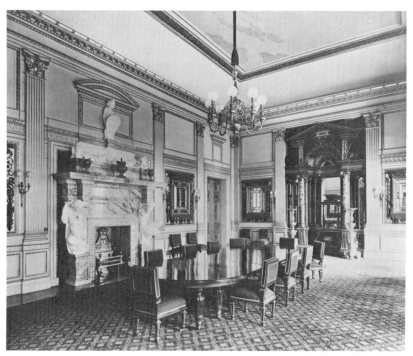

b. The dining room
Dorchester House
Photographs: R.C.H.M. (England)

PLATE XVII

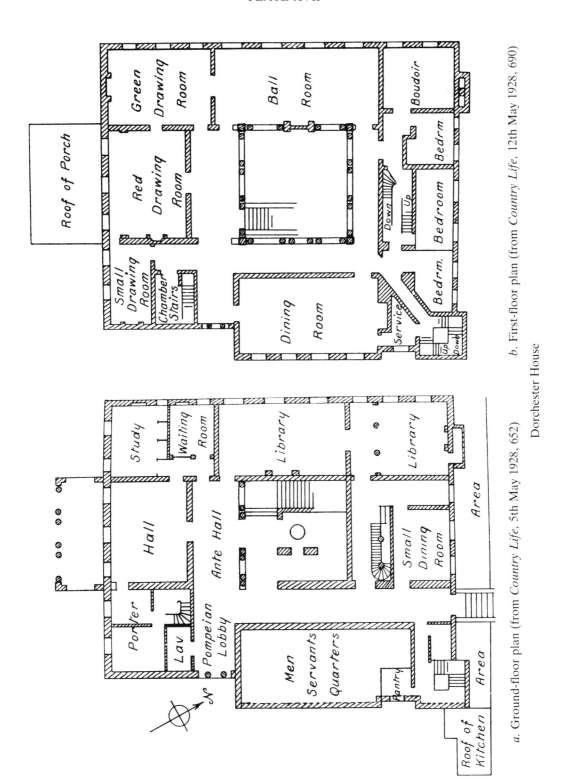

a. Ground-floor plan (from *Country Life*, 5th May 1928, 652)

b. First-floor plan (from *Country Life*, 12th May 1928, 690)

Dorchester House

first floor commanding the view over Hyde Park; and finally, being Italian, it had virtually no chimneys. And it is interesting that it is the design of the chimneys and of the staircase hall that caused most problems and about which Holford wrote so many letters to Vulliamy. The problem of gaining extra space was solved early on by raising the Peruzzi model up on a large rusticated ground floor, and by filling in the U-shaped west front up to the first floor. Related to the question of the chimney design was that of the roof itself: should it be pantiles like the Farnesina, or lead, or slate, or should it be hidden behind a balustrade like Bridgewater House. Having agreed with Vulliamy's 'reasoning upon the different feeling of an old Italian tile roof, and an imitation of [it in] lead', and after a reference to the Reform Club roof, Holford said, 'I think our feeling ought to be not to imitate anything, but to construct a roof lighter than the old Italian one because with cleaner materials, but still bold.'[3] He argued that it would be wrong to imitate pantiles or to have a lead roof, proposing slates as an intermediate.

The slate roof eventually adopted was largely concealed, but the great chimneys and overhanging cornice were amongst the principal external features. Holford wrote that 'You cannot make the chimneys otherwise than an important part of the composition, capping as they do the perpendicular lines of the pilasters, and as near to the cornice as they are. If you remember, I tried the experiment of making them unimportant at first . . .'.[4] The external carving, and especially the fine swagged frieze, was the work of Charles Harriott Smith in 1852. The stones in the chief projection of the cornice were 8 ft. 6 in. (2·6 m.) square. Smith was a distinguished neo-classical sculptor who carved the capitals of University College, London, the National Gallery, the Royal Exchange, and that of Nelson's Column. He also did the decorative carving at Bridgewater House in 1848. We know that Holford and Vulliamy looked very carefully at Barry's Bridgewater House, designed for Lord Ellesmere in 1845 and built in 1847–9, though work continued on the interiors until 1854. Both have west fronts looking on to a park, the Bridgewater House front being 120 ft. (36·6 m.) to the 135 ft. (41·1 m.) of the Dorchester House west front. However, the south entrance elevation of Bridgewater House is 140 ft. (42·7 m.), while that at Dorchester House is 105 ft. (32 m.) (pl. XIV*a*). But Holford was anxious that the west and south fronts of his house should be seen together, writing in 1852 that 'nothing but a very false impression of the real effect can be produced by a geometrical elevation of the west front. The whole pith of the thing consists in the perspective effect'.[5] Indeed, he suggested that Vulliamy give help to a draughtsman from the *Builder* magazine, which was proposing to publish a perspective view of the house from the south-west (pl. XIV*b*).[6]

Vulliamy, who wanted Dorchester House to have a picturesque surface texture, complained to Holford that the severity of Bridgewater House produced a rather bald effect. Holford replied,

I agree with your criticisms on Bridgewater House pretty generally—but you will find the world, more usually, will admire large spaces, treated so simply as to become unified, rather than appreciate clever intricacy though possibly producing much more pictorial effect. I cannot help thinking that if you have a Gallery to cut it into pieces with columns [as at Bridgewater House] is wrong. The narrowness of the drawing room is fatal; but I believe it originated in a mistake not in a false conception. I quite agree with you as far as I could judge of the meagreness of the

ceilings. No doubt the corridors upstairs will look very noble; but think it will puzzle them to make much of the Great Atrium. It is so large and so plain that statuary will be lost in it and I fear it will always look like a courtyard but *nous verrons*. The width of the corridors above with the power of placing sculpture in good places and *not* in the gangway is I think the great coup.[7]

The broad first-floor corridors of Bridgewater House made an effective re-appearance at Dorchester House, while there was much justice in Holford's prediction that Barry's great empty saloon, or Atrium, would always be a visual problem. Perhaps the earliest cortile of this kind in an English house was due not to Barry but to Thomas Hope's son, Henry Thomas Hope, in his remodelling of Deepdene in 1836. The exterior recalled the palaces of Genoa with a touch of the Villa Medici in Rome. Hope's friend Disraeli dedicated *Coningsby* to him in 1844, explaining that the novel had been 'conceived and partly executed amidst the glades and galleries of Deepdene'. So this opulent, Italianate setting was seen as the ideal background for the romantic Toryism of the Young England movement. Hope had done what Barry did not, which was to introduce the staircase into the central cortile. The novelty of Dorchester House was the combination of the Hope/Barry cortile with a grand staircase (pl. XV*a*) on the scale of those habitually used by the Wyatt family at houses like Heaton, Dodington, Ashridge and, in particular, at Stafford House, at which we know Holford looked. He looked even more closely at Continental models, visiting Italy in 1854–5 with the object of seeking inspiration. He wrote to Vulliamy from Nice in December 1854 that 'I have seen nothing very applicable to our questions . . . but . . . I saw a large staircase in Lyons', and promised that he would continue to look in Florence, Genoa and Rome. From Rome he wrote complaining that 'so large a proportion of the staircases that I have seen here are between walls, not in a hall, that I have been able to make no observations on the way of turning the corners'. He added, however, that 'I have got some console tables, chairs etc. in Genoa and Florence and I shall get some marble slabs for covering them here . . . I have sundry specimens of marbles to bring home with much information as to prices and capabilities.'[8]

In a letter of 5th February 1855 he refers to an important Roman building which is in many ways a close parallel to Dorchester House, the Palazzo Braschi, built in 1790–1804 by Cosimo Morelli for the future Pope Pius VI, who gave it to his nephews. This neo-classical mansion was built to house the Braschi collection of antique sculpture and sarcophagi and Renaissance and Baroque paintings by Titian, Caravaggio and Murillo. It is noted for its monumental staircase (pl. XV*b*)[9] which Holford described as 'one of the finest I have ever seen . . . very like ours in its position and has the differences of level at the two sides of the pedestal of which we complain . . . but there is a large pillar on the pedestal supporting one side of one of the arches that carry the flight alone so that the rise in the pedestal is only a portion of a perpendicular line going up to the ceiling.'[10] Morelli's dramatic staircase with its red granite columns is the heir to the Baroque staircases of seventeenth-century Italy. Neo-classical designers could rarely bear to give up grand staircases, even though they are a Baroque conception. One can point not only to Morelli but to architects like Holland and Chambers, whose staircases can be as Baroque as Kent's at 44 Berkeley Square. The pictorial effect of Vulliamy's staircase was carefully planned by Holford, who wrote to him in 1852 that, 'One of the principal points of view will be seen after entering the

vestibule from the outer hall, another from the vestibule upstairs, and a third from the first landing at the north-west corner of the hall.' He refers in the same letter to a model which had recently been made of the staircase. An additional Baroque touch was introduced by opening up the arches on its west wall into the ballroom (pl. XVI*a*). On the original drawings these are shown as blank arcades, but the idea of opening them was supposedly due to the painter Landseer: a truly painterly and Picturesque touch, so that on the occasion of great balls the sound of music and dancing would animate the entire house. It was with such spirited scenes in mind that Garnier was shortly to design his great staircase at the Paris Opera, that high point of Second Empire classicism.

In 1853, when work on the carcase of the house was nearing completion, Holford gave serious consideration to the choice of an artist and interior decorator who was up to the task of adorning the great interiors. Several decorators applied, but he eventually chose Alfred Stevens (1817–75). He probably envisaged Stevens decorating the entire house, but he had not reckoned on Stevens's complete absence of a proper sense of time and could not know that he was to be given the commission for the Wellington Monument in St Paul's Cathedral in 1858. The Wellington commission was partly due to the efforts of C. R. Cockerell, whom in many ways he resembled. A pupil of Thorvaldsen, Stevens admired Michelangelo, but even more Peruzzi, so that he was an ideal choice for a house partly inspired by the Farnesina. It was necessary to employ other artists, for example Holford's brother-in-law, Sir Coutts Lindsay, Bart., soldier and amateur artist, who painted the lunettes in the north and east galleries which surrounded the staircase hall on three sides. The south gallery, which formed the principal landing and was thus wider than the other two, was barrel-vaulted and painted with arabesques in 1856 by the firm of Morant and Boyd, while the other galleries were ceiled with saucer domes. It was in Italy in 1861 that Holford found painters for the main rooms, Gatti and Domenico Anguinetti. The latter painted the ceilings of the Red and Green Drawing Rooms in 1862 for £575, while the plasterwork was provided by Jacksons. Sir Coutts Lindsay painted the frieze in the Red Drawing Room in an inappropriately Pre-Raphaelite manner, the neo-classical chimney-piece in the same room being the work of Robert Westmacott in 1860. The ballroom or saloon was finished in 1869 with a ceiling, less heavily modelled than the others, painted by Morgan after Lindsay's designs. The chimney-piece of Carrara marble was commissioned from Alfred Stevens in 1859. A model was ready in 1864 but the chimney-piece was not finished until 1869. Holford wrote to Stevens in the following year, 'Had I known that the saloon chimney-piece would have cost so large a sum as £1,800 I should, while admiring its beauty, have been content with a good form and much less ornament.'[11]

On the first floor Stevens also designed the west wall of the south gallery, with its doors opening into the saloon and Green Drawing Room. He also enriched the walnut panelled doors with exquisite carvings of female figures in elaborately moulded circular frames. His most important work at Dorchester House was, of course, the dining room (pl. XVI*b*), for which he began making drawings in 1859, though the room was still incomplete at the time of his death in 1875. The splendidly Michelangelesque chimney-piece, for which a model was made in 1864, was not finished until 1878, three years after his death. The walnut sideboard or buffet, for which a model was also made in 1864, is a noble monument, though a form inspired by a Renaissance tomb might be considered incongruous for so domestic a function. An

earlier design[12] for the dining room with a high coved ceiling had made it look like the private chapel of an austere Counter-Reformation order. In 1870 Stevens began to make cartoons for the ceiling, which was to have been decorated with canvases representing the Judgement of Paris and the Flight from Egypt. Scenes from Geoffrey of Monmouth's Chronicle were to adorn the coves. However, although Stevens had started work on the canvases, the whole scheme was not worked out in sufficient detail for it to be executed after his death. Instead, Sir Coutts Lindsay provided a weak sky-painting with birds in flight. Eight mirrors with carved walnut frames were executed from Stevens's designs, but the painted arabesques which were supposed to fill the panels over them and over the doors were never even begun. The house was demolished in 1929, when the room was carefully dismantled by Knight, Frank and Rutley, who sold its fittings, including the chairs by Stevens, separately. Most of them went to the Walker Art Gallery, Liverpool, though the chimney-piece is at the Victoria and Albert Museum. It is a pity that the surviving parts cannot be reunited and the room reconstructed.

The plan of Dorchester House was a curious one (pl. XVII). Original and empirical, it suited its owner's requirements perfectly: the ground floor with its libraries was devoted to study by day; the first floor was exclusively devoted to reception rooms for entertainment in the evening; the top floor, for use at night, contained the bedrooms, of which there were, surprisingly, no more than five. Robert Holford died in 1892. His son, Sir George Holford, let the house to the American Ambassador, Whitelaw Reid, in 1905–13, during which period Bedford Lemere took the photographs of which some are reproduced in this article. On George Holford's death in 1926 Dorchester House and Westonbirt passed to his nephew, the Earl of Morley, while the picture collection and the fabulous library were split up among other nephews and nieces. Dorchester House, denuded of its contents, was offered for sale at £400,000. The Italian Government was prepared to purchase it for £300,000 for use as their Embassy, which would surely have been the ideal solution. Lady Beecham raised a fund to acquire it for the purposes of a national art centre with an opera house attached. The quality and importance of the house was thus widely appreciated, while articles by Christopher Hussey in *Country Life* and the *R.I.B.A. Journal* in 1928[13] emphasized its unique architectural quality. None the less, it was demolished to make way for the Dorchester Hotel, even though it was a house built for long endurance. The external walls of carefully chosen Portland stone were 3 ft. 10 in. (1·2 m.) thick, with many bonding stones and slate dowels so as to avoid the use of iron which might rust and expand. Thus, an account in the *Builder* in 1852 concluded in unwitting irony: 'If the New Zealander who is to gaze on the deserted site of fallen London in some distant time to come, see nothing else standing in this neighbourhood, he will certainly find the weather-tinted walls of Dorchester House erect and faithful.'[14]

NOTES

[1] The correspondence is preserved in the MS Collections of the British Architectural Library.
[2] Now at the British Architectural Library Drawings Collection.
[3] Holford to Vulliamy, 2nd October 1852.
[4] Undated letter of 1851 from Holford to Vulliamy.
[5] Holford to Vulliamy, 19th May 1852.
[6] Published in the *Builder*, x (28th August 1852), 551.

[7] Holford to Vulliamy, 29th September 1851.

[8] Holford to Vulliamy, 5th December 1854, and 6th January, 5th and 10th February, 1855.

[9] Illustrated in P. Letarouilly, *Édifices de Rome moderne* (Paris, 1840), ii, pls. 196–7. See also A. M. Matteucci and D. Lenzi, *Cosimo Morelli* (Bologna, 1977).

[10] Holford to Vulliamy, 5th February 1855.

[11] Draft letter from Holford to Stevens, 19th May 1870.

[12] Now at the British Architectural Library Drawings Collection.

[13] *Country Life*, 5th to 12th May 1928; *R.I.B.A. Journal*, 11th August and 22nd September 1928.

[14] The *Builder*, x (28th August 1852), 550.

English Painting and Italy: Giovanni Costa and the Etruscans, 1850–1885

Christopher Newall

The abstract notion of Italy suggested a variety of diverse associations in the minds of the many English painters of the period who travelled there. For many Italy was merely an artistic, rather than a geographical, expression, but to these painters that country was romantic and beautiful. The history of medieval and Renaissance painting in Italy was the subject of investigation on the part of painters and art historians alike, and the works of Giotto through to Michelangelo entered the canon of artistic inspiration during the period. Italy was, however, much more to the generation of painters whose careers followed those of the Pre-Raphaelites than just a repository of ancient paintings available for adaptation or plagiary—the cities of Italy and the very landscape of that country were highly attractive and the objects of an almost mystical veneration. I should like to try to convey something of what most impressed various English painters in the landscape of Italy, and for this purpose I have referred to the letters, diaries and memoirs of the painters with whom I am concerned.

It was not a general practice, as it had been for French and German art students, for Britons to travel to Rome as part of their training. Only briefly and on a small scale did anything like a colony of English painters in Rome exist. One Englishman who did travel to Rome and who lived and died there was Charles Coleman. He revived the tradition of oil sketching in the Campagna landscape, practised in the eighteenth century by Thomas Jones, which sought to convey the momentary effects of light and weather on the landscape. Coleman followed Claude's habit, as described by Sandrart, of wandering in the Campagna studying nature and sketching and painting in the landscape, attempting to absorb and record the particular character of the place. In the 1850s Coleman, who shunned any kind of reputation, gained the allegiance and friendship of three more ambitious young painters. One was an Italian

called Giovanni Costa, who was a patriot who fought for Italian liberty and independence. The other two were Englishmen, George Heming Mason and Frederic Leighton. These three were to evolve a landscape style which contradicted the principles laid down by Ruskin and which was concerned with the space and scale of distance rather than the minute depiction of foreground, and with the structure rather than the ornamentation of landscape. Costa advocated an exaggeratedly horizontal format in which the important compositional lines, reflecting the planes of the landscape, might be emphasized. The principles of landscape painting which Costa, Mason and Leighton evolved together in the early 1850s were influential both in England and Italy until the end of the century. Mason died in 1872 and therefore played no part in the second phase of the movement, when the precepts formularized by Costa, but deriving also from Mason's artistic beliefs, became the basis for the Etruscan School of landscape painters. The members of this school, who exhibited together at the Grosvenor Gallery from its inception in 1877, and who semi-formally constituted themselves as a group in 1883, believed in the principles which Costa laid down and which were quoted by his biographer, Olivia Rossetti Agresti, as follows:

> The whole of the Etruscan School consists in this—to draw your subject by drawing the spaces of the background.
> The Etruscan school consists in seeing the direction of the lines and in drawing them with strength.
> Be careful not to let the convex lines fall weakly in, and remember that the whole earth is concave.
> A picture should not be painted from nature. The study which contains the sentiment, the divine inspiration, should be done from nature. And from this study the picture should be painted at home, and, if necessary, supplementary studies be made elsewhere.
> Sentiment before everything. Art must express the sentiment of the artist's own country, and its merits can be judged by the success it gains in this respect.[1]

Mason first met Costa in 1852 in Rome and from that date the two worked together in the course of expeditions into the Roman Campagna. Agresti described a 'twenty days' sketching expedition which Costa made along with George Mason in 1853. The two friends went together to the seashore near Ardea, a famous seaport of Antiquity, mentioned by Virgil ... They spent the whole time out of doors, painting as long as daylight lasted, and passing the nights *à la belle étoile*.'[2] Whatever contribution Mason made to their joint theory of landscape, his poetic feeling for nature and the beauty and individuality of his works was declared by Costa, when he described Mason, long after his death, as 'the glory of English Art'.[3] Mason's paintings from the early 1850s to 1857, when he left Rome to return to his native Staffordshire, sometimes tend towards a picturesque type which reminds one of Costa's edict 'Art must express the sentiment of the artist's own country'. It was in Staffordshire, the landscape of which Mason found bleak and depressing, that he painted his most moving and spiritual paintings, described by Frederick Wedmore as 'a musical suite. Well-nigh from the beginning to the end they are the vision and presentment of pastoral beauty and rest.'[4]

We have no account in Mason's own words of his response to the Italian landscape. About Leighton, whom Costa met at the annual artists' picnic at the Tor dei Schiavi in May 1853, we have more information. In his diary of 1852 he wrote ecstatically:

> Italy rises before my mind. Sunny Italy! the land that I have so long yearned after

PLATE XVIII

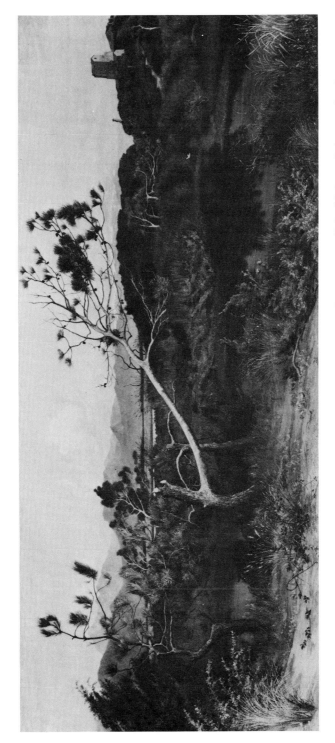

George Howard, 9th Earl of Carlisle, *The Fortress at Bocca d'Arno*; oil on canvas; 48·3×36·8 cm. Private collection

PLATE XIX

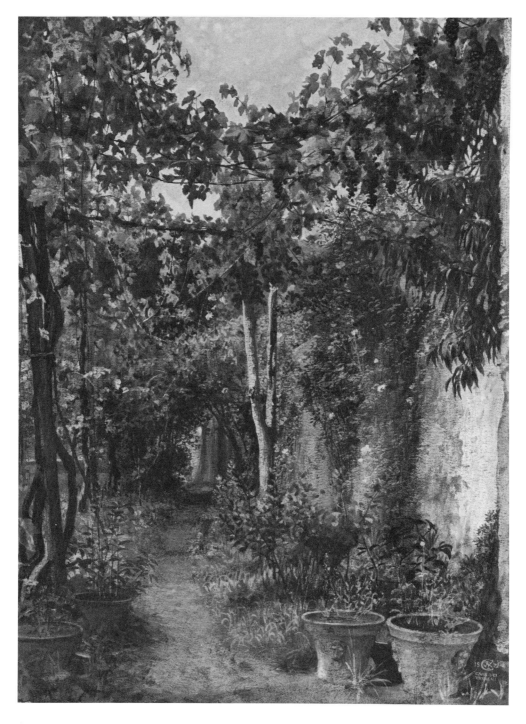

Walter Crane, *Cava dei Terreni*; watercolour; 34·3×24·1 cm; signed with monogram, inscribed and dated 1872. Private collection

with ardent longing, and that has dwelt in my memory since last I saw it as a never-fading, gentle-beckoning image of loveliness; I am about to tread the soil of that beloved country, the day-dream of long years is to become a reality. I am enraptured!⁵

Soon after his arrival in Rome he was writing 'I long to find myself again face to face with nature, to follow it, to watch it, and to copy it, closely, faithfully, ingenuously—as Ruskin suggests "choosing nothing, and rejecting nothing".'⁶ Leighton's pencil drawings of this period fulfil this objective, but otherwise his token respect for Ruskin's principle was irrelevant, for by education and instinct he was drawn to a painterly and fluent oil technique. The beauty of the Italian landscape was an inspiration to him as a painter of pure landscape throughout his career. Leighton's landscape painting is marked by an ability to create the masses of form by painterly methods; for him it was not necessary to provide a plethora of detail to convey a strong impression of landscape. Sympathetic as he was to Costa's approach he knew that construction was more important than minute representation and accent of tone more suggestive than local colour. Leighton adored Italy and the Italians; in 1857 he wrote to his mother: 'I have so often been to Italy, and so often written to you from thence, that it seems quite a platitude to tell you how much I enjoy it.' Later, in the same letter, he speaks of: '. . . the inexhaustible natural beauties of this garden of the world. I came through Switzerland this time, but as quick as a shot, as I was in a hurry to get *home* to Italy.'⁷ He travelled in Italy most years from the 1850s onwards, and after 1878, when he became President of the Royal Academy, he went to Perugia each year so as to be able to concentrate on his Academy Address. Leighton was a constant friend to Costa and was instrumental in gaining for Costa a circle of English admirers and patrons.

An interesting member of the Etruscan group was George Howard, later the Earl of Carlisle, who was a close friend of Costa's since their meeting in Italy in 1865. From this point on Howard regularly visited Costa in Italy and Costa occasionally travelled to England to be delighted by the Cumberland landscape around Naworth Castle, and to be dazzled by the splendours of Castle Howard. This friendship with Costa was of overwhelming importance for Howard's painting, to which, despite his fortune and patrician obligations, he was completely dedicated. A Pre-Raphaelite and rather fussy style was immediately abandoned in favour of a highly controlled landscape manner, never better executed than when he was painting in Tuscany or Liguria. Under Costa's guidance Howard evolved his oil technique, usually using pronouncedly oblong panels with the paint applied in dry, restrained strokes over a monochrome ground, or often on to the naked wood grain. Larger paintings were worked up in the studio from these sketches. Howard tended to give emphasis to the foregrounds of his landscapes, perhaps a legacy of his Pre-Raphaelite experience, but there is usually also a sense of atmospheric distance and wide panorama (pl. XVIII). George Howard also assisted Costa in a material way by forming a collection of Costa's works, and by introducing him to another collector of paintings and enthusiast for the Italian landscape, the Revd Stopford Brooke. In 1876, when in Rome with Howard, Brooke, who viewed the landscape with a painter's eye, wrote: '. . . the Campagna is becoming most lovely. The willows are becoming green by the side of every stream, and the grass will soon be quick with flowers. I have never seen such sheets of daises. They are like snow on the hill-sides.'⁸

Amongst the other members of the Etruscan group, all represented in Stopford Brooke's collection, were Edgar Barclay and Walter Maclaren, both of whom painted large-scale figurative landscapes of scenes from Italian life and who exhibited at the Grosvenor. Barclay and Maclaren had both been members of a colony of English artists in Capri in the late 1860s and 1870s, and Edward Blount Smith was another of this group. Matthew Ridley Corbet met Costa in 1880 and stayed with him at his house at Marina di Pisa regularly until the end of the century, becoming his most constant and devoted follower. He evolved a personal style derived from Costa, characterized by softer handling and a sweetness of colour which delights in the lush Italian vegetation and azure skies. His wife Edith also devoted herself to landscape painting in Italy.

William Blake Richmond was introduced to Costa by Leighton in 1866 when Richmond was in Rome studying Renaissance painting. Richmond said tellingly of Costa that he 'gave me good advice, criticized my work and made me cut from it small details',[9] Many of Richmond's figurative landscapes subscribe to Etruscan precepts, in the same sense that Leighton's do, in the scale of the figures and in their relation to the landscape setting. His pure landscapes carry the Etruscan ambition to concentrate on the physical mass of a landscape to its most extreme point. Richmond wrote of the Roman Campagna:

> The glad, gay morning; the solemn, shadowless midday, white with the full glory of light—silver and glistening, silent and drowsy, when the body is inactive and seeks shade from the perpendicular rays, throbbing in the pale blue—a time when the gods sleep and the shepherds speak low lest they should be wakened, when even the birds are silent. Then the golden afternoon, when the shadows lengthen, when the colour increases in intensity as the sun lowers from the meridian, and a sharp distinction cuts out each form incisively. Next, when the sun is sinking and the Alban hills are flushed, when the Claudian aqueducts stretch in long, golden lines towards the purple mist rising from the wet earth among the lower spurs of the hills, and a faint shadow is creeping over the gentle undulations of the mighty plain in which Rome lies. What was golden is grey, what was gay is grim, and with the swift oncoming twilight that steals over all the sadness which is inseparable from the highest, strangest beauty, till all has vanished in the dark, enshrouding night.[10]

The last painter I want to mention in the context of landscape painting inspired in Italy is Walter Crane, who also knew and admired Costa, again through the agency of Leighton. Crane's landscapes demonstrate Etruscan influence in their reduced range of colour and cool, light tones, and in their powerful, high horizons. Crane made a long Italian tour with his wife during the years 1871–3, and was enormously excited by everything he saw. He described the descent from the Brenner Pass to Verona: 'But the pine woods and crags gradually gave way to softer features, and the train soon descended into the vines and orchards of Italy. Verona looked lovely in the moonlight when we arrived there.'[11] After a winter spent in Rome, socially hectic as a result of various introductions made for them by Leighton, Crane 'found a subject on the Pincio, a view of Rome, with almond trees in front and two figures gathering flowers on the sloping gardens'.[12] Later on in the course of this extended honeymoon the Cranes reached Naples and the Campania and Crane later described how 'from Amalfi we journeyed (in one of those huge ramshackle barouche-landaus drawn by three horses abreast which was then the usual method of travelling in southern Italy)

along the road to Cava dei Terreni, a delightful spot among hills and chestnut woods, a little inland from the sea, commanding a view of the Gulf of Salerno and the town of Vietri'. They found a pensione where 'there was a charming old formal garden behind with box hedges and pomegranate trees and hydrangeas, and in front a vineyard where the pendant branches "into our hands themselves would reach" '[13] (pl. XIX).

I have tried to convey something of the enthusiasm that a succession of English painters felt for Italy and the Italian landscape, which they expressed with great poetry in their pictures and occasionally attempted to describe in prose. I have also tried to explain how two influential figures, Costa and Leighton, were at the centre of and were instrumental in perpetuating the particular fondness for Italy which was felt in certain circles in the second half of the nineteenth century. One must remember the affection and sympathy which many English people had for Italy during her struggle for independence and unity, of which cause Costa was a hero, a feeling which it might be said extended to the very landscape of that country. The Etruscans were Italophiles who adored the glorious landscapes of Tuscany and the Campagna and who preferred a quiet and subtle landscape style characterized by breadth and tonality, which was well matched to the calm of wide valleys and the majesty of mountainous distances.

NOTES

[1] O. R. Agresti, *Giovanni Costa* (London, 1904), 213.

[2] *Ibid.*, 68.

[3] G. Costa, 'Notes on Lord Leighton', in the *Cornhill Magazine*, lxxv (March, 1897), 377.

[4] F. Wedmore, *Studies in English Art* (1876), 218–19.

[5] Mrs Russell Barrington, *The Life, Letters and Work of Frederic Leighton* (London, 1906), 62.

[6] *Ibid.*, 109.

[7] *Ibid.*, 19 n.

[8] L. P. Jacks, *Life and Letters of Stopford Brooke* (London, 1917), 296.

[9] Richmond MS in the archives of the Royal Academy, London.

[10] A. M. W. Stirling, *The Richmond Papers* (London, 1926), 202.

[11] W. Crane, *An Artist's Reminiscences* (London, 1907), 120–1.

[12] *Ibid.*, 138.

[13] *Ibid.*, 146.

The Egyptian Revival

James Stevens Curl, F.S.A.

In this paper I shall confine myself entirely to the reign of Queen Victoria, that is, from 1837 to 1901. As I have made clear elsewhere, the Egyptian Revival was not solely a nineteenth-century phenomenon, but is traceable to Hellenistic and Roman civilizations. Egyptian motifs such as the obelisk, the pyramid, and the sphinx recur in Western European design with a startling frequency, and this, of course, is precisely because Egyptian artefacts, or objects made in the Egyptian Taste during the Roman Empire, had entered into the language of classical design, and were not even recognized as having an Egyptian origin until the first attempts were made by Kircher and others in the seventeenth century to classify specifically Egyptian elements in an orderly and systematic manner.[1]

In the second half of the eighteenth century the search for elemental forms and for the beginnings of the Classical Language of Architecture, prompted by men of genius (including Laugier and Winckelmann), led first to Ancient Greece and then to Egypt for the sources of design. The French Academicians, fired by the powerful visions of Piranesi, and by the demand for a return to basic forms, experimented with an architecture that derived many of its characteristics from Ancient Egyptian sources. Boullée, Ledoux, Desprez, La Barre, and others are obvious examples of designers who used Egyptian or Egyptianizing motifs.

It was with the publication of Vivant Denon's *Voyage* . . .[2] in 1802, Quatremère de Quincy's *De L'Architecture Égyptienne*[3] in 1803, Ledoux's *L'Architecture* . . .[4] in 1804, and the mighty *Description de l'Égypte*[5] from 1809 to 1828 that the sources of Egyptian design became based on scholarly observation rather than on fancy. It is true to say that Denon's book and the *Description* . . . were to the Egyptian Revival what *The Antiquities of Athens*[6] was to the Greek Revival. Denon's publication was the first really reliable attempt to provide comprehensive and accurate surveys with descriptions of Egyptian architecture. Thereafter the vast repertoire of motifs in *Empire* and Regency Taste owed not a little to Ancient Egypt, and designers such as Thomas Hope,[7] Heathcote Tatham,[8] and Wedgwood used Egyptian elements with imagination and verve. The marvellous Sèvres Egyptian Service[9] was one of the first great works of the Revival in the nineteenth century, and, apart from its bogus hieroglyphs, was one of the most scholarly examples. Rather too often the Revival

100

was misapplied, and, in the hands of men like Robinson[10] or Foulston[11] at Piccadilly and Devonport, owed more to the fairground than to impeccable sources, and became associated with what I would term a commercial-curiosity type of architecture (pl. XXII*b*).

One of the most scholarly of the first Egyptian Revival buildings in Victoria's reign was the Temple Mill in Leeds, by Joseph Bonomi Junior and James Combe (pl. XX*a*).[12] Bonomi had been to Egypt, but the source nevertheless appears to be the *Description* . . . illustrations of the temples at Antaeopolis and Edfu, augmented by Bonomi's own observations while in the lands of the Nile. Even the steam engine in the Mills had correct Egyptian details in its cast-iron structure. The notion of building a mill in Yorkshire in the Egyptian style for the weaving of flax may appear curious from the standpoint of today, but it is a clear instance of what Boullée called *Architecture parlante*, or architecture expressive of its purpose. Flax was grown by the Ancient Egyptians, who pioneered the manufacture of linen, so the style was intended to suggest this while serving an uplifting function by improving the architectural taste of the workers. The building was also an advertisement in itself, so that, although it was designed in a competent and scholarly manner, it also fell into the commercial category.

Bonomi also designed the Egyptian building over the spring at Hartwell House, Buckinghamshire, in 1851,[13] for springs were associated with the worship of Isis, with healing, and with eternal renewal or resurrection. The idea of Egyptian architecture to suggest strength, solidity, and durability made it ideal for mills, prisons, dams, and bridges. The pylon shape was tailor-made for suspension bridges, and the Clifton Suspension Bridge designed by Brunel in 1831[14] exploited the pylon form for the main supporting structure, while the chains were anchored to huge sarcophagus-blocks.

Egyptian features were not uncommon in garden design. Sphinxes occur in numerous gardens,[15] while the Antinous figure occurs in artificial stone at Buscot Park near Faringdon.[16] The most captivating of all gardens where Egyptian motifs are used is that at Biddulph Grange in Staffordshire, an unexpected and exotic creation of James Bateman and his wife, who moved to Biddulph in 1838 (pl. XX*b*).[17] The gardens were laid out mostly in the 1840s, with considerable assistance from the painter and designer Edward Cooke, and were described in detail in the *Gardener's Chronicle* of 1857–62.[18] The Egyptian Court has two sphinxes of bucolic mien that flank a path leading to a battered pylon-like entrance, but the rest of the *ensemble*, consisting of two pyramids on pedestals, massive blocky Egyptian forms, and a giant central truncated pyramid, is all of clipped hedge. It is a wonderfully effective idea, brilliantly rendered and darkly mysterious. The stone entrance leads to a gloomy tunnel at the end of which is a statue of the unattractive god Bes.

The Egyptian Revival style was used in funerary structures, as might be expected of an architecture associated with a celebration of death.[19] The mausoleum of Andrew Ducrow of 1837 in Kensal Green Cemetery is a wondrous concoction, partly by John Cusworth, and partly by Ducrow himself. The inscription modestly records that the tomb was 'erected by genius for the reception of its own remains'. It is a weird mixture of sub-Greek and Egyptian motifs. Nearby is the tomb of Sir George Farrant and his family of 1844. It is in the form of a pylon with inscriptions set within pylon-shaped panels formed by torus mouldings.[20]

The entrance to the Egyptian catacombs at Highgate Cemetery of the early 1840s by James Bunstone Bunning is suitably eerie,[21] although the peeling stucco hardly

signifies an architecture of permanence, and the crosses on the cavetto cornice are distinctly incongruous. The impermanence of the materials reflects the unsure financial foundations of the Cemetery Company which was responsible for building this extraordinary and theatrical necropolis (pl. XXI*a*). The entrance gates to Abney Park Cemetery by Professor William Hosking (advised by Joseph Bonomi Junior) are in the Egyptian manner, and are of stone.[22] The lodges are in the form of pylons, and the cast-iron gates have lotus-bud details. Needless to say, the biscuit-coloured chimney-pots are also in the form of an Egyptian pylon, and these became common during Queen Victoria's reign, occurring all over the country as caps of domestic stacks. Standardized granite mausolea (pl. XXI*b*) in the Egyptian style can be found in several of the great nineteenth-century cemeteries: most of these appear to have been catalogue items prepared by monumental masons, but presumably started on somebody's drawing board. An extraordinary range of tombs containing Greek, Egyptian, and Zoroastrian motifs can still be enjoyed in the Parsee section of Brookwood Cemetery near Woking, for Towers of Silence were not likely to be approved in Surrey (pl. XXII*a*).[23] Pugin's *An Apology for the Revival of Christian Architecture*[24] contains a splendid lampoon of an entrance to a cemetery for the New Economical Compressed Grave Cemetery Company, complete with peeling pylons, inverted torches, shaving-strop advertisements, gas lamp, and 'iron hieroglyphical gates which would puzzle the most learned to decipher' (pl. XXIII*a*).[25]

Thomas Willson produced a design for a pyramid mausoleum for the assassinated President Garfield in 1882,[26] each entrance of which is in the Egyptian style, while an obelisk surmounts the entire composition.

Richard Brown, whose published works,[27] in the words of Howard Colvin, are 'indiscriminately eclectic',[28] produced a strange design for an Egyptian house in 1842, which falls decidedly into the class of fairground whimsy (pl. XXIII*b*). The interiors and details are unscholarly, clumsy, and uncouth. It is very strange to find such a work forty years after the appearance of Denon's great book. Much more satisfactory are the designs for chimney-pieces in the Egyptian Taste by George Wightwick (1802–72), who was a partner and successor of Foulston (pl. XXIV*a*).[29] Egyptianizing chimney-pots, fireplaces, boot-scrapers, and even entrances, became not unusual in domestic architecture after Belzoni's discoveries and exhibitions: a fine range of sphinxes and obelisks occurs at Richmond Avenue in North London dating from the 1830s and 1840s (pl. XXII*c*).

The Egyptian Court at the Crystal Palace, Sydenham,[30] by Owen Jones and Joseph Bonomi Junior, was intended for educational purposes. The huge figures based on those at Abu Simbel were photographed in 1854 by Delamotte shortly after they were completed,[31] and made a staggering impact on the Victorian public.

As a style, the Egyptian Revival was associated with Freemasonry, especially on the European continent.[32] In Great Britain there are two spectacular Masonic Halls in the Egyptian manner, one in Mainridge, Boston, Lincolnshire (pl. XXIV*b*),[33] and the other in Edinburgh. The Boston Hall is based on a Nubian temple that was illustrated in Denon's *Voyage . . .*, and has a massive façade of gault brick with stone dressings. There is a distyle *in antis* portico of columns with palm-capitals, and the cavetto cornice is adorned with a winged solar orb supported with cobras. The inscription in hieroglyphs records that in the twenty-third year of Queen Victoria's reign the building was erected.

As previously noted, the pylon form is ideally suited for dams, and can be found in

PLATE XX

a. Temple Mills at Leeds by Joseph Bonomi Junior and James Combe
b. The gardens at Biddulph Grange, Staffs.

PLATE XXI

b. Standard Egyptianizing mausoleum in Kensal Green Cemetery, London

a. The Egyptian Avenue at Highgate Cemetery, London

PLATE XXII

a. Parsee tombs in Brookwood Cemetery, near Woking, Surrey

b. Egyptianized façade, *c.* 1830, at 42 Fore Street, Hertford

c. Sphinxes at Richmond Avenue, London

PLATE XXIII

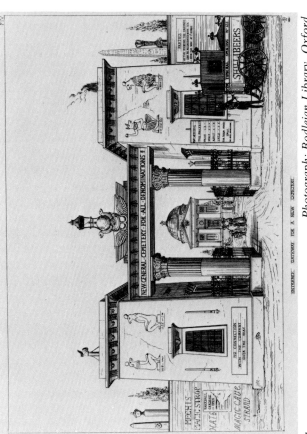

Photograph: Bodleian Library, Oxford

a. Lampoon published in Pugin's *Apology*. . . .
b. Richard Brown's design for an Egyptian house (from Brown's *Domestic Architecture* . . . , pl. XXVIII)

PLATE XXIV

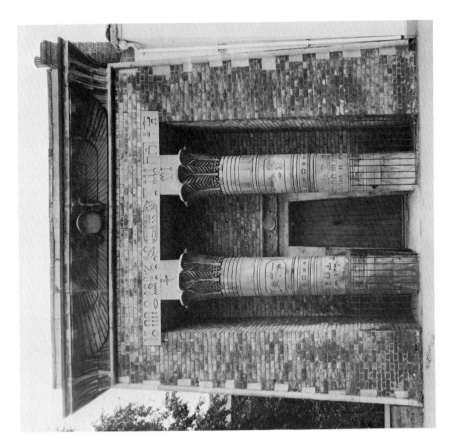

Photograph: R.I.B.A.

b. Masonic Hall at Boston, Lincs.

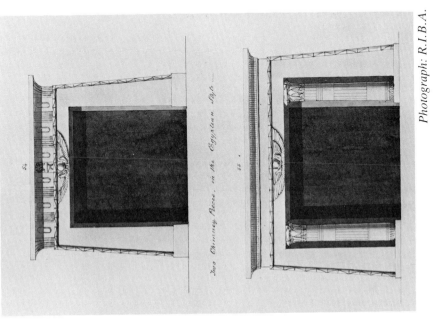

a. Chimney-pieces by George Wightwick. British Architectural Library Drawings Collection

PLATE XXV

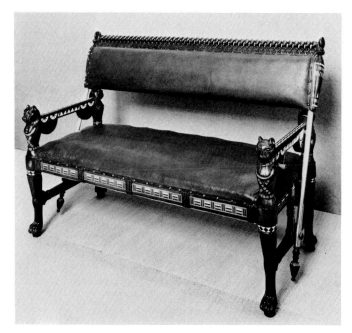

a. Sofa by Christopher Dresser

b. Liberty's Thebes Stool

Photographs: Victoria and Albert Museum

PLATE XXVI

Photograph: Mitchell Library, Glasgow

Thomson's Queen's Park Church, Glasgow

buildings associated with reservoirs and waterworks. An excellent example of a waterworks building occurs at East Farleigh in Kent,[34] designed by James Pilbrow, of 1860.

Very fine Egyptian Revival details were incorporated in a sofa of 1880 (pl. XXV*a*) by that most interesting designer, Christopher Dresser, who used leopard-headed *monopodia* and brilliant colouring.[35] Owen Jones, too, inspired a wooden stool of 1870 that was painted with designs from his indispensable *Grammar of Ornament*[36] of 1856. Even more spectacular is a wardrobe of 1878–80 made of oak and pine and painted with Egyptian motifs.[37]

The erection of 'Cleopatra's Needle' in 1878 (it had been given to the nation in 1819 as a memorial to Nelson and Abercromby) required a special base and flanking sphinxes to set it off. The sphinxes were designed by Vulliamy and were cast by Young and Company. Even the cast-iron seat-supports along the embankment near the obelisk have Egyptianizing detail.[38]

The popularization of the Egyptian style owed not a little to the paintings and engravings of John Martin (1789–1854).[39] His huge visionary and apocalyptic scenes with biblical and oriental settings, like the *Seventh Plague of Egypt*, exerted a great influence on taste in Europe and America. His work was honoured by Charles X and by Louis-Philippe, and attracted the admiration of Sainte-Beuve, Victor Hugo, and Gautier, among others. He was, in short, a master of Sublime Terror. Martin greatly influenced the misnamed Alexander 'Greek' Thomson,[40] who used Egyptian motifs with considerable flair and often with genius. His St Vincent Street Church in Glasgow of 1859 has pylons that break through the side walls of the aisle, while his Queen's Park Church of 1867 (pl. XXVI) has marked Egyptianizing detail, including the columns, pylons, and square-piered clerestory, a device much used by Karl Friedrich Schinkel some forty years earlier in Berlin. The Egyptian Hall in Union Street of 1871–3 has a remarkable number of items derived from Ancient Egyptian architecture in its composition, and has a vigorous and inventive façade. Finally, his villa at 200 Nithsdale Road of 1871 has Egyptian columns, simplified blocky detail, and Egyptianizing chimney-pots. All Thomson's work is in Glasgow or in the immediate vicinity.[41]

My last example of Victorian design in the Egyptian Taste is a very beautiful stool based on an Ancient Egyptian original found at Thebes (pl. XXV*b*).[42] It was called the Thebes Stool, was marketed from 1884 by Liberty's, and was made of mahogany with a leather seat. Egyptian elements were used by Holman Hunt, Godwin, Alma-Tadema, Poynter, and many other Victorian artists and designers. The style remained a potent source for creative work, receiving renewed vigour from the works of Bugatti, from the discovery of Tutankhamun's tomb, from the 1925 Paris *Exposition*, from the great Hollywood spectaculars of the 1920s, 1930s, and 1940s, and from the Tutankhamun Exhibition in the 1970s. It is still very much alive and well.[43]

NOTES

[1] J. S. Curl, *The Egyptian Revival. An Introductory Study of a Recurring Theme in the History of Taste* (London, Boston, and Sydney, 1982), 65–7.

[2] D. Vivant Denon, *Voyage dans la Basse et la Haute Égypte pendant les campagnes du Général Bonaparte* (Paris, 1802).

[3] A. C. Quatremère de Quincy, *De L'Architecture Égyptienne, Considérée Dans son origine Ses*

principes et son goût, et comparée Sous les mêmes rapports à L'Architecture Grecque. DISSERTA-TION Qui a remporté, en 1785, Le Prix proposé par L'Académie des Inscriptions et Belles-Lettres (Paris, 1803).

[4] C.-N. Ledoux, *L'Architecture considérée sous le rapport de l'art, des mœurs et de la législation* (Paris, 1804–6).

[5] Commission des Monuments d'Égypte. *Description de l'Égypte, ou Recueil des observations et des recherches qui ont été faites en Égypte pendant l'expédition de l'armée française, publié par les ordres de Sa Majesté l'empereur Napoléon le Grand* (Paris, 1809–28).

[6] J. Stuart and N. Revett, *The Antiquities of Athens, measured and delineated by James Stuart, F.R.S. and F.S.A., and Nicholas Revett, painters and architects* (London, 1762–95).

[7] D. Watkin, *Thomas Hope 1769–1831 and the Neo-Classical Idea* (London, 1968).

[8] Curl, *op. cit.* (note 1), 103, 104–5, 134, 143, 150, 168.

[9] *Ibid.*, 124.

[10] *Ibid.*, 124, 127, 128, 129, 175, 182.

[11] J. Foulston, *The Public Buildings Erected in the West of England* (London, 1838). See also Curl, *op. cit.* (note 1), 129–31, 173, 175, 179.

[12] *Ibid.*, 130–3.

[13] *Ibid.*, 133. See also W. H. Smyth, *Aedes Hartwellianae* (London, 1851).

[14] E. de Mare, *The Bridges of Britain* (London, 1954). See also Curl, *op. cit.* (note 1), 133.

[15] *Ibid., passim.*

[16] *Ibid.*, 110.

[17] *Ibid.*, 151–2.

[18] *Ibid.*

[19] J. S. Curl, *A Celebration of Death. An Introduction to some of the Buildings, Monuments, and Settings of Funerary Architecture in the Western European Tradition* (London and New York, 1980).

[20] Curl, *op. cit.* (note 1), 161–2. See also, *id.* (note 19), 222–3.

[21] Curl, *op. cit.* (note 1), 161, 164; *id.* (note 19), 224–8.

[22] Curl, *op. cit.* (note 1), 165; *id.* (note 19), 238, 239.

[23] Curl, *op. cit.* (note 1), 167; *id.* (note 19), 288–90.

[24] A. W. Pugin, *An Apology for the Revival of Christian Architecture in England* (London, 1843).

[25] *Ibid.*, 12. See also Curl, *op. cit.* (note 1), 169.

[26] *Ibid.*, 181; *id.* (note 19), 201–3.

[27] R. Brown, *Domestic Architecture: containing a history of the science, and the principles of designing Public Edifices, Private Dwelling-Houses, Country Mansions, and Suburban Villas*, etc. (London, 1842).

[28] H. Colvin, *A Biographical Dictionary of British Architects 1600–1840* (London, 1978), 147.

[29] Curl, *op. cit.* (note 1), 175, 178, 179.

[30] *Ibid.*, 178–81.

[31] Reproduced *ibid.*, 180.

[32] *Ibid.*, 3, 33, 63–4, 65, 66, 69, 73, 83–8, 89, 103, 188.

[33] Reproduced *ibid.*, 181–2.

[34] *Ibid.*, 183–4.

[35] *Ibid.*, 184–5.

[36] *Ibid.*, 184–5.

[37] *Ibid.*, 184, 186.

[38] *Ibid.*, 187–8.

[39] *Ibid.*, 188–9.

[40] *Ibid.*, 189–92.

[41] R. McFadzean, *The Life and Work of Alexander Thomson* (London, Boston, and Henley, 1979).

[42] Reproduced in Curl, *op. cit.* (note 1), 193.

[43] P. Conner (ed.), *The Inspiration of Egypt. Its Influence on British Artists, Travellers and Designers, 1700–1900* (Brighton, 1983).

'Wedding Archaeology to Art': Poynter's *Israel in Egypt*

Patrick Conner

Israel in Egypt (pl. XXVII) was the sensation of the 1867 season at the Royal Academy. Like Frederic Leighton's painting of *Cimabue's Madonna* in 1855, it brought immediate fame to a young and relatively obscure artist. In the words of the *Illustrated London News:*

> It is not merely one of the largest, most ably painted, and probably the most elaborate, but it is incontestably the most original picture in the exhibition. The painter presents, with every evidence of having fully profited by recent Egypto-logical research, a grand 'restoration' of ancient Thebes in all the glories of the pyramids and pylons, the temples and colossal statues of the Pharaonic period . . . [It is] a typical example of the successful application of the modern principle of wedding archaeology to art.[1]

Some anxiety was expressed over the theme of Poynter's picture: the *Art Journal* found it 'a disagreeable, not to say revolting subject'.[2] But there were no doubts as to what the same reviewer called its 'general historic correctness'. The *Athenaeum* declared it 'a mine of archaeological knowledge',[3] while the *Times,* regarding the picture as 'a reproduction of antique life showing extraordinary industry and research', shared (or perhaps originated) the notion that the scene was intended to be 'the avenue at Thebes', which the reviewer believed was flanked by colossal statues such as Poynter depicted.[4]

Before discussing the location—or locations—of the scene, we may briefly consider the context and the origins of Poynter's picture. Subject paintings set in ancient Egypt, with Old Testament theme and cast of thousands, had flourished in Britain forty years before, and the fashion for such works was already waning in 1838 when the first British artists in oils went out to Egypt; from 1840 onwards, visitors to the Academy could see the remains of ancient Egypt portrayed by artists (led by David Roberts and William Müller) who had seen them at first hand.[5] It was not until the 1860s that artistic 'reconstructions' of ancient Egypt again caught the imagination of

artists and public. Alma-Tadema began to work in this genre in 1859, creating *The Sad Father* (or *Death of the First-Born*), and in 1863 he painted the remarkable *Pastimes in Ancient Egypt: 3,000 Years Ago*, which broke new ground in portraying an ancient Egyptian interior, with figures and furnishings carefully derived from recent publications and from objects in the British Museum.[6] Twelve more Egyptian pictures were to follow from Alma-Tadema, all but one painted in the 1860s and 1870s.

Poynter himself had exhibited two Egyptian scenes at the Academy before *Israel in Egypt—On Guard in the Time of the Pharaohs* (1864) and *Offerings to Isis* (1866). He had also, moreover, contributed several drawings which were to be engraved in the Dalziels' *Bible Gallery*. Of the sixty-two woodcuts in this series, Poynter was responsible for twelve (more than any other artist), and he seems to have specialized in Egyptian subjects, which account for seven of them. Several features which were to reappear in *Israel in Egypt*—not least the lion—can be seen in these prints. The immediate genesis of the painting was a two-hour sketch which Poynter drew at a meeting of the Langham Sketching Club in 1862, on the prescribed subject of 'work'.[7] So favourable was the response from his fellow members ('spontaneous exclamations of surprise and admiration')[8] that he decided to work up the composition as a substantial painting.

Edward Poynter was the son of an architect, and was eager to promote what he called the artistic side of architecture. Observing that Turner had been 'apprenticed to an architect', he told his audience at the Slade School in October 1874 that he could imagine no better preparation for a student of painting, and suggested that this education had inspired Turner's epic scenes of ancient Rome and Carthage. 'I doubt if there be half-a-dozen figure-painters in England at the present time who could introduce correctly a background of Classical or Gothic architecture into their pictures, much less design one. Therefore, I intend to make this an important object of study in this school . . .'[9]

This insistence on 'correctness' he no doubt inherited from his father, Ambrose Poynter, F.S.A., who, like his son, was closely involved in art education, and who both in print and in architectural practice was much concerned with authenticity in Romanesque and Gothic design.[10] On the other hand, 'correctness' in a Gothic Revival church meant something significantly different from 'correctness' in a painting which evoked an ancient civilization. It is similarly misleading to apply the term 'archaeological' both to the architectural revivalists of the 1840s and 1850s, who sought to reproduce earlier styles in historical, homogeneous detail, and to *Israel in Egypt*, which in a clear sense is wilfully incorrect and historically false. Its assemblage of Egyptian architecture is taken from periods ranging from the Old Kingdom to the Roman period, a span of some 3,000 years. The temple complex which Poynter placed by the foot of the Great Pyramid, in the left distance, can be identified as that of Philae in Upper Egypt, with the small Roman temple known as 'Pharaoh's Bed' or 'Trajan's Kiosk' picked out in darker colour—although, as Poynter and every Victorian schoolboy would have known, a structure dating from the Christian era could hardly have appeared during the Israelites' captivity in Egypt.

Equally remarkable is the geographical spread of the monuments represented. They include (north to south) the obelisk at Heliopolis, the Great Pyramid of Giza, the mountains of the west bank at Thebes and the Temple of Seti I at Gourna (shown behind the principal lion), the pylon gateways of the temple at Edfu (somewhat

adapted), and the Philae complex. The colossal seated statues at the right of the picture are loosely based on the black granite figures of Amenophis III brought back by Belzoni from Thebes to the British Museum. This geographical disparity did not escape comment at the time of the picture's exhibition—'It has been objected that the lion here painted was found four hundred miles away from the pyramid in the background'[11]—but such objections were drowned by the chorus of praise.

And so they should have been, we may believe; an artist should surely be allowed a few anachronisms, and a certain licence in the matter of topography, in re-creating an Old Testament episode. This paper does not seek to belittle Poynter's achievement, but simply to suggest that 'correctness' and 'archaeology' were very flexible concepts in the context of pictures of historical subjects. *Israel in Egypt* belongs to the tradition of the grand capriccios painted in the 1820s by John Martin, Francis Danby and David Roberts, which included such Egyptian motifs and monuments as were published in easily accessible source-books, and which reorganized these elements according to the dictates of the composition, with little regard for historical plausibility. Since that time, however, the artist's task of reconstruction had been facilitated by the publication of J. G. Wilkinson's *Manners and Customs of the Ancient Egyptians* (1837), which illustrated the implements and trappings of everyday life revealed in Egyptian tombs and tomb-paintings. Poynter may well have consulted Wilkinson's volumes for such details as the spoked wheel of the cart, the palanquin and parasols at the left, and the method of transporting massive statuary on rollers.[12] Nevertheless, he did not take the option which Wilkinson had made feasible—that of portraying a scene of ancient Egyptian life as it could conceivably have been.

This was the course adopted by Alma-Tadema in his Egyptian works, some of which even include cartouches giving the names of the pharaoh or emperor in whose reign the episode depicted was supposed to have taken place.[13] Although Alma-Tadema sometimes included incongrous elements, he evidently pursued an ideal of historical consistency; the same intent can be seen in Valentine Prinsep's *Death of Cleopatra*,[14] exhibited at the Royal Academy in 1870, which attempted to provide an appropriately Romano-Egyptian background with a figure-statue of Antinous and Ptolemaic capitals. On the other hand, Frederic Leighton's paintings of leisured life in ancient Greece and Rome frequently indulge in anachronisms in their use of classical vases, whose shapes the artist was quite prepared to modify.[15] *Israel in Egypt* is closer in principle to Leighton's practice than to Alma-Tadema's. Poynter did not scruple to exaggerate the scale of the lion statues and the seated colossi, nor to include a hand-cart, which is quite uncharacteristic of pharaonic Egypt.

These considerations help to explain why Poynter chose a lion as the focal point of his picture, rather than a sphinx, which might have been more evocative of Egypt and also more plausible from an archaeological point of view. The British Museum was not well supplied with sphinxes, but did possess a pair of magnificent granite lions of the 18th Dynasty, which originally guarded the approach to the temple of Soleb in Nubia: Lord Prudhoe had found them at Gebel Barkal, and transported them to the British Museum, where they were displayed in 1835. Crayon sketches by Poynter of one of the lions, together with figures which were to appear in *Israel in Egypt,* survive in the Musuem's collection;[16] the artist had lodgings opposite the Museum, and must have known the lion sculptures well. He would also have known the pair of 30th-Dynasty lions from the Isaeum Campense in Rome, which Piranesi had admired at the Acqua Felice fountains and which are now in the Vatican Museum.[17] The type of

PLATE XXVII

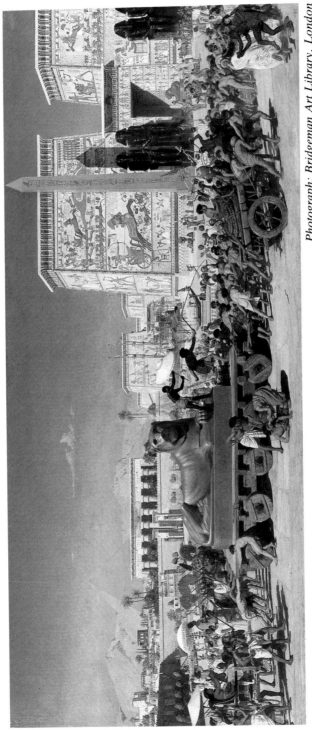

Sir Edward J. Poynter, *Israel in Egypt*, 1867; oil on canvas; 137·2×317·5 cm.; signed 'E.J.P.' and dated 1867. Guildhall Art Gallery, Corporation of London

PLATE XXVIII

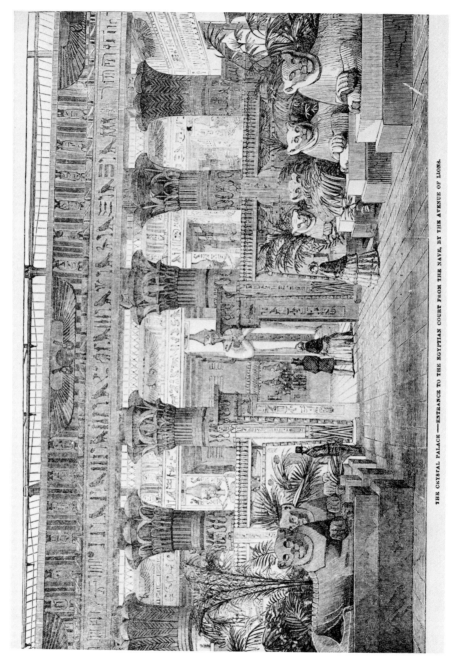

THE CRYSTAL PALACE.—ENTRANCE TO THE EGYPTIAN COURT FROM THE NAVE, BY THE AVENUE OF LIONS.

The Egyptian Court at the Crystal Palace, Sydenham (from the *Illustrated London News*, 5th August 1854)

PLATE XXIX

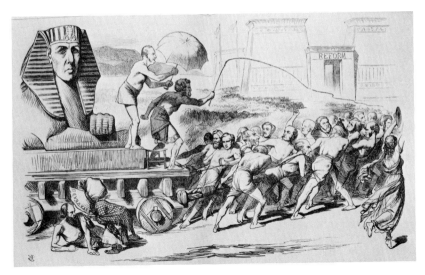

a. 'D'Israeli in Triumph; or, The Modern Sphynx' (from *Punch*, 15th June 1867)

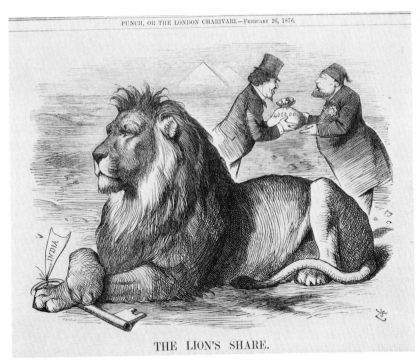

b. 'The Lion's Share' (from *Punch*, 26th February 1876)

lion with head turned to one side and forepaws crossed was characteristically Egyptian: to that extent Poynter's 'archaeology' cannot be faulted.[18]

'Prudhoe's lions' were, moreover, celebrated as works of art. Their 'noble conventionalism' was praised by Ruskin[19] (who was later to embark on a bitter dispute with Poynter), and Owen Jones thought them superior to Canova's 'attempted imitation of a natural lion'.[20] Owen Jones and Joseph Bonomi were chiefly responsible for the Egyptian Court built in the Crystal Palace at Sydenham in 1854, for which casts of the 'Prudhoe lions' had been made: not content with a pair, however, they had created an avenue of lions (see pl. XXVIII), on the principle of the avenues of ram-headed sphinxes at Karnak. The lion avenue at Sydenham could be regarded as archaeological absurdity, for whereas the guardian-sphinxes at Karnak face forward so that each pair in turn scrutinizes the advancing visitor, the Sydenham lions face only the back of the lions in front of them. Nevertheless, Poynter seems to have followed this example, in creating an avenue of lions (visible in front of the further pylon, above the slave-driver's lash), soon to be augmented by the pair which is shown approaching the first pylon. Possibly the *Art Journal's* remark that Poynter's principal lion 'looks less granite than painted plaster or canvas'[21] was a sly allusion to the Crystal Palace replicas.

The foreground lion also solved, or went some way to solving, a purely pictorial problem. Procession scenes are liable to present the spectator with a monotonous series of profiles. Some of the figures may be made to turn aside or around *à la* Mantegna, but not without a degree of awkwardness. In *Israel in Egypt*, the task of heaving the statue has enabled some of the figures to face left naturally enough, but the artist's greatest asset is the lion itself, with its head turned 90 degrees to face the onlooker. Having witnessed the development of *Cimabue's Madonna* in Leighton's studio, Poynter was well aware of the problem; he was present when Peter von Cornelius proposed that Leighton re-draw the group of figures at the front of the procession so that they were turned towards the spectator—a suggestion which Leighton finally adopted.[22] According to one account, the suggestion came not from Cornelius, but from Sartoris and Poynter.[23]

It is fair to say, then, that where pictorial considerations might clash with archaeological scholarship, Poynter (like Leighton) was inclined to sacrifice the latter. But this does not in itself account for Poynter's apparently perverse desire to bring together wildly disparate elements within a single frame. For a clue to this mentality we may return to the Egyptian Court at the Crystal Palace, Here, indeed, was eclecticism in extreme form, a display of diverse examples of Egyptian architecture and sculpture, derived from Abu Simbel, Beni Hassan, the Ramesseum, Medinet Habu, Edfu and other Ptolemaic and Romano-Egyptian temples. At Sydenham, as in Poynter's painting, much of the sculpture was reproduced out of scale. Even the 'Ptolemaic' temple at Sydenham was a conglomerate, its outer walls and columns 'copied from the best specimens of the order in various parts of Egypt'.[24] On the frieze above the columns were genuine hieroglyphs, but when deciphered they were found to be a tribute to Queen Victoria, ruler of the waves.

The Egyptian Court was a magnificent oddity, an attempt to inculcate knowledge and 'taste' in a thousand dislocated fragments. Something of its spirit pervades *Israel in Egypt* also; it is not so much an urge to didacticism—although this was perhaps an element in Poynter's character—as a desire to incorporate within firmly drawn boundaries all that was most striking and characteristic in an alien civilization. And it

may not be entirely coincidental that British economic and political interest in Egypt was growing rapidly at the time. *Israel in Egypt* and the Suez Canal developed together (the former only a little more rapidly than the latter). Photographs of the Abu Simbel colossi in the Crystal Palace remind us now of a Roman triumph, in which exotic chieftains, captured and transported by some proconsular army, are exhibited to the populace as tokens of the might of Rome. *Israel in Egypt* can be seen in the same light, as the response of an Englishman to the fabled treasures of an unseen land, his imagined collection of the 'best specimens' placed on view like exhibits in a Victorian museum without regard for the meaning of each in its original context. Poynter's 'Egypt' is the Egyptian Court on canvas, an attempt to capture and contain the essence of an ancient culture within the familiar limits of a picture-frame.

It would be simplistic to interpret the painting as an expression of British territorial cupidity, a foreshadowing of the day when Britain would take control of the 'treasure-cities' of Egypt. It is only in retrospect that we become aware of a parallel between the Old Testament episode depicted by Poynter and the reality of Egypt in the 1860s, where huge numbers of *fellahin* were compelled to work at starvation wages on the European project to build the Suez Canal. Those who reviewed the painting conspicuously omitted to refer to its modern-day equivalent, and no doubt they would have been shocked by the suggestion that the two situations were in any way comparable. The Old Testament episode was seen as the epitome of brutal tyranny, 'a disagreeable subject' indeed, whereas the use of forced labour on the Canal was justified by the advantages in trade and communications which the Canal would bring, and also by the notion that compulsion was 'the only way to manage Arabs'.[25]

Yet the symbolic potential of Poynter's work was not entirely lost on his contemporaries. A month after the opening of the 1867 exhibition at the Royal Academy, *Punch* published a caricature by Tenniel entitled 'D'Israeli in Triumph; or, The Modern Sphynx' (pl. XXIXa),[26] in which an impassive Disraeli compels Gladstone and other unwilling subjects to carry him to the gates of Reform. Disraeli's purchase of the Khedive Ismail's stake in the Suez Canal, a major step on the road to the 'veiled Protectorate', is represented by Tenniel more subtly (pl. XXIXb).[27] As money changes hands, the British Lion settles down on Egyptian soil, holding fast the key to India. The lion differs from Landseer's masculine creatures, the guardians of Nelson's Column, in one crucial respect: one of its forepaws is folded over the other, in the Egyptian manner celebrated by Poynter. Britannia has usurped the symbol of pharaonic dominion.

NOTES

[1] *Illustrated London News,* 11th May 1867, 478.
[2] *Art Journal,* May 1867, 139.
[3] *Athenaeum,* 11th May 1867, 628.
[4] *Times,* 4th May 1867, 12 (and see 9th May 1867, 7).
[5] See P. R. M. Conner (ed.), *The Inspiration of Egypt* (Brighton Museums and Art Gallery, 1983), 75 ff., 115 ff.
[6] See M. J. Raven, 'Alma-Tadema als amateur-egyptoloog', *Bull. van het Rijksmuseum,* iii (1980), 103 ff.
[7] See W. Cosmo Monkhouse, 'The life and work of Sir E. J. Poynter', *Art Journal,* special number (Easter Art Annual) (1897), 10.

[8] A. Margaux, 'The art of Sir Edward J. Poynter, Bart., P.R.A.', *Windsor Mag.* xxi (1905), 67.

[9] E. J. Poynter, *Ten Lectures on Art* (1879), 215.

[10] For a summary of Ambrose Poynter's career see H. Colvin, *A Biographical Dictionary of British Architects 1600–1840* (London, 1978), 656–8.

[11] *Op. cit.* (note 2), 67.

[12] Sir John Wilkinson, *Manners and Customs of the Ancient Egyptians* (1837), I, 354–5; II, 207–8; III, 179, 328.

[13] See Raven, *op. cit.* (note 6).

[14] Illustrated in Sotheby's Belgravia catalogue, 10th April 1973, lot 174. Like *Israel in Egypt*, this picture uses the device of incense smoke to lend an effect of distance to the background.

[15] See I. Jenkins, 'Frederic Lord Leighton and Greek vases', *Burlington Mag.* cxxv (October 1983), 597–605.

[16] See Conner, *op. cit.* (note 5), 138.

[17] G. B. Piranesi, *Diverse maniere d'adornare i cammini* (1769), 14.

[18] See A. Roullet, *The Egyptian and Egyptianizing Monuments of Imperial Rome* (Leiden, 1972), 130 ff. Most examples of this type are, however, associated with the Late Period.

[19] *The Works of John Ruskin*, ed. E. T. Cook and A. Wedderburn (1903–12), IV, 303 and XII, 111.

[20] O. Jones *et al.*, *Description of the Egyptian Court; Erected in the Crystal Palace . . .* (1854), 13.

[21] *Op. cit.* (note 2), 67.

[22] See L. and R. Ormond, *Lord Leighton* (Yale, 1975), 27.

[23] Monkhouse, *op. cit.* (note 7), 4.

[24] Jones, *op. cit.* (note 20), 15.

[25] See Lucy Duff Gordon, *Letters from Egypt* (1983 edn.), 65 (1st edn. 1865).

[26] *Punch*, 15th June 1867. For Disraeli in the guise of Sphinx see also 11th December 1875, 15th July 1876, and 25th November 1876.

[27] *Punch*, 26th February 1876.

The Islamic Inspiration.
John Frederick Lewis: Painter
of Islamic Egypt

Briony Llewellyn

'Our current hypothesis about Mahomet, that he was a scheming Imposter, a Falsehood incarnate, that his religion is a mere mass of quackery and fatuity, begins really to be now untenable to anyone. The lies which well-meaning zeal has heaped around this man are disgraceful to ourselves only.'

In his lecture, 'The Hero as Prophet', given in London in May 1840,[1] Thomas Carlyle summed up current attitudes towards the Prophet of Islam in order to refute them and to express his own quite contrary views. Brushing aside the myths and exaggeration, he attempted to explain what Muhammad actually represented, insisting on his sincerity of belief and action. Carlyle's reappraisal of Muhammad and his religion was in advance of his time, but it was also a manifestation of the increasing awareness of the lands of Islam that was emerging towards the mid nineteenth century. Gradually the people and culture of North Africa and the Near East were becoming better known to the West, not only to travellers, but, through their published accounts and through artists' images, also to a wider public. Responses to these countries nevertheless varied greatly, determined both by individual personalities and by more general sociological factors. On the whole, attitudes to Islam itself were unsympathetic, and while a few intellectuals shared Carlyle's views, popular opinion of Islam was expressed by Chateaubriand: 'a religion hostile to civilization, systematically favourable to ignorance, despotism and slavery'.[2]

Many British artists travelled to the Orient during the nineteenth century and depicted its subject matter, but only a few attempted to comprehend the true nature of its contemporary Islamic culture. Some virtually ignored it, preferring its ancient ruins or its landscape, others valued it primarily for its evocation of the Bible, and most overlaid it with the sentiments of their own western society. Architects who studied and drew its mosques, tombs and secular buildings were concerned more with

their structure and decoration than with their underlying purpose.³ Islam itself was not a strong influence on Victorian art as a whole. In its wider role as the creator of an entire society, rather than in its narrow religious sense, it was, however, a potent source of inspiration for one Victorian artist, John Frederick Lewis. For him the attraction of the East lay not in its antiquities, or in its biblical associations, but in its contemporary life. His subjects were its people: in their houses and shops, in the streets, and in the rural areas and deserts. He was not the only Victorian artist who depicted these subjects, but he, to a greater extent than his fellows, as a comparison with some of them will reveal, was able to portray these aspects of a Muslim society in its own rather than in European terms.

Before this claim is substantiated, a brief indication of what was known or believed about Islam in the early decades of the nineteenth century, and how British artists reacted to it, should provide a background to later representations of Orientalist subjects.

Since the Crusades, the Islamic religion and the society it generated, particularly in relation to women, had been generally regarded with abhorrence. Muhammad represented evil incarnate; he was a false prophet who imposed his creed with force and violence and who promoted immorality. His followers were wicked tyrants and impious blasphemers who indulged in a variety of sinful pursuits. They were, nevertheless, objects of a piquant curiosity. *The Arabian Nights*, translated into French, and from that into English, early in the eighteenth century, embodied all the pleasures of the flesh which Christians associated with 'Muhammadanism'. They conjured up images of voluptuous houris, wonder-working genii, sweet-scented gardens, luxurious palaces and glittering treasure. This fantasy was extremely alluring, and from the late eighteenth to early nineteenth century, the *Nights* inspired a whole host of oriental tales written in their likeness, notably William Beckford's *Vathek* (1786), Robert Southey's *Thalaba the Destroyer* (1801) and Thomas Moore's *Lalla Rookh* (1817). Oriental imagery plays a major part in several of Byron's poems and, while stimulating an interest in the fabulous Orient, he too perpetrated the concept of the vile and degenerate Turk. Richard Parkes Bonington was one of several artists inspired by his example, and although he never visited the East several of his watercolours are of romantically conceived oriental subjects: for example, *Turk Reposing* (1826).⁴

Several artists did travel eastwards in the early nineteenth century in search of the exotic imagery evoked by Byron and his like, but they still saw its people and customs in the light of romantic sentiment. Sir William Allan spent several years in the 1800s and again in the 1820s in Turkey and on its north-eastern borders. Despite this first-hand experience, his pictorial representation of its people was conditioned by romantic ideology rather than by reality: hence the heightened emotion and drama of *The Slave Market, Constantinople* (pl. XXXIa).⁵

Gradually, however, the demand for factual information about the East in travel books and compendia of costumes and manners increased. Thomas Allom was one artist who illustrated such books with images of Islamic types and customs. His *Turkish Scribe*, lithographed *c.* 1840 in his *Character and Costume in Turkey and Italy*, is, despite its sugary appearance, based on reality, and it includes in the background a man performing the ritual ablutions or *abdest* before entering the mosque.⁶ In 1836 the first really thorough and factual survey of an eastern people appeared. E. W. Lane's *An Account of the Manners and Customs of the Modern*

PLATE XXX

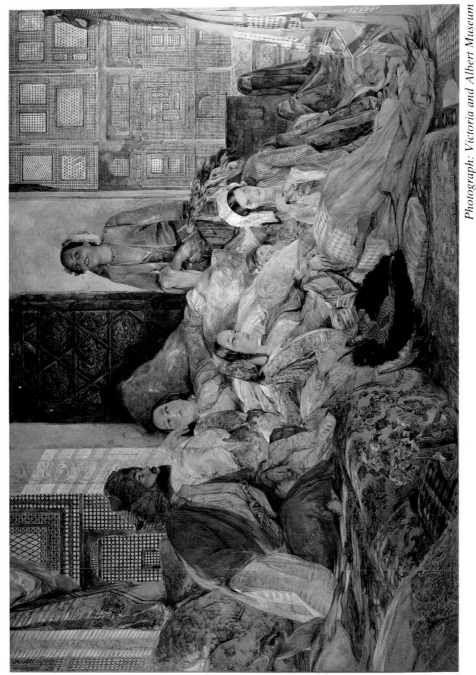

John Frederick Lewis, *The Hhareem*, c. 1850; watercolour and bodycolour on paper; 47×67·3 cm. Victoria and Albert Museum, London

PLATE XXXI

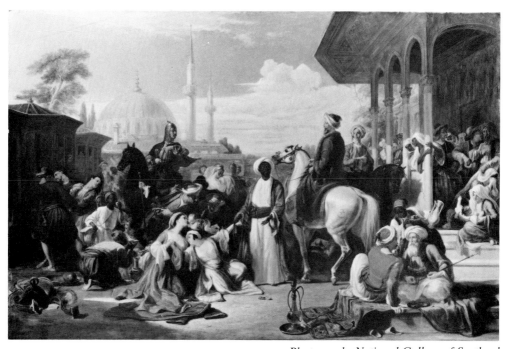

a. Sir William Allan, *The Slave Market, Constantinople,* 1838; oil on panel; 129×198 cm.; signed and dated 'William Allan pinxt 1838'. National Gallery of Scotland, Edinburgh

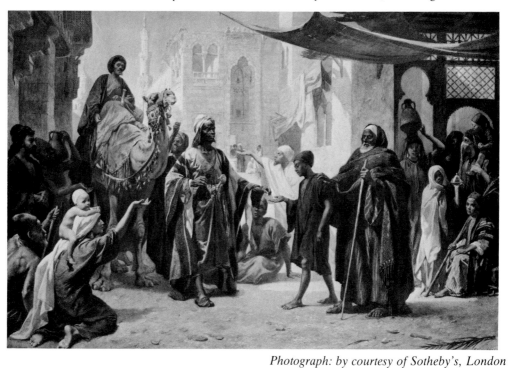

b. Frederick Goodall, *Sheik distributing Alms,* 1865; watercolour over pencil; 51×87 cm.; signed and dated 'F. Goodall RA 1865'. Private collection

PLATE XXXII

b. John Frederick Lewis, *And the Prayer of the Faith shall save the Sick*, 1872; watercolour and bodycolour on paper; 58·6×45·7 cm.; signed and dated 'J. F. Lewis RA 1872'. Private collection

a. John Frederick Lewis, *Indoor Gossip, Cairo*, 1873; oil on panel; 30·5×20·3 cm.; signed and dated 'J. F. Lewis RA 1873'. Whitworth Art Gallery, University of Manchester

PLATE XXXIII

Photograph: by courtesy of Sotheby's, London

b. Frederic, Lord Leighton, *The Light of the Harem*, c. 1880; oil on canvas; 122×81 cm.; inscribed on a label on the stretcher. Private collection

Photograph: by courtesy of Eyre & Hobhouse Ltd, London

a. Henry Warren, *The Song of the Georgian Maid*, 1858; water-colour and bodycolour; 106·5 (within ogival mount) ×77 cm.; signed 'Henry Warren'. Private collection

PLATE XXXIV

Photograph: by courtesy of The Fine Art Society, London
John Frederick Lewis, *The Bezestein Bazaar of El Khan Khalil, Cairo,* 1872; oil on panel;
113×85 cm.; signed and dated 'J. F. Lewis 1872'. Private collection

PLATE XXXV

Photograph: Guildhall Library, London

a. Frederick Goodall, *Early Morning in the Wilderness of Shur,* 1860; oil on canvas; 109×305 cm.; signed and dated 'Frederick Goodall 1860'. Guildhall Art Gallery, Corporation of London

Photograph: Victoria and Albert Museum

b. John Frederick Lewis, *A Halt in the Desert,* 1855; watercolour and bodycolour; 37×50 cm.; signed and dated 'J. F. Lewis 1855'. Victoria and Albert Museum, London

Egyptians (1836) described in painstaking detail every aspect of the Muslim way of life, as practised in Egypt. Not only was the doctrine and ritual of Islamic belief clearly delineated, but also its application to everyday existence. For the first time an oriental culture was seen as a living and coherent entity.

A few years later (1838–41) Lane's translation of *The Arabian Nights* was published. The explanatory notes which accompanied this further undermined the vague notions of the Orient derived from previous translations and redefined them in terms of the reality on which the tales were founded. They revealed that many of the settings of the stories had a precise location and that the objects and manners described had a specific character and purpose. Perhaps surprisingly, the significance of both these publications was recognized at the time. The *Athenaeum* of October 1838 carried a long review of the first part of *The Arabian Nights*, acknowledging the notes as its most informative component:

> Mr. Lane's residence in Egypt has enabled him to acquire so complete a knowledge of the language, manners and customs of the Egyptian Arabs, that he has suc-ceeded in giving us, in a series of illustrative notes appended to the several chapters, a faithful, and, as it were living picture of the East. Indeed we know of no traveller or writer who has let us so fully into the privacy of domestic life among the Arabs; his notes on the baths, on dress and on furniture, on the meals and manner of eating, on hunting and hawking, are invaluable; his historical illustrations are also numerous and well-selected; in fact the book, when finished, will be the most complete manual of Eastern manners which has ever been published.[7]

Far from destroying the exotic vision of the East engendered by *The Arabian Nights* and other oriental tales, Lane showed that they could be directly experienced. Improved communications in the 1840s meant that travellers could discover for themselves the world Lane had revealed. His books could assist their understanding of the alien culture which confronted them and artists in particular could use his detailed descriptions as an aid to accurate representation. When painting *Prayers in the Desert* (1843), William Müller may have consulted the relevant passages and illustrations in Lane's *Modern Egyptians* to remind himself of the exact positions adopted by Muslims at prayer. William Holman Hunt's *A Street Scene in Cairo: the Lantern Maker's Courtship* was exhibited at the 1861 Royal Academy with a quotation from Lane in the catalogue.[8]

The most extensive visual counterparts to Lane were the oriental pictures of J. F. Lewis, although whether by design or chance is not clear. Lewis probably knew Lane's two books, whose publication just preceded his arrival in the East. Direct communication between the two men would also have been possible, since both were living in Cairo, in native style, during the 1840s.[9]

Lewis's mode of life in the East in part explains his attitude towards its society and his manner of representing it. Leaving England in 1837, he travelled to Italy, Greece and eventually Constantinople, arriving there in October 1840. The following November he sailed to Alexandria and spent the next nine and a half years in Cairo, occasionally visiting other parts of Egypt. As a British artist travelling to the East on his own resources, Lewis had recently been preceded by David Roberts, William Müller and Sir David Wilkie, but none of these had stayed more than a few months. Lewis was the first, and for many years the only, British artist to spend an extended

period in the Near East, as a resident rather than as a tourist. For nearly a decade, 1841–51, he lived in one of the old Cairo houses, totally immersing himself in the local way of life, just as Lane had done in the 1820s and 1830s and was doing in 1842–9. He appears to have made a deliberate effort to loosen the ties of his western culture so as to absorb more fully the customs of another. There were many English tourists in Cairo in the 1840s and Murray's *Handbook for Travellers in Egypt* (1847) mentioned Lewis's presence there, but he had little contact with his compatriots, although he certainly knew several members of the resident foreign community.[10] Only a few passing references by English visitors allow glimpses of Lewis's life in Cairo. His numerous sketches, some inscribed and dated, also indicate something of his activities. The rest must remain speculation based on what is known of Cairene society in the mid nineteenth century and of European reactions to it.

The most informative account is that of a former London club associate, William Makepeace Thackeray.[11] In Cairo at the end of a tour of the Levant in 1844 as the guest of the newly formed Peninsular and Orient Steam Navigation Company, he one day called on Lewis. From the narrow crowded street he was admitted to the house through a 'mysterious outer door' into a wide, picturesque courtyard, full of animals, from which 'rose up the walls of his long, queer, many-windowed, many galleried house'. Thackeray was then conducted into the large 'hall of audience', which had a ceiling 'carved, gilt, painted and embroidered with arabesques and choice sentences of Eastern writing' and a large bay window overlooking a garden. He was given a *narghile* pipe and soon his host appeared in a long yellow gown and red tarboosh, quite transformed from the London dandy he had known. 'When he goes abroad', Thackeray continued, 'he rides a grey horse with red housings, and has two servants to walk beside him. He wears a very handsome grave costume of dark blue, consisting of an embroidered jacket and gaiters, and a pair or trowsers which could have made a set of dresses for an English family. His beard curls nobly over his chest, his Damascus scimitar on his thigh. His red cap gives him a venerable and Bey-like appearance. There is no gew-gaw or parade about him . . .'. A sumptuous oriental dinner was then served, of 'delicate cucumbers stuffed with forced meats; yellow smoking pilaffs', kid and fowls, several vegetables and 'kibobs with an excellent sauce of plums and piquant herbs'; ending with 'ruby pomegranates'.

Here, then, is a picture of Lewis's oriental life, but, Thackeray hints, an incomplete one. From the courtyard he had noticed 'two of the most beautiful, enormous, ogling black eyes in the world' peering through a *mashrabiya* window, and he had wondered, 'Why the deuce was Zuleikah there'. When asked if it were her charms that kept him in Cairo away from the comforts of London life, Lewis retorted that she was only the black cook; for him the attraction of Egyptian life was 'the indulgence of laziness such as Europeans, Englishmen at least, don't know how to enjoy'. He had for the moment so completely discarded the restrictions imposed by Victorian convention and its commitment to industriousness and self-improvement that he was content to live 'like a languid Lotus-eater, a dreamy, lazy, hazy, tobbacofield life', just like the characters in *The Arabian Nights*, and like those in *The Hhareem*, the watercolour which in 1850 ended his long absence from the London exhibition galleries.

If no longer bound by Victorian rules of behaviour, it is unlikely that, living as he did as the master of an oriental household, he would have been able to ignore one of the basic customs of a Muslim society—the maintenance of at least one female slave.

In his compendium of Egyptian customs Lane had written: 'To abstain from marrying when a man has attained a sufficient age, and when there is no just impediment, is esteemed by the Egyptians improper and even disreputable.'[12] The very least one could do was to purchase a slave-girl. Lane himself had been censured for not conforming, but subsequently he had acquired a Greek girl, Nefeesah, whom he eventually married, and when in Cairo in the 1840s he maintained a respectable entourage consisting of his wife, sister and two nephews. It seems unlikely that for six years (before he married Marian Harper in 1847) Lewis would have been able to resist the social pressure, and therefore possible that the 'black-eyed Zuleikah' was his female slave. Only in this way would he have been able to acquire the first-hand experience—albeit limited—of a Muslim harem which his realistic portrayal of it suggests. Like Lane, he could have obtained further information about the harem system from his Egyptian friends, but only if they had trusted the sincerity of his sympathy with their traditions.

Lewis, it seems, accepted and was accepted by Cairene society. His way of life, unproductive in European eyes, allowed him to sketch the people and scenery of Cairo without the hindrances usually encountered by foreign artists. He had the opportunity and leisure to acquire the knowledge of Muslim manners and customs manifest in his work. A remark made by Sir Thomas Phillips, who met Lewis at dinner with the British Consul, Colonel Burnett, is revealing both of Lewis's motives for being in Cairo and of the impression he conveyed to his compatriots: '. . . amongst other persons I met the artist Lewis who has resided here for sometime to study the character and costume of the people. I am told that he has not been very usefully employed hitherto.'[13] The number of Egyptian sketches in the four major sales of Lewis's work prove that, on the contrary, he was by no means idle.[14] Altogether he accumulated enough material from which to work for the remaining twenty-five years of his life.

Lewis returned to England with his wife early in 1851, prompted, it seems, by the fulsome praise lavished on *The Hhareem* when it was exhibited at the Old Water-Colour Society.[15] From then on his oriental subjects in watercolour, exhibited at the Old Water-Colour Society, and later in oil, exhibited at the Royal Academy, continued to attract considerable attention, notably from the great art critic, John Ruskin. With one exception, then, the pictures which drew inspiration from Islamic culture were painted within the quite different environment of Victorian Britain. The problem which thus confronted him of combining East and West is central to his work. To what extent he was able to retain the authenticity of his subject-matter and at the same time meet the requirements of his public may be judged by examining a few of his pictures more closely.

The Hhareem (pl. XXX) was his first orientalist picture to be seen in London; it is also his only full-scale work, completed in Cairo, of which the entire composition is now known. From it much about his attitude to his oriental subjects can be detected. His description of it in the catalogue of the Royal Scottish Academy, where it was exhibited in 1853, reveals his understanding of the harem system:

The scene is laid in an upper or women's apartment of a house in Cairo, the lower part of the house being always appropriated to the men. The master (a Bey or a Turk) is habited in the old Mameluke dress of Egypt, now not often worn. Immediately to his left is seated a Georgian, the 'sit el Gebir' or ruling lady of the

Hhareem, having attained the privilege by being the mother of his eldest son, who is leaning against her knee. The lady stooping forward is a Greek, and the one reclining at the Bey's feet a Circassian. The laughing slave, an Abyssinian—an old inmate.

The latter could be Lewis's private reference to his own slave-girl, 'Zuleikah', possibly the model for this figure. He explains further that the woman seated in the background is the slave-dealer's wife, correctly veiled in the presence of strangers, who, acting on behalf of her husband in the confines of another man's harem, has brought in the girl for display.[16]

Like Lane, Lewis differentiated between the disparate peoples of the Near East; his characters are nearly always of an identifiable race or creed, not vaguely 'oriental'. As well as the Greek, Circassian, Georgian and Abyssinian slave-girls, the Nubian eunuchs and Turkish beys who inhabit his harem interiors, Lewis portrays Bedouin tribesmen, Egyptian *fellahin*, Persians, Copts and Muslim *sufis*, as well as a variety of occupations, such as those of doctors, teachers, scribes, merchants, dragomen and servants. Sometimes he deliberately juxtaposes several different types in one picture, creating the contrasts of colour, form and texture for which his pictures were renowned, but also reflecting the kaleidoscopic nature of nineteenth-century Cairo.

Most western observers regarded the Muslim practices of slave-trading and polygamy as barbaric and depraved. Such prejudices coloured European artists' treatment of these subjects, so that they are represented either in terms of the degradation and suffering which were supposed to have been caused or with deliberately erotic connotations. No suggestion either of disgust or of titillation disturbs the languid splendour of Lewis's harem scenes. As the *Athenaeum* reviewer of *The Hhareem* acknowledged: 'The scene is realized in its spirit and in its minute details—yet so as to give no offence to Western feelings of decorum. Nevertheless, the picture is voluptuous—or it would not be true to its theme.'[17] The slave-girl, still half-clothed, retains her dignity; her spectators coolly evaluate her according to their own interests: the Bey as he would a piece of merchandise, his two favourite wives with suspicion as a possible rival. Through the varying expressions on the faces of the protagonists, the currents of feeling within an eastern harem are subtly conveyed. Thus, instead of the moral comment one might expect from a European, Lewis elucidates an aspect of Muslim life. In doing so he displays not so much detachment from, as sympathy with, the traditions he represents. Not only is each element in Lewis's composition authentic, the whole is interpreted from an eastern rather than a western point of view.

This is not to deny the intrinsic western component of the picture. Painted by a European artist using European stylistic conventions, it was intended for a European and not an Egyptian audience. It thus brings two very different cultures into close contact, but not without a clash of interests. If Lewis's depiction of the sale of a slave did not breach western taste, the visual representation of a harem would certainly have offended eastern sensibilities. It would have been justifiable in terms of Islamic morality, however, only if it had been based on a scene in the artist's own house. This not only reinforces the suggestion, made elsewhere, that the Bey is an ideal projection of Lewis himself,[18] but also the possibility that the laughing Abyssinian was his own slave-girl, brought to him in the manner shown in the picture. If Lewis's 'harem' was not as extensive as seen here—and, according to Lane, few in Cairo at that time

were—women who would have been prepared to model for the other characters could with difficulty be found in the city.

Despite its western idiom, *The Hhareem* is the most consistently eastern of all Lewis's harem and domestic interiors. Subsequent examples were painted in England away from the first-hand experience of the East which is so intensely felt in the Cairo picture. Lewis never renewed his direct contact with Islamic society and its inspiration inevitably became diluted by his English environment. But it was never lost, probably because, living quietly with his wife in Walton-on-Thames, he held himself aloof both from other artistic influences and from the mainstream of London society. With the numerous and varied sketches he had made in Cairo and his wife to model the costume he had brought back with him, he could continue to draw on his oriental experience.[19] His isolation from his contemporaries was not total, since he was a professional artist dependent for his living on the sale of his pictures. Sometimes he apparently allowed western pictorial considerations to override his allegiance to the authenticity of eastern details in his work, but, despite this, his pictures remain convincing in oriental terms because of his fundamental rapport with the subject.

Indoor Gossip (1873) (pl. XXXII*a*),[20] with its narrow glimpse of the outside world and its mirror reflecting only the girl's other profile rather than any space beyond the picture, undoubtedly stresses the inward-looking nature of harem life, but the brilliant light and vibrant colour suggest that, far from being in a position to be pitied, the two pampered beauties, with their fine jewels and sumptuous clothes, are protected from the harsher existence outside and are therefore privileged members of society. As Lane explains, Egyptian wives were not discontented with the seclusion in which they lived; on the contrary, they felt neglected and unloved if their husbands allowed them unusual liberty.[21]

Lewis's later domestic images could nonetheless be assimilated with western equivalents more than the earlier examples of the 1850s. *The Intercepted Correspondence* (1869)[22] repeats part of the very successful composition of *The Hhareem*, painted twenty years before, but it significantly changes the narrative: whereas the introduction of a new slave into a harem was not an event which Victorians could understand, the interception of an illicit love message—in this case through the medium of a bouquet of flowers—was. *The Reception* (1873)[23] depicts the visit of a group of ladies from one harem to another. The costume and setting are authentic: the great bay window, for example, is the same as that sketched three decades earlier in a drawing inscribed 'Mandarah of my house at Cairo', and the very one described by Thackeray.[24] So convincing is Lewis's rendering of the scene, that few would have noticed that he placed his women not in the upper apartment of his house, but in the *mandarah*, or men's reception room. The event itself was an everyday occurrence in Cairo, described by Lane, but one that could also be paralleled in ordinary Victorian life.[25] *And the Prayer of Faith shall save the Sick* (1872) (pl. XXXII*b*)[26] illustrates a tradition practised among both Christians and Muslims; by implying an analogy between the two religions, Lewis reveals his tolerance of Islam. While the title is from the New Testament (James 5:15), the setting and characters are clearly Islamic: the central figure reading from an illuminated *Qur'an* wears a white turban and is probably an *'alim*, or religious scholar. However, in the presence of a man not their husband, father, or grandfather, they should be veiled; that Lewis has chosen instead to show their faces is evidence of the artistic licence he now permitted himself.

The conflict between eastern and western ideologies inherent in such pictures is

brought sharply into focus precisely because of their credibility. Few other Victorian representations of the subject were either so plausible or so complex; indeed, most had different intentions. Some still presented the fanciful vision of the East derived from *The Arabian Nights* and later romantic oriental tales. Henry Warren's *Song of the Georgian Maid* (1858) (pl. XXXIIIa)[27] illustrates 'The Light of the Haram', one of the poems in Moor's *Lalla Rookh* (1817), especially the lines:

> The Imperial Selim held a feast
> In his magnificent Shalimar
> . . .
> And see—a lovely Georgian maid,
> With all the bloom, the freshen'd glow
> Of her own country maidens' looks
> . . .
> With a voluptuous wildness flings
> Her snowy hand across the strings
> Of a syrinda,

As with the poem, each element in the picture is probably derived from a real object, but the ensemble is a sentimental extravaganza. Warren was generally admired for his so-called 'truthful' representation of the East, but a more perceptive assessment of the picture is Ruskin's: 'Full of cleverness; but continually false in passages, owing to the violent striving for brilliancy'.[28]

The harem beauty is the subject of one of Lord Leighton's few paintings with an ostensibly oriental theme. *The Light of the Harem* (pl. XXXIIIb), exhibited at the Royal Academy in 1880,[29] is superficially similar in iconography to Lewis's *Indoor Gossip*, exhibited six years earlier. But for Leighton, essentially a classicist, the oriental title is merely an excuse for an exotic effect. The architecture and costume are purely decorative and intended to create a mood rather than an authentic image of an eastern harem. Frederick Goodall's painting with a similar title, *A New Light in the Hareem*, shown at the Royal Academy in 1884,[30] although oriental in its context, is entirely western in its sentiment. The new-born babe with its mother was an image with which every Victorian family could readily identify; the alien concept of the harem has been translated into the vernacular.

Because of the special circumstances of the taboo imposed on the harem by Muslim custom, western interpretations of them differed widely. Restrictions on the portrayal of men outside the home were less stringent and more artists could therefore depict the streets and bazaars of the East from direct observation. With this subject too, however, Lewis's representations carry greater conviction than those of his fellow artists because of his superior knowledge of Islamic society.

The Bezestein Bazaar of El Khan Khalil (1872) (pl. XXXIV)[31] is especially notable for its virtuoso rendering of the imposing architecture, for its colourful costume and for the numerous facial types represented, all creating a vivid and animated effect. Two musicians entertain a rapt audience to a rousing song—no doubt of love and adventure—possibly during the heat of mid-day when there was a lull in trade. The assembled members of the crowd—merchants and other well-to-do folk—are seen, not as a bunch of worthless bazaar idlers, but as robust individuals who rightly enjoy the pleasures of life to the full. They are an essential part of the scene. Each plays a separate role in the picture's conception and is not merely a picturesque adjunct

placed at random for compositional purposes. By contrast, William Müller's *Carpet Bazaar* (1843)[32] conveys a more generalized impression of an eastern market. He had been in Cairo in 1838–9, shortly before Lewis's arrival, and had been fascinated by its people and colour, likening its streets to 'humanity put into a kaleidoscope'.[33] But, confronted with the reality of E. W. Lane's descriptions and illustrations, he was reminded of Rembrandt, a western, Old Master, painter. Müller's picture, with its bright light filtering through the awnings on to the colourful scene below, captures the atmosphere of the bazaar, but the figures only augment this and are not clearly defined individuals. David Roberts, also in Egypt in 1838–9, positively disliked much of its modern life. In his journal he constantly compared its present state of degeneration to its past glory, of which its magnificent Pharaonic ruins were a reminder. Of its Islamic culture, he admired only the architecture, particularly the mosques with their ornate doorways and tall minarets, although he found sketching them in the midst of stinking rubbish and a babbling throng of natives distinctly arduous. He considered Islam to be 'a religion of barbarism' responsible for Egypt's decay.[34] Mosques and tombs are the focal point of most of his pictures of Cairo, but because of their picturesque qualities, not because of the religion they represent; the main role of the figures is to define scale and create atmosphere.

David Roberts was one of many European artists who deplored the poverty and squalor of contemporary Egypt. Few, however, included more than a decorous suggestion of this in their pictures. Buildings crumble picturesquely and the odd beggar squats idly in a corner, but there is little evidence of the extreme filth, disease and suffering which existed. Even Lewis's realism does not extend to this. The giving of alms is the subject of a watercolour by Frederick Goodall (1865) (pl. XXXI*b*) but the recipients of the sheikh's largesse from the hand of the proud Nubian are a noble and deserving poor: the elegantly posed woman and child are hardly starving and the features and bearing of the blind old man are suitably venerable. The watercolour is a version of the oil exhibited by Goodall at the 1862 Royal Academy exhibition, *The Return of a Pilgrim from Mecca; his purse bearer distributing alms to the poor of Cairo*.[35] It thus represents two of the duties required of a Muslim, the pilgrimage to Mecca and the sharing of a proportion of his wealth; but the distinctly classical implications of both figures and composition equate this eastern custom with similar virtues admired in the West.

More often Goodall's pictures have a biblical slant. He spent several months in Egypt in 1858–9 sketching the people of Cairo and its environs, but more because of their associations with events and scenes in the Bible than for their own sake. 'My sole object in paying my first visit to Egypt', he wrote later, 'was to paint Scriptural subjects'.[36] His first Royal Academy exhibit after his return home, *Early Morning in the Wilderness of Shur* (1860) (pl. XXXV*a*) was inspired by a trip to Suez and across the Red Sea to the Wells of Moses.[37] The Royal Academy catalogue refers to a sheikh addressing his tribe preparatory to breaking camp, and the intention to evoke the image of Moses exhorting the Israelites at the oasis of Elim in the wilderness of Shur is plain (Exod. 15: 22–27).

Lewis's desert encampments carry neither biblical nor classical connotations. His concern was to represent an aspect of contemporary Islamic society with precision and accuracy. One typically eastern sight—a camel train—is the subject of a watercolour, *A Halt in the Desert* (1855) (pl. XXXV*b*).[38] *En route* between Syria and Egypt, a caravan has halted at an oasis in the Sinai desert; in the foreground,

merchants reclining beside their richly caparisoned camels are apparently striking a bargain over the textile placed on the ground before them. He conveys their languid repose as a natural part of the scene, with no hint of criticism.

Lewis did not feel the need to represent the men and women of Egypt at work. Goodall's numerous rural scenes, by contrast, show *fellahin* labouring productively: carrying water to or from the Nile or a well, leading their flocks to or from pasture, rescuing the helpless from the Nile flood. His emphasis on moral virtues admired by the Victorians introduces western values into each of his paintings. The figures in Lewis's Nile and desert scenes are apparently aimless. *Waiting for the Ferry Boat* is an example,[39] the purpose of which Ruskin, usually an enthusiastic admirer of Lewis's work, could not comprehend: 'Well, of course, it is very nice. Housings and camels— palm trees—clouds, and sheikh. But waiting for a ferry-boat is dull work; and are we never to get out of Egypt any more? nor to perceive the existence of any living creatures but Arabs and camels?'[40] Ruskin did not appreciate that these things, as representatives of Egypt's contemporary Islamic society, were part of its living character, and, as such, the very essence of Lewis's work.

Lewis did not paint every aspect of contemporary Egypt. He ignored the hardships and misery suffered by the poor both in the rural areas and in the towns; no violence or brutality enters his work; his characters, though animated and full of expression, display no extremes of emotion. But the elegance and indolence of the rich, the prosperous hum of the bazaars, the langour induced by the heat of the desert, in sum, the luxuriance which for many Europeans represented the Islamic East, he rendered with a consummate mastery and fidelity to his subject which has not been equalled. This Ruskin did appreciate: 'Lewis saw in men and women only the most beautiful of living creatures, and painted them as he did dogs and deer, but with a perception of their nature and race which laughs to scorn all the generic study of the scientific method.'[41] Edward Lear, too, was among the few who recognized this special quality which set Lewis apart from his contemporaries and which even today is not sufficiently acknowledged. Writing to Lewis's wife Marian in 1875, Lear, himself well travelled in the East, summed up his fellow artist's achievement: 'There never have been, and there never will be, any works depicting Oritental life—more truly beautiful and excellent—perhaps I might say—*so* beautiful and excellent. For, besides the exquisite and conscientious workmanship, the subjects painted by J. F. Lewis were perfect as representations of real scenes and people.'[42]

Acknowledgements

I am indebted to Charles Newton, to Major-General Michael Lewis, and to Peter Stocks for their invaluable assistance with and encouragement of this article.

NOTES

[1] 'The Hero as Prophet. Mahomet: Islam', lecture by Thomas Carlyle, delivered 8th May 1840, the second in the series, *On Heroes, Hero-Worship and the Heroic in History*, published 1841 (1908 edn., ed. G. A. Twentyman, 3).

[2] F. R. de Chateaubriand, *Travels in Greece, Palestine, Egypt and Barbary during the Years 1806 and 1807*, translated from the French *Itinéraire de Paris à Jérusalem*, 2 vols. (London, 1811), II, 62.

3 On Victorian architects in the Near East, see M. Darby, *The Islamic Perspective: an Aspect of British Architecture and Design in the 19th century*, exhibition catalogue, Leighton House (London, 1983).

4 Wallace Collection, London; the subject in fact wears Albanian or Greek dress, an indication of the confusion which existed.

5 Exhibited Royal Academy 1838 (156); now National Gallery of Scotland.

6 T. Allom, *Character and Costume in Turkey and Italy*, text by Emily Reeve (London, *c.* 1840), pl. 14.

7 The *Athenaeum*, 13th October 1838, 737.

8 Müller, *Prayers in the Desert*, oil on canvas, Birmingham Museum and Art Gallery; exhibited Royal Academy 1843 (47); Hunt, *The Lantern Maker's Courtship*, oil on canvas, Birmingham Museum and Art Gallery; exhibited Royal Academy 1861 (28); see *The Pre-Raphaelites*, exhibition catalogue, Tate Gallery (London, 1984) (86).

9 It would seem strange if the two did not meet in Cairo, but no definite evidence has yet been discovered. There is no mention of Lewis in the biography of Lane by his great-nephew Stanley Lane-Poole, *Life of Edward William Lane* (London, 1877), although other Europeans who knew Lane are mentioned; nor does his name appear in the Lane MS material perserved in the Griffith Institute, Oxford. On Lane, see L. Ahmed, *Edward W. Lane. A Study of his Life and Work and of British Ideas of the Middle East in the Nineteenth Century* (London, 1978).

10 John Murray (pub.), *Handbook for Travellers in Egypt*, text by Sir J. G. Wilkinson (London, 1847), 131. On Lewis, see Major-General J. M. Lewis, C.B.E., *John Frederick Lewis, R.A. 1805–1876* (Leigh-on-Sea, 1978), including a catalogue of the artist's work. Lewis made portrait sketches of several Europeans in Cairo (*ibid.*, 82 ff.). Investigation of sources where there might be mention of Lewis has so far yielded nothing (see *ibid.*, 25, n. 20); neither have the J. W. Wild and J. Bonomi MSS and sketches, Griffith Institute, Oxford, or the Sir J. G. Wilkinson MSS and sketches, private collection. The author is grateful to Dr J. Málek and Mr H. Colvin for their assistance with these investigations.

11 In W. M. Thackeray (pseud. M. A. Titmarsh), *Notes of a Journey from Cornhill to Grand Cairo* (London, 1846), 282–91; the quotations used here are from this work.

12 E. W. Lane, *An Account of the Manners and Customs of the Modern Egyptians Written in Egypt during the Years 1833–1835* (London, 1836). All references in this article are from the East-West Publications edn., 1978; this, p. 159.

13 Sir Thomas Phillips, letter to his brother Benjamin, from Cairo, 9th December 1842, private collection. I am grateful to Patricia Allderidge for showing me her copy of his letter.

14 Almost 600 Egyptian sketches are known: see Lewis, *op. cit.* (note 10), 24 and n. 24.

15 Old Water-Colour Society 1850 (147). For the reviews and a discussion of the picture see Arts Council of Great Britain, *Great Victorian Pictures, their Paths to Fame* (1978) (29), exhibition catalogue by R. Treble. The original picture is so far untraced, but a photographic reproduction is in the *Souvenir* of the Franco-British Exhibition, London, 1908 (471), as *The Harem of a Bey*. An almost identical version of the left half of the composition is in the Victoria and Albert Museum, London (P1.–1949), apparently cut down. For further interesting commentary on the composition, see K. P. Bendiner, 'The Portrayal of the Middle East in British Painting, 1835–1860', Ph.D. thesis, Columbia University, 1979, ch. 6.

16 Royal Scottish Academy 1853 (494); quoted in Bendiner, *op. cit.* (note 15).

17 The *Athenaeum*, 4th May 1850, 480.

18 See Bendiner, *op. cit.* (note 15).

19 For the sketches, see Lewis, *op. cit.* (note 10), 49–50 and 82–92; fifty-seven lots of Eastern dresses, robes, head-dresses, weapons, etc., were sold on the last day of Lewis's studio sale, held nine months after his death, Christie's, 7th May 1877.

20 Oil on panel, Whitworth Art Gallery, University of Manchester; exhibited Royal Academy 1874 (352).

21 Lane, *op. cit.* (note 12), 180.

22 Oil on panel, private collection, Houston, Texas; exhibited Royal Academy 1869 (157); see Royal Academy of Arts, *The Orientalists: Delacroix to Matisse, European Painters in North Africa and the Near East*, exhibition catalogue, ed. M.-A. Stevens (London, 1984) (95), repr. in colour p. 50.

23 Oil on panel, The Yale Center for British Art, Paul Mellon Collection; exhibited Royal Academy 1874 (354); repr. in Lewis, *op. cit.* (note 10).

24 Victoria and Albert Museum, London; Thackeray, *op. cit.* (note 11), 286.

[25] Lane, *op. cit.* (note 12), 191. For a further account of harems in Cairo, see Sophia Lane-Poole, *The Englishwoman in Egypt: Letters from Cairo, Written during a Residence there in 1842, 3, & 4, with E. W. Lane, esq. by his Sister*, 2 vols. (London, 1844); e.g. II, 85.

[26] Watercolour and bodycolour, private collection; an oil version exhibited Royal Academy 1872 (242), now in the Yale Center for British Art, New Haven.

[27] Watercolour and bodycolour, private collection; exhibited the New Society of Painters in Water-Colours, 1858 (182).

[28] J. Ruskin, *Academy Notes 1858*, 51.

[29] Royal Academy 1880 (256); whereabouts unknown; an oil study for the painting sold Sotheby's Belgravia, 23rd March 1981, lot 71.

[30] Royal Academy 1884 (235); Walker Art Gallery, Liverpool.

[31] Oil on panel, private collection; exhibited Royal Academy 1874 (332); see *op. cit.* (note 22) (96), repr. in colour p. 47.

[32] Oil on board, The City of Bristol Museum and Art Gallery; see *ibid.* (103), repr. in colour p. 71.

[33] W. Müller, 'An artist's tour in Egypt', *Art-Union*, September 1839, 131.

[34] David Roberts, Eastern Journal, 1838–9, MS on loan to National Library of Scotland; e.g. entries for 13th, 25th, 29th December 1838, 19th January 1839. I am grateful to Helen Guiterman for lending me her transcript of the Journal. For Roberts's illustrations of Cairo, see *Egypt and Nubia*, III (1849).

[35] Royal Academy 1862 (372); sold Sotheby's Belgravia, 9th December 1980, lot 89. The watercolour version sold Sotheby's 15th March 1983, lot 54.

[36] F. Goodall, *The Reminiscences of Frederick Goodall, R.A.* (London, 1902), 97. On Goodall, see also N. G. Slarke, *Frederick Goodall, R.A.* (Oundle, 1981).

[37] Royal Academy 1860 (295); now Guildhall Art Gallery, London.

[38] Victoria and Albert Museum, London.

[39] Oil, exhibited Royal Academy 1859 (135); whereabouts unknown.

[40] J. Ruskin, *Academy Notes 1859*, reprinted in E. T. Cook and A. Wedderburn, *The Works of John Ruskin* (1903–12), XIV, 218–19.

[41] See Cook and Wedderburn, *op. cit.* (note 40), XXXV, 405.

[42] Edward Lear to Marian Lewis, from London, 22nd June 1875; collection of Major-General J. M. Lewis, C.B.E. I am grateful to the owner for sending me a copy of this letter.

Bagshot Park and Indian Crafts

Raymond Head

In the eighteenth and early nineteenth centuries Indian decorative schemes were little more than rooms filled with paintings, drawings and mementoes of India. Such rooms were commonplace among the returned nabobs of the eighteenth century. In 1790 Humphry Repton recorded seeing a Gothic hermitage at Louth, Lincolnshire which was dedicated to the owner's brother, who had died in India. Inside, there were references to India in every room: in one there were prints and drawings; another, a library, had books and 'Asiatic' manuscripts, its bamboo furniture imported from India. In the Oratory of this Gothic hermitage, which Repton likened to a scene from the Arabian Nights, there were sparkling gems and walls hung in the finest 'Indian Matting'.[1] There were many other similar rooms and temporary structures of this kind in England and Scotland during the 1780s and 1790s. Some are known, like Sir William James's room in Severndroog Castle, Shooters Hill, London, William Frankland's at Muntham in Sussex, Sir Hector Munro's at Novar, Scotland, but many have been swept away without any record. It is as part of this world that Thomas Hope's Indian room has also to be seen, for although he undoubtedly took some interest in Indian architecture as part of the neo-classical ideal, he shrank from its application in his own houses. Hope was probably more interested in India's literary culture than anything else, becoming a member of the Royal Asiatic Society at its foundation in 1823, and a founder member of the Oriental Translation Society in 1828.[2] By the end of the nineteenth century, exotic India had invaded the fastnesses of the Victorian interior in a completely new form.

The billiard room at Bagshot Park, Surrey, designed and constructed for the Duke and Duchess of Connaught, was the first room in England to owe its origin to the re-evaluation of the arts and crafts of India. Bagshot Park had been purchased in 1875 and the old house was demolished to make way for a Tudor-Gothic design of little distinction by Benjamin Ferrey,[3] a conservative architect who had built up a considerable practice as a designer of country houses and Gothic churches. In the 1830s he had been responsible for a fashionable development on the sea front at Bournemouth which included among its features a Chinese and an Indian pavilion. The new

139

house was finished in 1878, and altered in 1879 for the Duke's new bride, Princess Louise Margaret, daughter of Prince Frederick of Prussia.

Arthur, Duke of Connaught was born in 1850,[4] the third son of Queen Victoria and very much her favourite. Beside the cavortings of the Prince of Wales he was a model of virtue and generally well liked by all those who came into contact with him. He was the most travelled of all Queen Victoria's children, spending many years in posts throughout the Empire. For this reason he was also the least known. He had been given a commission in the army at the request of his father and in 1882, much against his mother's wishes, he took an active and distinguished part in the Egyptian Campaigns. The military action over, he developed a fondness for strolling through the bazaars of Cairo buying *objets d'art*. This taste of freedom, and his encounter with the Orient, gave him a desire to visit India as the Prince of Wales had done some years before. He was already an officer in the British Army and was given a transfer to the Indian Army. In November 1883 the Duke and Duchess left England for Bombay. After their arrival they travelled across country to Allahabad, then on to Calcutta and finally back to Meerut via Benares and Lucknow, which they reached in February 1884. In the autumn they travelled privately up-country to Kashmir, Peshawar and Lahore, returning to Meerut at the end of October.

From the correspondence which has survived among the Kipling Papers at Sussex University it would appear that both the Duke and Duchess very quickly immersed themselves in India, finding much to interest them in her ancient culture. They had already met the designer of their future billiard room, John Lockwood Kipling, Principal of the Mayo School of Art, Lahore,[5] at the Calcutta Exhibition held during the winter of 1883–4. It was his enthusiasm for promoting the crafts of India that in all probability led to the 'Indian' billiard room and the Connaughts' trip to Lahore in the autumn of 1884. At the suggestion of Sir Howard Elphinstone, the Duke's comptroller and guardian of many years, the room was given as a belated wedding present to the Connaughts from the Indian princes.[6]

Kipling arrived in India in 1865 to teach at the newly founded Bombay School of Art. He quickly perceived the weaknesses of the teaching system, but in a position of little authority he could not do much to change policies, although he managed to obtain permission for his sculpture students to work on the new buildings of Bombay. As a result of the 'schools of art' policies, it had been the custom to train Indian craftsmen in western techniques. Much of the time was given to developing fine artists along European lines rather than encouraging India's own craft traditions. The effects of these efforts were quite devastating upon Indian craftsmen. Indian art manufactures had astonished all those critics who saw them at the 1851 exhibition.[7] The Indian art wares which exhibited a natural feeling for form and contour, for appropriate and intricate pattern, for non-illusionistic surface decoration, were considered the highlights of the exhibition. Their obvious quality revealed the poverty of the European imagination and technical skill. The Europeans' low technical standard and poor design, often based upon novelty, or the compilation of historical styles and naturalistic decoration, were seen to be the disastrous effects of industrial processes and loss of a craft tradition.

However, between 1851 and 1878 the standard of the art wares of India plummeted both in design and execution. It had been realized even in 1851 that India's craft traditions were under siege from cheap imports, which was why the schools of art system was established in 1853. But whereas English schools of art now looked firmly

PLATE XXXVI

a. Partial view of the southern end of the billiard room, showing some of the carved panels, two wall 'pagodas' the adjoining smoking room on the right, and, beyond, the corridor

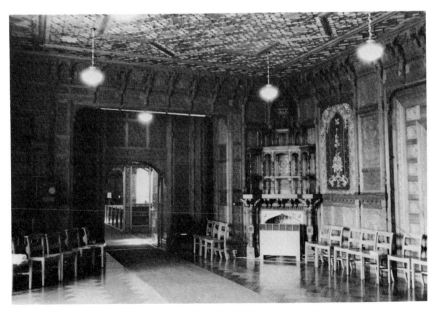

b. Partial view of the northern end of the billiard room, showing carved details, fireplace, embroidered panel (to right), and carved archway of about 1910 which today leads into the chapel

Bagshot Park

PLATE XXXVII

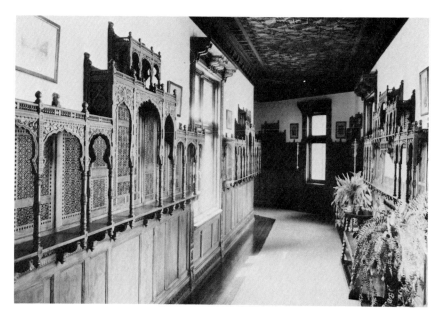

a. Display brackets of *pinjra* or lattice-work in the corridor. The ceiling has geometrical panels in wood like the billiard room

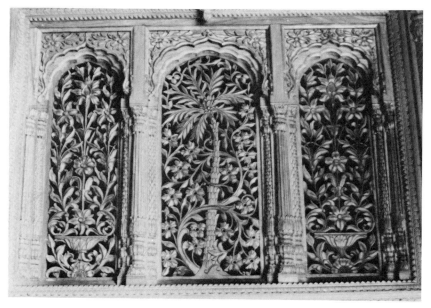

b. Pierced screen of palm-tree and flowers above the smoking room entrance

Bagshot Park

PLATE XXXVIII

b. Fireplace with carved mantel and 'Hindu' columns

Bagshot Park

a. Detail of the carved panels between smoking room and door shown in pl. XXXVI*a*

PLATE XXXIX

b. Detail of panel dedicated to Princess Louise Margaret, Duchess of Connaught, with carved initials 'LM'; above, three domes or royal umbrellas and two parrots; below, a seated Ganesha and two rats (Ganesha's emblems)

a. Detail of panel dedicated to Arthur, Duke of Connaught, with carved throne or *diwan*; above, two *chauris*, symbols of royalty

Bagshot Park

towards the East, those in India looked nostalgically at European traditions and acknowledged valid Indian traditions with the greatest reluctance. The art wares in the Indian Court of the Paris Exhibition of 1878 blatantly displayed the folly of the policies then being pursued in India. Sir George Birdwood, who wrote the guide to the section, was outraged,[8] fearing that village traditions would also follow in this decline, just as they had done in Britain and America.[9] For questioning the official policy which inculcated and bureaucratized apathy towards India's crafts, Birdwood was much praised by fifty-two of the leading artists, architects and writers of the day.[10] Kipling, who helped select the items for the Paris Exhibition and visited it, must have been only too aware of the standard of the art wares and the scathing criticism they aroused. Once at Lahore Kipling had introduced reforms, but his appointment in 1875, coming so close to the exhibition date, gave him little time to encourage his students to produce a different type of work with assurance.

Kipling returned to India with a good deal to consider, the most important problem of which was that of patronage for India's crafts. He was especially keen for the renowned woodcarvers of the Punjab to find adequate outlets for their obvious talents.[11] Hitherto they had been mainly used for making display brackets, tables and cabinets for the Anglo-Indian market. He felt they could be better employed, and he wrote in 1886 (but probably expressing views which had been formulated some years previously) that he thought 'the best use to which Punjab and other varieties of woodwork . . . can be put is undoubtedly in the larger and bolder forms of domestic architecture . . .',[12] an allusion to his current work at Bagshot and other schemes for the 1886 India and Colonial Exhibition.

It is into this atmosphere that the Duke and Duchess of Connaught entered when they visited the Calcutta Exhibition. They were early supporters of Kipling's idea for a journal of Indian art which would stimulate interest in Indian craft-works. In a letter of 23rd June 1884 to Kipling, Princess Louise very much hoped that interest in Indian art would increase by such a publication and that perhaps it would help to dispel the apathy and 'don't care' attitude so common among the British.[13]

It is probably true to state that the billiard room was even then under way in some form, for in a letter to Kipling from Connaught dated 19th September[14] it was apparent that a plan for the extension to Bagshot had already been received from Ferrey. Connaught urged Kipling to send more details of his design so that it could be sent back to Ferrey in England.[15] The 'Tudor' shell was to have a lining of Punjabi panels (pl. XXXVI) and an exotic billiard table. Also in the plans of the extension were a corridor (pl. XXXVII*a*) from the main house and a smoking room. There was a suggestion from the architect that the panels could be made by English craftsmen, or by Indian woodcarvers in England. In the event the Duke was against both these ideas, preferring the panels to be made in Lahore and shipped to England.[16] Indian woodcarvers were brought to London in 1885 for Liberty's re-creation of an Indian village at the Albert Palace, Battersea Park, London,[17] and to carve the Durbar Hall for the Indian and Colonial Exhibition.

Progress on the extension was slow, but by the end of 1884 the shell of the billiard room, the adjoining smoking room, the corridor and a connecting vestibule had been completed. Arrangements were put in hand to have the billiard table made at the well-known firm of Burroughes and Watts of Soho Square, London. The work in England was overseen by Casper Purdon Clarke, an architect and director of the Indian Museum, South Kensington, and an experienced designer of 'Indo-Saracenic'

pavilions for exhibitions.[18] Twenty years later he designed the Durbar Hall at Elveden Hall, Suffolk, for the 1st Earl Iveagh. In a letter of 24th January 1885 Connaught asked Kipling if he had sent Purdon Clarke the design for the door and window trims which were to be made in pine in England. The Duke and Duchess went on leave to England in 1885 and, because of the death of the latter's father, they did not arrive back until 1886, after they had seen the 1886 exhibition.

During 1885 Kipling was very preoccupied with the organization of the Indian and Colonial Exhibition. There was to be a carved Punjabi Court in which the art wares of the Punjab would be shown. There were to be carved screens from every part of India, and one of the reasons for this was to educate the public in London in the different varieties of pattern used by each region. The Indian palace was heralded by a large stone gateway given to the South Kensington Museum by the Maharajah of Gwalior and re-erected at the exhibition.[19] A major feature of the exhibition was the Durbar Hall designed by Purdon Clarke and carved by two Punjabi woodcarvers, Muhammed Baksh and Juma, who came over in June 1885. Their work was a *tour de force* of carving and design, for not one single pattern was ever duplicated. It brought the unstinting praise of all who saw it. After the exhibition it was bought by one of the exhibition's commissioners, Lord Brassey.[20] He had it redesigned by Purdon Clarke and re-erected at his home at 24 Park Lane in 1887, probably with the help of the two carvers, who stayed on after the end of the exhibition.[21]

Between 1885 and 1887 the lull in operations allowed the craftsmen at Lahore to get on with the job of carving the panels and doors. In all, there were 241 panels of various sizes, carved in deodar wood; no two panels were the same (pls. XXXVII*b*, XXXVIII*a*). They also carved the fireplaces and surrounds, skirtings, ceilings, cornices and display brackets for the corridor. The panels are rich in imagery: tulips, irises, carnations, daffodils, roses, palm trees, woodpeckers, peacocks, hoopoes, paddy birds, kingfishers, parrots, fishes, snakes, elephants, even the cast brass door-handles are in the form of flying birds. Either side of the room there are fireplaces decorated with Hindu columns, Turkish tiles and brasswork (pl. XXXVIII*b*). Above the fireplaces are ornately carved display units, one of which has two inscribed panels. One panel reads 'Ram Singh, Master, Mayo School of Art 1885–1887' and displays two chisels and a pair of dividers. The other reads 'Lahore, J. L. Kipling Principal Mayo School of Art 1885–1887'.

Ram Singh was a master craftsmen of Lahore who worked for many years at the School of Art. Working under the guidance of Kipling, he produced many panel and furniture designs, some of which were published in the *Journal of Indian Art and Industry*. In 1891 he came to London and worked with Kipling on the Queen's new dining room at Osborne, often erroneously referred to as a 'durbar hall'.[22] He carved the models for Jackson & Co., who supplied the fibrous plaster enrichments for Osborne. The carved panels in the music gallery were made in Lahore. Ram Singh was very much liked by the Queen, who had a cottage put at his disposal on the estate. He was paid £5 per week and was left to do his own cooking. During the Christmas of 1891 he stayed for five days at Osborne, during which time the Queen said how much she was delighted with his work and gave him a signed portrait of herself and a gold pencil-case. In the absence of Kipling in India, Ram Singh became responsible for some improvements to the dining room. He altered two of the doors and their surrounds, added a ventilator in the ceiling and designed all the light fittings.[23] Ram Singh's portrait, commissioned by the Queen, is at Osborne.

Opposite the bay window in the billiard room at Bagshot there are two vertical panels which contain emblems of the Duke and Duchess. The Duke's consists of a throne with yaks' tails (*chauris,* symbols of royal power), (pl. XXXIX*a*), a hookah pipe, vase and ewer, and beneath the main panel two elephants. The Duchess is indicated by her initials 'LM' above a seated figure of the Hindu deity Ganesha, a symbol of good fortune and wisdom (pl. XXXIX*b*); above the main panel there is a crown and vase and beneath it are two rabbits. In a letter of 16th March 1888, Sir Howard Elphinstone suggested that the panels, or casings as he called them, should be sent to England before the hot season of 1888 and requesting Kipling to furnish an explanation of the panels. Work had been held up while the Duke returned to England for the Queen's Jubilee celebrations in 1887. He was also the Queen's representative at the celebrations held in India.

There were still many aspects of the scheme to be decided. No mention had been made of the smoking room, the corridor and its ceiling, or how two large open panels either side of the score-board were to be completed. The Duchess had wanted the ceiling in the smoking room to be taken from those found in the famous Jain temples of Mount Abu in Rajasthan.[24] Kipling duly supplied a design which, after some amendments, was approved by Connaught in November 1889. It was much liked for its grotto-like effect and the contrast which it made to the geometrical-patterned ceiling in the billiard room. Around the walls of this small oriental alcove there were ogival panels inset with 'Indian' wallpaper by Walton & Co. of London. The corridor was decorated by a geometrical-patterned ceiling and arrangements of *pinjra,* or lattice-work display brackets, very similar to those illustrated in the *Journal of Indian Art and Industry,* 1886, pl. IX (see pl. XXXVII*a*). The original idea was to leave the walls free for the Duke's pictures and displays of arms and armour, as his brother had done in the Indian room of Marlborough House and at Sandringham. The curtains for this corridor had still to be chosen, but the Duchess suggested an old gold material to be bought in India and something broad and plain for the billiard room which could be embroidered in England upon their return if necessary. Plain curtains were also suggested for the smoking room. Kipling had proposed painting the empty panels in the billiard room, but the Connaughts rejected this idea firmly, as they thought it would have looked too European for the magnificent carvings. The Duke favoured a Kashmir embroidered curtain material of the type made in Amritsar. As a contrast to the honey-coloured wood, his wife fancied a turquoise and blue coloured material with Indian bright old gold.[25] Finally, a deep green material was chosen with coloured spangles representing lions lying down either side of a vase bearing a flowering tree. In 1889 the billiard table was finished and Kipling was asked to design a marker and cue-rack in the 'Indian' style. He also designed the fire-dogs.[26]

The Connaughts left Bombay for England on 13th March 1890, by which time probably everything except the carpet had been finished and installed. Kipling was in England in 1890 and seems to have been satisfied with the extension. The patrons, too, must have been relieved to see the product of six years' labour. There is no doubt that the Queen, who saw it in the company of J. L. Kipling, was delighted with it, for when she saw it in August 1890 she wanted one herself.

This is not quite the end of the story of the Indian room for Bagshot, since it is known that Ram Singh worked at Bagshot in February 1892, shortly after finishing at Osborne, although what he did is not known. Between about 1908 and 1910 a gun and a trophy room were added to the billiard room. This was at a time when the Duke and

Duchess were away. The Duke had been appointed Commander-in-Chief and High Commissioner in the Mediterranean. According to a drawing recently discovered in the Indian Department of the Victoria and Albert Museum, a carved wooden archway was designed by Sadhoo Singh, an architect at the Mayo School of Art, Lahore, with the help of a student, Gurbachan Singh.[27] It was approved by Lionel Heath, the new Principal of the School of Art, and cost 486 rupees. This archway replaced the north windows in the billiard room and today leads into a chapel, formerly the trophy room. The work was probably completed by 1910, when the Duke returned to Bagshot prior to his appointment as Governor of Canada.

Contrary to Kipling's undoubted expectations, the Indian extension of Bagshot is only known to have directly influenced one other room, the Queen's dining room at Osborne. Indeed, very few people may have known anything about the unusual billiard room. The cost of making such a room was also prohibitive, and had it not been for the generosity of the Indian princes it could not have been made. The length of time required to have such panels made rendered them too expensive for ordinary consumption; even the Queen's room was made mostly in plaster. The market was therefore very limited. Brassey's room has already been mentioned, but it would be interesting to know if Muhammed Baksh and Juma did any more rooms, for it is known that they stayed on in London during the 1890s because they had received so many commissions as a result of the exhibition.

Although made by Punjabi carvers, Indian rooms of the kind made for Lord Brassey and the Duke of Connaught were unknown in that part of India. In India, as T. N. Mukharji noted in the *Journal of Indian Art and Industry* (1886), the climate of the plains was too hot for the extensive use of woodwork in buildings; it was also too expensive and therefore was mostly used for door-panels. In constructing the two rooms it had been hoped to create a demand for the skills of the Indian woodcarvers and show how they could be utilized in the 'bolder forms of domestic architecture' in England. As yet, there is no evidence to suggest that this actually happened.[28]

NOTES

[1] *Humphry Repton: Landscape Gardener 1752–1818*, exhibition catalogue by G. Carter, P. Goode, K. Laurie (Norwich, 1982), 135–6.

[2] Lists of members published in *Trans. Royal Asiatic Soc.* i (1827); ii (1830).

[3] G. C. E. Crew, *Bagshot Park, Surrey, and the Royal Army Chaplain's Departmental Museum* (Derby, 1974).

[4] G. Aston, *H.R.H. Duke of Connaught and Strathearn* (London, 1929).

[5] For details about J. L. Kipling, see M. Tarapor, 'John Lockwood Kipling and British art education in India', *Victorian Studies*, xxiv, 1 (Indiana University, 1980), 53–81.

[6] See Crew, *op. cit* (note 3).

[7] O. Jones, *Grammar of Ornament* (London, 1856), chaps. 12, 13.

[8] G. Birdwood, *Handbook to the British Indian Section . . .* (London, 1878).

[9] *Id.*, *The Industrial Arts of India* (London, 1880), contains a reprint of the *Handbook* with added texts.

[10] Letter to Birdwood, 1st May 1879, published in *J. Indian Art & Industry*, viii, 65 (January, 1899), 51–2; signatories included: George Aitcheson, Edwin Arnold, C. Purdon Clarke, Walter Crane, Henry Doulton, Edward Burne-Jones, Lord Leighton, William Morris, Richard Redgrave, R. Norman Shaw, E. Alma-Tadema, Philip Webb and Thomas Woolner.

[11] J. L. Kipling, 'Punjab wood-carving', *J. Indian Art & Industry*, i, 4 (1886), 3.

12 *Ibid.*

13 Kipling Papers, Sussex University: Princess Louise at Meerut to Kipling, Lahore, 23rd June 1884.

14 Kipling Papers: Connaught at Mussoorie to Kipling, Lahore, 19th September 1884.

15 Benjamin Ferrey died in 1880 and was succeeded by his architect son with the same name.

16 See note 14.

17 A. Adburgham, *Liberty's: a Biography of a Shop* (London, 1975), 59–60.

18 Kipling Papers: Connaught at Meerut to Kipling, Lahore (?), 24th January 1885. For Purdon Clarke's exhibition architecture, see R. Head, *The Indian Style: Indian Influences on Western Architecture* (London, 1985).

19 F. Cundall, *Reminiscences of the Colonial and Indian Exhibition* (London, 1886), 27–8.

20 M. Darby, *The Islamic Perspective* (London, 1983), illus. no. 115.

21 D. Devenish, 'The Brassey Collection', *Area Service Magazine* of the Museums of South-East England, summer no. xxix (Milton Keynes, 1976), 6–8.

22 Kipling Papers: Jackson & Co.'s estimate of 9th April 1891 is for 'A new Indian dining room'. Hence the extending dining-table in the Bedford Lemere photograph *c.* 1893: see Head, *op. cit.* (note 18), pl. 83.

23 Kipling Papers: Ram Singh, London, to Kipling at Lahore, 25th February 1892.

24 Kipling Papers: Connaught at Poona to Kipling, Lahore (?), 4th June 1889.

25 *Ibid.*

26 Kipling Papers: Connaught at Poona to Kipling, Lahore (?), 28th October 1889.

27 Drawing entitled, 'Proposed Punjabi Carving, Panel and Moulding for Bagshot Park, England'. Watermarked, 1908

28 Head, *op. cit.* (note 18).

England and Japan: Notes on Christopher Dresser's Japanese Visit 1876–1877

Stephen Jones

Scattered examples of Japanese applied arts were accessible to European artists as early as the seventeenth century. It is fair to say also that some understanding of the civilization which created such art objects was feasible in England from the second quarter of the eighteenth century: Kaempfer's *History of Japan* was, for example, translated into English in 1727. However, intellectual curiosity about Japanese art, as opposed to generalized enthusiasm for things oriental, cannot be identified before the 1850s, when, in the wake of the internationalism engendered by the Great Exhibition, the Museum of Ornamental Art, antecedent of the South Kensington Museum, acquired a group of Japanese furniture.

If one considers carefully the possible reasons for this long-delayed enthusiasm, one significant factor emerges. When Japanese taste did begin to be understood and appreciated it was in terms of artefacts and popular art media collected and studied. Lacquer, porcelain, furniture and prints from the studios of the great printmakers like Haronobu, Utamaro and Hokusai formed the staple aesthetic diet of nineteenth-century collectors and artists. Many regarded these objects simply as a means to an end. In the works, most obviously, of James McNeil Whistler, the original aesthetic of Japanese works of art is subordinated to their role as props in the dramatic setting of his own pictures. Neither his Peacock Room, designed for Leyland, nor the *Princesse du Pays de la Porcelaine* that he painted as its centrepiece, demonstrates a serious concern with sources. The eclecticism characteristic of the Aesthetic Movement informs such an *ensemble*. Only in such works as *Old Battersea Bridge* is the relation to Whistler's sources in Japanese prints sufficiently close for us to be able to begin to define sources at all precisely. Even an aesthete like Lord Leighton, who assembled in his paintings, as in his Academy discourses, an altogether more serious and conscious academic underpinning for his artistic ideas, did not, in the case of Japanese art, go far into the context from which it sprang.

If Japanese art objects were frequently seen by fine artists as appealing dressing for their sets, there is another thread in the history of English Japanese taste that is worth examining. Of the design philosophers of the nineteenth century, Christopher Dresser approached more nearly than most, in his book *Japan, its Architecture, Art and Art Manufactures*, an understanding of the highly sophisticated culture of which Japanese art was an emanation.

Dresser was by training a botanist. He found in the capacity of plants to adapt physically to adverse environments an example of the need for design to adapt to its function: how, as he wrote in *General Principles of Ornament* in 1862, 'An object must fitly answer the purpose for which it has been originated'. That book was written as a *vade mecum* to the layman visiting the International Exhibition of the same year. It lays down many of the fundamental tenets of Dresser's beliefs regarding design. The exhibition was itself important for Dresser, as for other designers and artists, as being the first occasion when a large and representative body of Japanese design was shown publicly. William Burges wrote in praise of the asymmetry of the Japanese aesthetic. Godwin, Whistler, Leighton and Dresser all visited and noted the excellence of the Alcock collection, which was the centrepiece of the display and had been assembled by Rutherford Alcock, author of *The Capital of the Tycoon* (1863), an account of Tokyo and its Shogun heritage.

Of these artists, critics and designers, Dresser was certainly the most sensitive observer and commentator on Japanese art. His own visit to Japan in 1876–7 is recorded in his book, whose subtitle, *Architecture, Art and Art Manufactures*, gives a clue to his superior perception of the qualities of Japanese design. Dresser recognized that the Japanese did not make the western distinction between fine and applied arts. This distinction was to Dresser an unnecessary one, and in addition to travel chronicle and art monograph, his writings veil a subtle polemic against such divisions. Believing as he did that beauty grew out of function, Dresser considered that ornament originated in architecture and was then applied to art objects. Thus the pre-eminence in Japan of decorative technique was for him laudable and readily comprehensible. He writes, after visiting the Mikado's collections of antiquities at Nara and Kioto:

In the last Paris International Exhibition a large folding screen was exhibited by a Yokohama dealer named Chogaro, which was in every sense a work of the greatest excellence . . . it was, as a work of art, a thing to be loved and treasured quite as much as a painting by a master hand.

I cannot help thinking that we in England overestimate the decorative value of pictures. Many who cover their walls with costly paintings have scarcely an object in their houses besides these which has any art merit. The vases on the chimney piece, the epergne on the table, the nick-nacks in the cabinets, and the service for the afternoon tea drinking are all alike incongruous and meretricious. Surely persons whose houses are thus furnished have but little real love of the beautiful: he who admires what is pleasant in form and lovely in colour would regard the beauty of each object around him and the tout ensemble.

Choice objects in lacquer are about the most recherché of drawing room ornaments, and in art merit exceed almost any of the bric-a-brac now collected. Indeed some specimens are so perfectly worked, so rich in decoration, so minute in detail, and so tender in execution as to be fit for a place in any boudoir in the land . . .

The irony of Dresser's argument is implicit in the last line. He evidently held in low regard the design standards of the average British boudoir.

Dresser was, of course, as susceptible to the excitement and glamour of the Far East as any less serious traveller. On 26th December 1876, when he arrived off the coast of Japan, he recorded his first sight of Fujiyama in terms as passionately purple as any Brompton aesthete:

> There at a vast height, shines the immaculate summit of Japan's peerless cone. I have seen almost every alpine peak in the land of Tell; I have viewed Monte Rosa from Zermat, Aosta and Como; I have gloried in the wild beauty of the Jungfrau and the precipitous heights of the Matterhorn; but never before did I see a mountain so pure in its form, so imposing in its grandeur, so impressive in its beauty as that on which we now gaze.

But in his perceptions of Japanese design he is refreshingly bold and innovative. He is alive to the extraordinary brilliance of the Japanese juxtaposition of colour and material when he visits the Shogun cemetery at Shiba near Tokyo:

> The roof of the temple overhangs the balcony and protects it from the weather, while the constructive rafters and joists which support it are left fully exposed to view. Internally we have a ceiling of which the structural features are not visible. The ceiling is panelled out in small squares and is decorated; red, blue, green, white and gold being applied to it in all their intensity.
>
> It might be thought that such a system of colouring as this could only produce a coarse and vulgar effect; but this is not so, for the overhanging roof ... does not permit the entrance of any excessive amount of light; and the light that ultimately reaches the ceiling is all reflected, and that from a black floor.

As indicated above, Dresser was highly responsive to the nuances of culture and religion reflected in Japanese design. As well as admiring the design of the Shogun shrines, he investigated their purpose: he established that each shrine contained the 'Sacred Name' of the Shogun there buried, but failed to ascertain the meaning of this, deciding finally that 'throughout Japan there is a strange confusion of Buddhism and Shintoism, for while Shintoism deifies heroes, Buddhism does nothing of the kind'. Such close analysis at this date of the religious and cultural context of Japanese arts distinguishes Dresser as informed and highly sensitive. These subtle perceptions can lead to his striking a sadder, even ominous note in the book. Touring the Mint and the Armoury he notes:

> In the factory guns were being made and small arms altered, but all this had little interest for me. In the first place there was no art merit in the things produced; and in the second the processes employed were all European.

He enlarges upon the influence of the west as he passes on to the surrounding gardens, pleasure grounds laid out in the sixteenth century:

> In the garden are some lovely summer pavilions, their little lattice windows being most charming in design. Yet they are all perishing for lack of attention ... It is indeed lamentable that such exquisite structures should go to ruin, yet I fear that European civilization is likely to prove fatal to some of the finest monuments of the country but why it should be I cannot divine. No nation can afford to do away with

its ancient monuments. If they are of great excellence in design they tend to uphold the character of national manufactures: and by attracting visitors to a country the money which they spend in it contributes to its wealth . . .

The reference to the touristic possibilities of such monuments indicates a basic naivety in Dresser's attitude throughout his visit. He comes as a pilgrim to a great altar of beauty, the achievement of Japanese art and culture. However, he comes as a representative of the West, bearing examples of British manufacture as gifts for the Mikado: objects that represent for the Japanese a new world as exciting for them as their own Floating World was for European aesthetes. In his speech to the Mikado, Dresser lists the manufacturers who have given examples of Western manufacture:

> The small present, of which I have been the bearer, to your Majesty's National Museum was got together at the suggestion of Mr. P. C. Owen, the director of the South Kensington Museum in London. For the objects I am indebted to Messers London and Co. who gave the greater number, Messers Green and Nephew, Messers Doulton, Messers Elkington and Mr. Jonathan Lewis, all of London: to Messers Jonathan Brinton and Co. of Kidderminster and to Messers Ward and Cope of Nottingham . . .

He continues, in contrast, with a plea that the Mikado will shield his nation's artists from the influence of this formidable roll-call of Victorian industrial and commercial interests:

> I humbly beg that your Majesty may be pleased to order the adoption of such means as will preserve to your Majesty's people their national arts in a form unpolluted by European influences, for the ornamentists of our western countries feel that it is their privilege humbly to follow the great artists of your Majesty's dominions.

In return for his gifts Dresser requested that four models of the ceilings of the Shogun shrines, referred to above, be made for him. In addition Okubo Toshimichi, the Mikado's Minister of the Interior, was ordered to provide details of the lacquer techniques which went into the creation of the floors of the shrines. In sending both the models and the information to Dresser after his return to England, Toshimichi wrote an accompanying letter, the text of which Dresser published in his book:

> Sir
> In January of last 10th year of Meiji you have brought the articles sent by Mr. Owen to our museum and I am much obliged that you have taken the trouble to arrange them. After your returning home last April the articles have been exhibited to all the people and I have notified all through the country your valuable information, regarding to the important points of industry which you have given to the officer who attended your visit to several industrial establishments. It must be for [because] of your kindness that I could make all industrial men to understand the points which were obscure heretofore and I can assure that in the future time they will make a progress and bring great interest upon the commerce.

This extract indicates how Dresser's plea for insulation of the Japanese artistic tradition became submerged in official enthusiasm for the industrial development of the nation, a development already noted by Dresser in his speech to the Mikado. The

remaining, unpublished portion of Toshimichi's communication included the information which was the original source for Dresser's much enhanced and expanded consideration of lacquering techniques in chapter 3 of the second part of his book on Japan. Toshimichi's letter and accompanying text are both preserved in manuscript in the Library of the Victoria and Albert Museum. Of the four models made for Dresser, three also now form part of the Victoria and Albert collections, having been left to the museum by Dresser on his death in 1905.

Illness on his return to England delayed Dresser's publication of the exhaustive account of his travels for five years, a hiatus unprecedented in an age of rapid publication. Thus, in April 1883, when the Edinburgh Review noticed the book in its pages, the critic was modest in his enthusiasm, noting that 'it fails to possess that element of novelty which would have been so striking had the record been printed before the publication of other volumes'. By 1882 *Japonisme* was closely associated in the public mind with the Aesthetic Movement, guyed by Gilbert and Sullivan in *Patience* (1882) the year before Dresser's book came out, and even more immediately satirized in *The Mikado* (1884).

As must be clear from even this cursory account of Dresser's travels and writings in 1876–7, his encounter with Japanese culture, society and religion was of a much more profound order than anything known to the average faddist of the Aesthetic Movement. Therefore Dresser's early visit to Japan and the subsequent book remain a major text for the study of the influence of the country upon English art. Sadly, it must be clear that the subtext of Dresser's *Japan* is a prophetic commentary on the complementary influence of the West on Japan.

Sources of Inspiration in the Arts and Crafts Movement

Alan Crawford

The most useful way of discussing the sources of inspiration of the Arts and Crafts Movement in a short paper is to list them, and so to give a sense of the range and variety of the Movement.

The first, and arguably the most important, source was 'old work', as architects and designers at the turn of the century would often say. Most of the papers in this seminar take for granted that inspiration should be found in the admirable works of the past; in the case of the Arts and Crafts, however, that assumption cannot be made, for the most influential writing on this subject has taken the opposite view, that the interest of the Movement lay in an attempt to break free from dependence on the past. Coming at the end of the nineteenth century, cultivating a sense of homely usefulness and an often Puritan style, the Arts and Crafts has been seen as a harbinger of twentieth-century Modernism.

There is much in the writings of members of the Arts and Crafts Movement to sustain this point of view; less, but still much, in their designs. But it is partial, and to interpret the Movement exclusively in this way is to misunderstand it. A cautionary tale will illustrate the point. In the 1950s a cabinet designed by Ernest Gimson, perhaps the best-known furniture designer of the Movement, came on to the art market. Its sides and doors were decorated with an intricate design of curved segments in palm, ebony and orangewood marquetry; the pattern was abstract and geometrical, and seemed to have a distinctly twentieth-century flavour; people spoke of it as having a quality of Art Deco about it. Among Gimson's early sketchbooks, now in the possession of Cheltenham Art Gallery and Museum, are drawings of a pattern virtually identical to that on the cabinet, painted on the walls of the church at Berkeley in Gloucestershire in the late thirteenth century. The inspiration for his very modern-looking cabinet lay partly in the Middle Ages.[1]

To get to know old work, Arts and Crafts people probably followed the same paths as their nineteenth-century predecessors. Architects went on sketching-tours and chose the major and obvious buildings; if there was a new emphasis in their sketches it

was that they paid special attention to details of craftsmanship and humble artefacts. They also turned to the South Kensington Museum for examples in their design work; indeed, there is a sense in which they benefited more than anybody else from the Museum. Its collections were substantial by the 1880s and 1890s, and though they were meant for the instruction of designers in all branches of the decorative arts, in trade and industry, this magnificent collection of largely pre-industrial craftsmanship must have had a richer appeal to revived craft designers, who saw them as exemplars in the round, than to those who saw them simply as sources for designs, as it might be for calico-printing in Manchester.

The Movement was catholic in its historical sources, by no means wedded to a single style, and I cannot do justice here to their full range, let alone suggest why some works were felt to be suggestive, and others not. I pass over debts to India, Japan, Scandinavia, to Byzantine and Early Christian architecture, to Celtic ornament and all sorts of medieval enamelling; and I simply pick out three examples which seem to me characteristic: a panel of tiles by Voysey decorated with confronting birds and a tree in an ogee pattern (pl. XL*a*), a group of motifs with a history in the decorative arts going back to the ancient Near East, but possibly picked up by Voysey in the textiles of fourteenth-century Italy; a book illustration by Robert Anning Bell (pl. XL*b*), whose open line and architectural setting shows the influence of the *Hypnerotomachia Poliphili* of 1499, pervasive in the Movement; and a design for a decorative plaster ceiling of mansard type by George Bankart (pl. XLI*a*), which owes a debt to the late seventeenth-century ceiling of the Vine Room at Kellie Castle in Fifeshire.[2] It is noticeable how popular seventeenth-century exemplars were in precious metalwork, furniture and architecture, partly because the medieval period, to which Arts and Crafts people looked in a romantic way, could not always provide exemplars of the sort they wanted in these media.

There is a particular emphasis in the Arts and Crafts sense of the past which is striking and characteristic of the Movement, though not universal, and that is the sense of the vernacular. Of a seventeenth-century farmhouse at the west end of the village of Broadway in Worcestershire, William Morris wrote:

> . . . 'tis no ideal house I am thinking of: no rare marvel of art, of which but few can ever be vouchsafed to the best times and countries; no palace either, not even a manor-house, but a yeoman's steading at the grandest, or even his shepherd's cottage: . . . everything about it is solid and well wrought: . . . there is a little sharp and delicate carving about its arched doorway, and every part of it is well cared for: 'tis in fact beautiful, a work of art and a piece of nature—no less: there is no man who could have done it better considering its use and its place.
>
> Who built it then? No strange race of men, but just the mason of Broadway village . . .[3]

The cult of the cottage was not peculiar to the Arts and Crafts, or started by it; the distinctive contribution of the Movement was to populate the quaint cottage: behind vernacular buildings of this kind they saw a band of sturdy yeomen, England's native stock, who gave the buildings a kind of authority. One need hardly say that these 'people' were not very real: they were part of the romantic mythology of the Arts and Crafts; neither their existence nor their habits were studied historically; they were simply inferred, extrapolated, so to say, from the buildings themselves.

After old work comes romance. There was a good deal of pictorial work in the Arts

PLATE XL

b. 'Julia offering Silvia the ring of Proteus', an illustration by Robert Anning Bell to Charles and Mary Lamb, *Tales from Shakespeare* (London, 1899), facing p. 348

Photograph: Victoria and Albert Museum

a. A panel of tiles designed by C. F. A. Voysey and made by Maw & Co. of Jackfield, Shropshire, *c.* 1900. Victoria and Albert Museum

PLATE XLI

Photograph: Victoria and Albert Museum

b. A cup and cover in silver set with enamel and turquoises, designed by C. R. Ashbee, 1900, and presented by Harris Heal to the Painter-Stainers' Company in the City of London. Victoria and Albert Museum

a. 'A Mansard Ceiling', detail of pl. 57 from George P. Bankart and G. Edward Bankart, *Modern Plasterwork Design* (London, 1927)

and Crafts—book illustration, mural-painting, tapestries, enamels—and they often took their subjects from Arthurian legend, particularly as handled by Burne-Jones, and from Spenser. One explanation for this would be the yearning for the Middle Ages, for the age of the Guilds and Carlyle's *Past and Present*, which could be more easily satisfied by romance than by examples of medieval craftsmanship, which, as I have suggested, were scarce in some kinds of work.

Then we have nature. In his influential handbook, *Silverwork and Jewellery*, Henry Wilson devoted a section to the making of a pendant in the form of a nightingale. It begins: 'First go and watch one singing. There are happily numberless woods and copses near London in which the nightingale may be heard and seen at almost any time of day. Take an opera glass . . .'[4] Unlike the design reformers of the mid nineteenth century, who saw in natural forms quasi-scientific laws and an underlying geometry, the Arts and Crafts saw flowers and leaves, and this realism is one of the pleasures of their natural ornament. But, though listening to nightingales will provide inspiration, it will not provide a design, and the naturalism of the Arts and Crafts was equally dependent on tradition and convention. There was another kind of nature all around them, in the traditions of the decorative arts, and William Morris's pattern designs, for example, show influence from fourteenth-century Italian textiles and the long-lived acanthus leaf, as much as from the fields and woods of Oxfordshire.

Materials: if one had asked the members of the Arts and Crafts Movement themselves where they got their inspiration from, their first answer would probably have been, from the feel of the metal under the hammer, from the coloured glass, fissured and bubbled, lying on the glazier's bench. They would have said that they were designing in the nature of the materials, and I for one would not have altogether understood them. They might have meant—perhaps they should have meant—a constructional approach to design: using materials with a precise sense of their capacities and strengths, using no more than was necessary. But as a matter of fact Arts and Crafts objects often use redundant material, and for quite considered effects. They might have meant—and I suspect they did—that they were continually, and rightly, seduced by the surfaces of things, by colour and roughness in particular, the mixed colour and uneven surface and shape of hand-made bricks, the grain of wood, the colour of ivory and coral.

Technique: some people in the Arts and Crafts were fascinated by particular techniques; they saw them used in old work, did not see them in quite the same way in modern work, and set about reviving them. A good example is the lustre wares of William De Morgan, who admired such glazes but did not at first know how to achieve them. And so he set out to re-create them all by himself: dissatisfied with smoke as a reducing agent, he experimented for twenty years with such different recipes as steam, coal gas, water vapour, and glycerin and spirit, before he was satisfied. There are two things to be said about this practice. One is that he could probably have saved himself time and aggravation by a short trip to Stoke-on-Trent: he could have taken advice; but it was important to him to sort it all out himself. The other is that this is a case where to travel was just as important as to arrive: the satisfaction was as much in the technical experiment and prowess as in the pots or tiles themselves.

A sense of place was important in Arts and Crafts architecture. Normally this was expressed by an observance of local building traditions; a different, and well-known example is the craggy and eccentric cottage called Stoneywell which was built by Ernest Gimson in the Charnwood Forest ouside Leicester. Charnwood is not a forest

properly speaking, but a stretch of heath-like upland, a freakish geological mass of granite sticking up suddenly in the soft marls and clays of Leicestershire. The soil is thin, and small rocks sticking out of the ground are a feature of the landscape. Gimson took his cue from the geology of the place and created a cottage which seems to burrow into the ground or jut out of it, as if it was itself an inhabited outcrop.[5]

Finally, a form of negative inspiration. The Arts and Crafts was a progressive, élite movement of the sort familiar in modern art. Its members carried with them a more or less crude and powerful image of the unenlightened mass from which they were set apart, as artists from bourgeois *philistia*, as revived craftsmen from the world of commerce and industry. This stereotype itself influenced their designing, which was often quite deliberately the antithesis of ordinary middle-class taste. Jewellery provides a telling example. Much fashionable jewellery round 1900 was made of pale, sparkling, close-set diamonds which, following discoveries in South Africa, came on to the market in increasing quantities after 1868; they were more or less expensive, and the Arts and Crafts adopted an antithetical taste for stones which had a strong and variable colour, and cost (or looked as if they cost) a great deal less. Their jewellery was a visual, and perhaps also a moral or sumptuary, rebuke to the taste of the time.

I hope I have shown how rich in inspiration the Arts and Crafts was; how sources are present in designs as allusions, widening their meanings; and how there is no need to oppose old and new, tradition and modernity, for they are part and parcel of the same thing. The presentation cup of 1900 by C. R. Ashbee obviously belongs within the tradition of English standing cups of *c.* 1660 (pl. XLI*b*). That was a part of its character, carefully judged and appropriate to the place it would take among the plate of a City Company. It is, however, only when it is seen in that traditional context that the freshness and modernity of the design, the things that mark it so unmistakeably as belonging to 1899, can be fully appreciated.

NOTES

[1] The cabinet is illustrated in L. Lambourne, *Utopian Craftsmen* (London, 1980), 167; the drawings from Berkeley in M. Comino, *Gimson and the Barnsleys* (London, 1980), 63.
[2] The Kellie Castle ceiling was illustrated by G. Bankart in *The Art of the Plasterer* (London, 1908), 203–5.
[3] M. Morris (ed.), *The Collected Works of William Morris* (London, 1910–15), xxii, 126–7.
[4] *Silverwork and Jewellery* (London, 1903), 127.
[5] Stoneywell is described in L. Weaver, *Small Country Houses of Today,* ii (London, 1922), 15–21.

Index

Compiled by PHOEBE M. PROCTER